MMCA 청주프로젝트 2021

천대광 집우집주

MMCA CHEONGJU PROJECT 2021

CHEN DAI GOANG: DREAMS OF THE PERFECT CITY

MMCA 청주프로젝트 2021 《천대광: 집우집주》

2021. 9. 17. - 2022. 7. 24.
국립현대미술관 청주 미술품수장센터 앞 잔디광장

관장	윤범모
학예연구실장	김준기
미술품수장센터운영과장	임대근
학예연구관	김경운
전시기획	현오아
전시보조	허동희
전시운영	장수경
그래픽디자인	박현진
교육	이승린, 박소현
홍보	정원채, 진승민, 홍보고객과
고객지원	연상흠, 이소연
행정지원	미술품수장센터관리팀
사진	정환영
영상	Studio-AA
도움주신 분들	청주시, 청주공예비엔날레조직위원회 관계자분들께 진심으로 감사의 말씀을 드립니다.

MMCA Cheongju Project 2021, Chen Dai Goang: Dreams of the Perfect City

September 17, 2021 - July 24, 2022
Front Lawn, MMCA Cheongju Art Storage Center

Director	Youn Bummo
Chief Curator	Gim Jungi
Head of Curatorial Department of National Art Storage Center	Lim Dae-geun
Senior Curator	Kim Kyoungwoon
Curator	Hyun OhAh
Curatorial Assistant	Huh Donghee
Technical Coordination	Jang Soogyeong
Graphic Design	Park Hyunjin
Education	Lee Seungrin, Park Sohyeon
Public Relations	Jung Wonchae, Jin Seungmin, Communications and Audience Department
Customer Service	Yeon Sang-heum, Lee Soyeon
Administrative Support	MMCA Cheongju Administration Team
Photography	Andy H. Jung
Film	Studio-AA
Special thanks to	Cheongju-si, Cheongju Craft Biennale Organizing Committee

MMCA 청주프로젝트 2021

천대광 집우집주

MMCA CHEONGJU PROJECT 2021
CHEN DAI GOANG: DREAMS OF THE PERFECT CITY

발간사

MMCA 청주프로젝트는 청주관 앞 넓은 잔디광장을 비롯한 야외공간에서 매년 국내 작가의 신작을 소개하고 있습니다. 관객들에게 현대미술의 다양한 양상을 경험할 수 있는 기회를 제공하는 동시에 작가들에게는 새로운 작품 제작지원을 통해 도약할 수 있는 발판을 마련하고자 기획되었습니다. 작년에 이어 올해는 《천대광: 집우집주》를 선보입니다.

대규모 설치 작업을 주로 하는 천대광 작가는 이번 전시를 위해 수장센터 앞 잔디광장에 작은 도시를 만들었습니다. '우주'라는 단어가 집'우'(宇), 집'주'(宙)로 이루어졌듯이, 《천대광: 집우집주》는 우리가 사는 '집'이 모여 '도시'를 이루고 더 나아가 '우주'가 된다는 개념에서 출발했습니다. 작가는 국내 및 아시아 국가를 여행하면서 촬영한 건축물 사진에 상상력을 발휘해 가상의 건축물을 재창조했습니다. 다양한 장소의 건축물과 가구들은 역사와 경제, 문화 등이 복잡하게 얽혀 있는 관계와 흔적을 보여줍니다.

사람들은 대부분 도시에서 살고 있습니다. 더 편리하고 효율적인 도시를 추구하면서 환경오염, 인구 밀집 등 여러 도시문제가 발생했습니다. 특히 코로나19라는 팬데믹을 겪으면서 이 난제를 해결해야 하는 절박함을 안게 되었습니다. 이러한 상황에서 《천대광: 집우집주》는 우리 주변의 공간을 새로운 시각으로 돌아보게 합니다. 스쳐 지나갔던 일상 공간의 의미를 재발견함으로써 이상적인 공간과 삶은 무엇인지 성찰하는 계기가 될 수 있게 합니다.

국립현대미술관은 청주관 특화사업인 MMCA 청주프로젝트를 지속적으로 개최해 국내 작가들을 적극적으로 지원할 것입니다. 이번 프로젝트가 가능하기까지 많은 분들의 도움이 있었습니다. 참여 작가를 비롯하여 원고를 집필해 주신 필진과 진행 과정에서 협조해주신 청주시 관계자분들, 청주공예비엔날레조직위원회에 감사의 말씀 전합니다. 그리고 전시를 개최하기까지 힘써준 미술관 가족들에게도 감사의 말씀을 드립니다.

윤범모
국립현대미술관 관장

Foreword

The MMCA Cheongju Project has introduced Korean Artists' new artworks in an expansive outdoor space including front lawn of MMCA Cheongju every year. The series was planned with the twin aims of bringing viewers diverse experiences of contemporary art in an outdoor setting and providing artists with a platform for creative advancement through the production of new works. For this year, *Chen Dai Goang: Dreams of the Perfect City* is presented following last year.

For this exhibition, Chen Dai Goang, whose work focuses on large-scale installations, has created a small 'city' on the lawn space in front of Art Storage Center. Wuju (우주; 宇宙), the Sino-Korean word for cosmos, is made up of two characters, 宇 (Wu) and 宙 (Ju), that both mean 'house.' In the same way, the houses we live in make up cities, which in turn constitute the cosmos itself. This is the starting premise of *Dreams of the Perfect City*. Chen has recreated imaginary buildings based on architectural photographs taken and collected while traveling through various Asian countries including South Korea. The materials and styles of buildings and furniture in various places bear traces showing how the politics, economics and culture are imprinted in architecture, and of the tangled relationships between these influences.

Today, most of the world's population lives in urban environments. Issues such as pollution, population density and etc. have gained prominence amid our search to build more convenient and efficient cities. We now face a crisis in which solving these problems has become a matter of desperate urgency, heightened further by the COVID-19 pandemic. In our present situation, this project offers us a chance to explore our own homes, urban space and communities living within it from a new perspective. By rediscovering the meaning of the everyday spaces and places we normally pass by without a thought will provide opportunities to reflect on our cities, and on what constitutes ideal lives and spaces.

MMCA is determined to support local artists with the MMCA Cheongju Project, one that is specialized for the MMCA Cheongju. This round was made possible with the cooperation and help of many. I would like to extend my gratitude to Chen Dai Goang and the writers who have contributed meaningful words for the catalog, as well as staff of the City of Cheongju and Cheongju Craft Biennale Organizing Committee, as well the museum staff who have dedicated themselves to the opening of this exhibition.

Youn Bummo
Director, National Museum of
Modern and Contemporary Art, Korea

MMCA 청주프로젝트 2021
《천대광: 집우집주》

05 발간사
 윤범모 (국립현대미술관 관장)

12 기획의 글
 현오아 (국립현대미술관 학예연구사)

24 전시 전경

58 남방의 건축을 '역사의 양피지'로 재체험하는,
 회억 속에서 비전이 재출현하는 건축술 — 천대광론
 김남수 (안무비평)

66 집우집주, 집들 사이로 우주의 바람을 불러들이다
 이진경 (서울과학기술대학교 교수)

78 청주淸州 도심 거주환경과 문화
 김태영 (청주대학교 건축학과 교수)

88 작가 인터뷰

100 작가 약력

MMCA CHEONGJU PROJECT 2021
CHEN DAI GOANG: DREAMS OF THE PERFECT CITY

05 Foreword
 Youn Bummo (Director, MMCA)

12 Curatorial Essay
 Hyun OhAh (Curator, MMCA)

24 Exhibition View

58 On Chen Dai Goang's Work: The Technique of Architecture
 to Re-experience the Architecture of the South, the Technique of
 Architecture Where Vision Reappears in Remembrance
 Kim Nam Soo (Choreography Critic)

66 The Houses in Wu (宇) and Ju (宙):
 Calling in the Cosmic Wind through the Houses
 Yi-Jinkyung (Professor, Seoul National University of Science and Technology)

78 The Residential Environment and Culture of Central Cheongju
 Kim Tai Young (Professor, Department of Architecture, Cheongju University)

88 Artist Interview

100 Artist CV

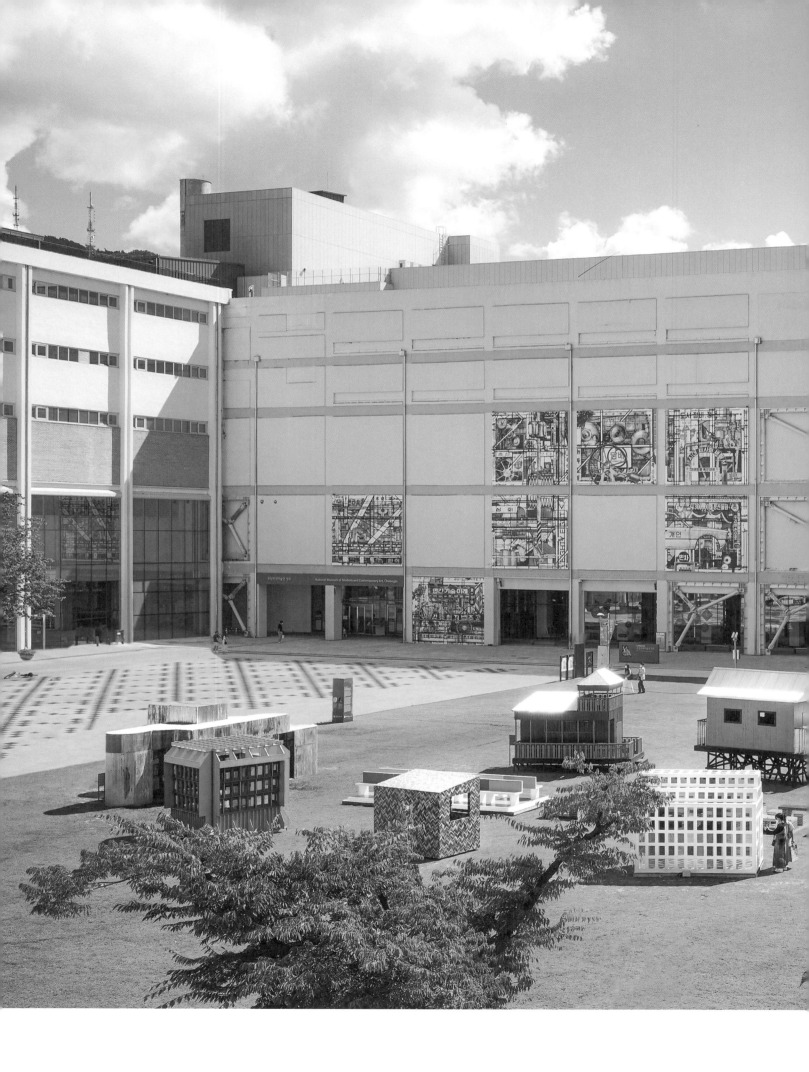

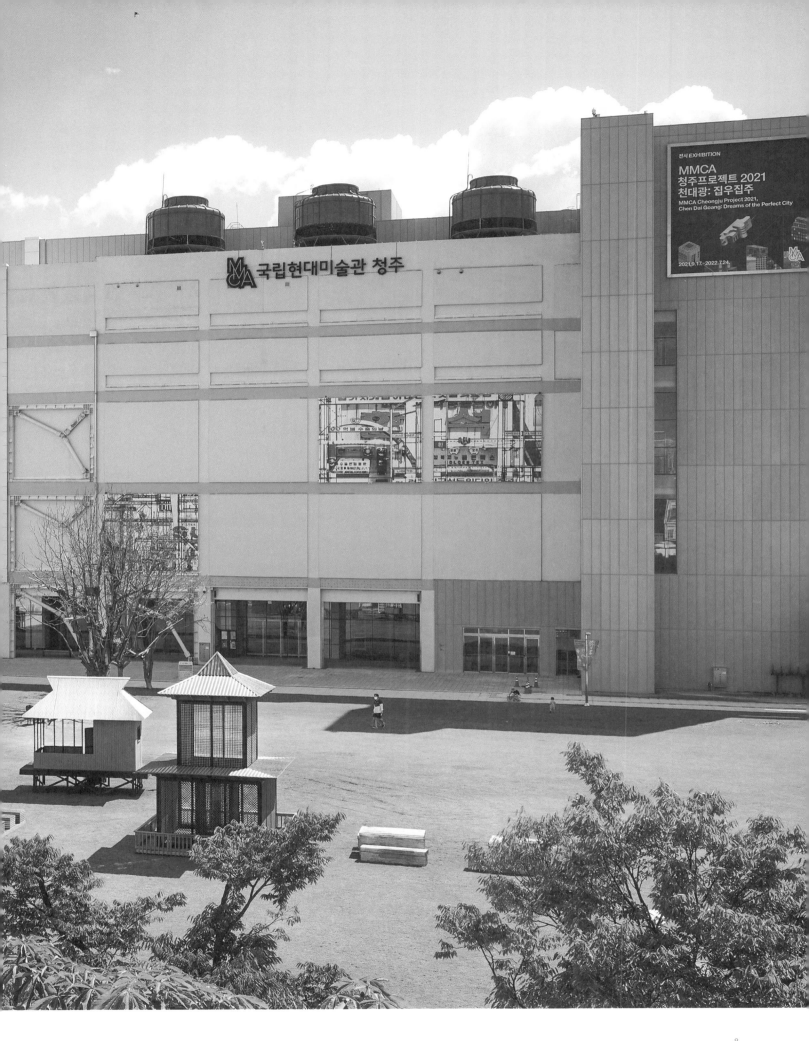

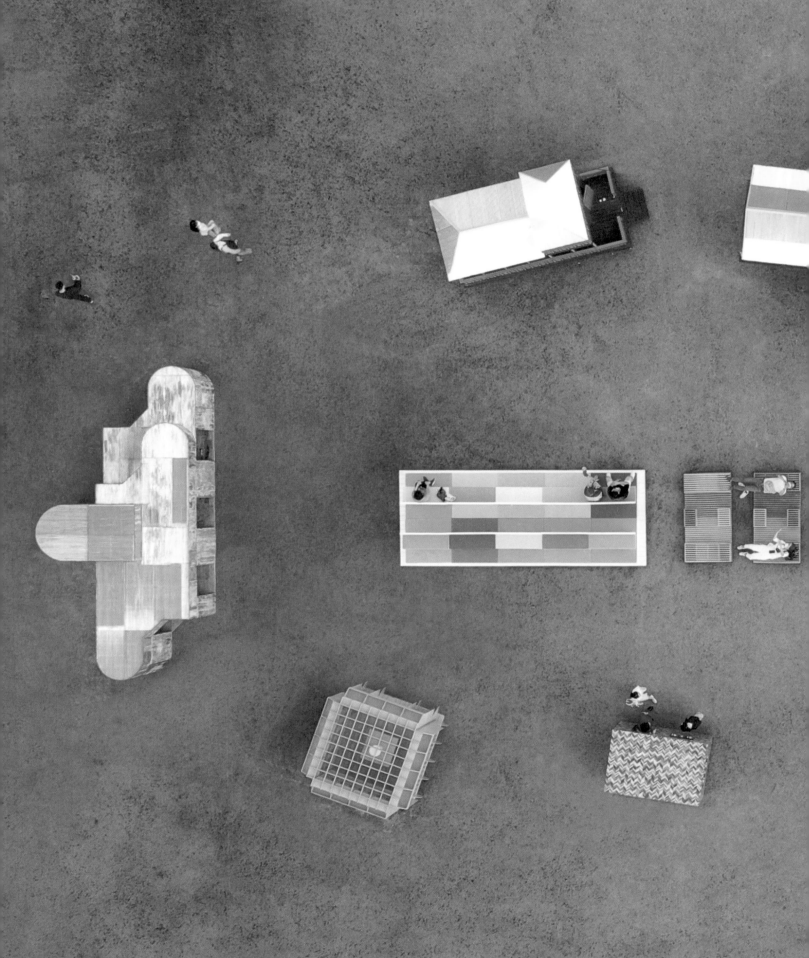

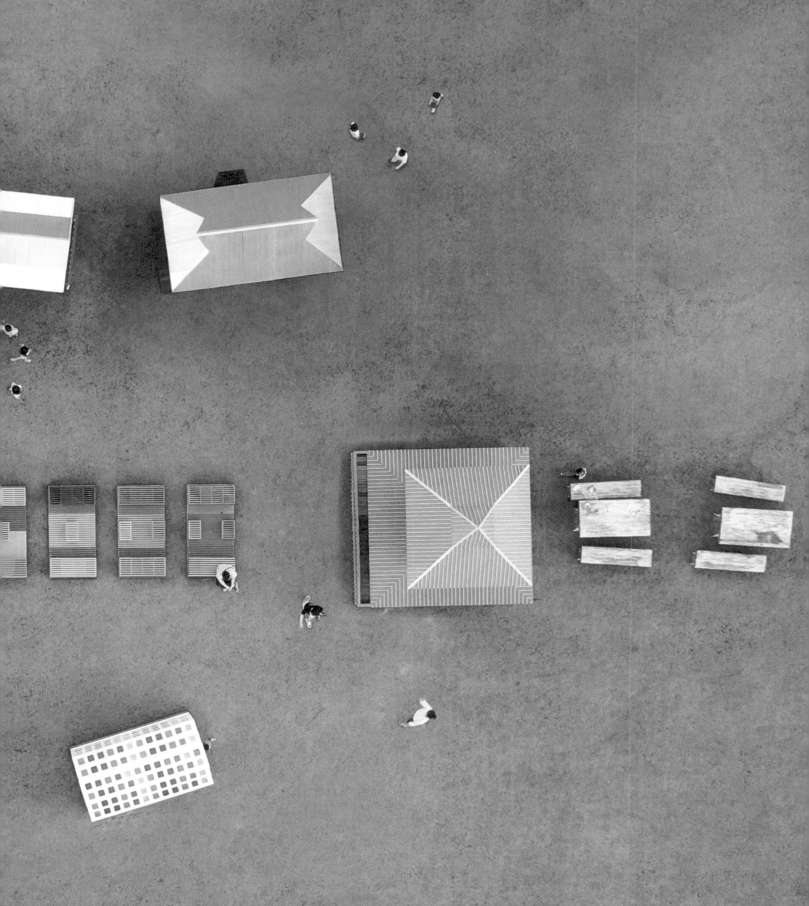

MMCA 청주프로젝트 2021
《천대광: 집우집주》

현오아
(국립현대미술관 학예연구사)

MMCA Cheongju Project 2021,
Chen Dai Goang: Dreams of the Perfect City

Hyun OhAh
(Curator, MMCA)

도시는 기억으로 넘쳐흐르는 이러한 파도에 스펀지처럼 흠뻑 젖었다가 팽창합니다. 자이라의 현재를 묘사할 때는 그 속에 과거를 모두 포함시켜야 할 것입니다. 그러나 도시는 자신의 과거를 말하지 않습니다. 도시의 과거는 마치 손에 그어진 손금들처럼 거리 모퉁이에, 창살에, 계단 난간에, 피뢰침 안테나에, 깃대에 쓰여 있으며 그 자체로 긁히고 잘리고 조각나고 소용돌이치는 모든 단편들에 담겨 있습니다.[1]

- 이탈로 칼비노, 『보이지 않는 도시들』

이탈리아 소설가 이탈로 칼비노(Italo Calvino)의 소설 『보이지 않는 도시들(Le città invisibili)』(1972)에서 화자인 마르코 폴로는 중국 황제 쿠빌라이 칸에게 자신이 방문했던 도시에 관한 이야기를 들려준다. 총 55개의 도시가 등장하는 이 소설은 파편화된 현대 도시처럼 각각의 짧은 텍스트 하나하나가 연속적으로 다른 텍스트들에 근접해 있는 다면적인 구조를 구축하고 있다.[2] 마르코 폴로의 여행은 실제 물리적인 도시 여행기라기보다 이상적인 도시로의 상상 여행으로, 그의 사유가 덧붙여진 환상 이야기라고 할 수 있다. 그래서 그가 들려주는 도시의 묘사는 우리가 주변에서 흔히 볼 수 있는 풍경이 아니라 비현실적이고 몽환적이다.

　소설 속 마르코 폴로가 방문한 도시 여행기를 이야기로 '들려'주었다면, 천대광은 <집우집주>를 만들어 우리에게 다양한 도시의 건축물을 '보여'준다. 각기 다른 '집' 조각은 천대광이 아시아 국가를 여행 다니며 촬영한 건축물 사진을 기반으로 디자인되었다. 작가는 다양한 건물을 섞기도 하고, 새로운 문양을 넣기도 하는 등 자신만의 독특한 미감으로 재해석하여 어디에도 없는 가상의 건축물을 만들어냈다. 다양한 건축 재료를 이용한 건축물 내부에는 각 공간에 어울리는 가구와 집기들이 설치된다. <집우집주> 속 도시들은 어떤 모습일까.

As this wave from memories flows in, the city soaks it up like a sponge and expands. A description of Zaira as it is today should contain all Zaira's past. The city, however, does not tell its past, but contains it like the lines of a hand, written in the corners of the streets, the gratings of the windows, the banisters of the steps, the antennae of the lightning rods, the poles of the Bags, every segment marked in turn with scratches, indentations, scrolls.[1]

- Italo Calvino, *Invisible Cities*

In the novel *Invisible Cities* (*Le città invisibili*; 1972) by Italian author Italo Calvino, narrator Marco Polo tells Kublai Khan tales of the cities he has visited. Featuring a total of 55 cities, the book builds a multifaceted structure in which each short text constantly approaches the next, as in a fragmented contemporary city.[2] Polo's journey is not an actual one through physical cities but an imaginary one through ideal cities; his tales can be seen as fantasies featuring the addition of his own thoughts. His descriptions of cities thus feature not the kinds of scene familiar to us, but unrealistic, dreamlike visions.

　If the Marco Polo of Calvino's novel 'tells' of the cities he has visited through tales, Chen Dai Goang 'shows' us diverse forms of urban building through *Dreams of the Perfect City*. Each different 'house' sculpture was designed based on buildings photographed by Chen on his travels through Asia. The artist blends a variety of building exteriors, sometimes adding new patterns and reinterpreting architecture through his own unique aesthetic, to create unprecedented imaginary structures. Inside these buildings crafted from diverse materials, are furniture and equipment installed in ways appropriate to each space. So what kinds of city does *Dreams of the Perfect City* contain?

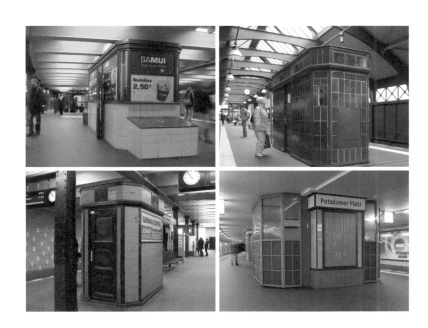

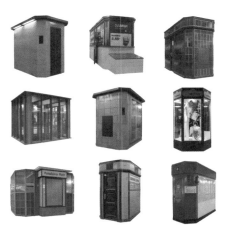

<견인 도시 프로젝트-베를린 지하철 프로젝트-키오스크> 중
일부, 2012, 디지털 사진

Parts of *Traction City Project-Berlin U-Bahn (Subway)
Project-Kiosk*, 2012, Digital Photos

조각과 건축의 경계에서

이번 전시를 위한 신작 <집우집주>는 천대광이 2000년대부터 진행해 온 도
시 프로젝트의 연장선상에 있는 작품으로, 그는 '건축 채집', '독일 베를린 지하
철(U-Bahn) 프로젝트', '파사드 프로젝트', '견인 도시 프로젝트' 등 다양한 주제
와 형식으로 작업을 지속해 오고 있다. 작품이 실현되는 공간과 장소에 대한 고
찰과 탐구에서 작업은 출발하는데, 그는 전시 공간의 환경적 특성, 조건, 그리
고 장소 고유의 역사·사회·문화적 맥락을 참조할 뿐만 아니라 개인의 경험과
기억, 그리고 종교, 철학 등 관심 있는 다양한 분야의 인문학적 연구를 결합해
작업을 전개한다. 천대광은 평생 진행하게 될지도 모르는 도시 프로젝트에 대
해 그 자신은 철저하게 눈으로 보이는 시각적 환경만을 고려하고 자신의 실험
이 미학적이라고 주장하지만, 실제로 그의 '건축적' 작업 구성의 과정에는 노동
과 예술을 포함하여 도시의 여러 층위에 대한 그의 성찰이 반영되어 있다.[3]

2001년 독일에서 <보청기> 작업을 시작으로 천대광은 관람객이 작품
내부로 들어갈 수 있는 거대한 규모의 설치 작업을 주로 진행해 오고 있다.
<보청기>는 나팔이 거꾸로 세워져 있는 형상으로, 커다란 파이프가 지붕 위
에 세워져 있어서 바람이 불면 소리가 공명한다. 그때 내부에 있는 사람은 바
람 소리를 들을 수 있다. 이처럼 천대광은 주변 환경-작품-관람자를 매개하
여 관람자가 이동하거나 머물 수 있는 새로운 공간을 창출한다. 이러한 작업
방식과 전략으로 작품이 전시되는 장소를 생경한 풍경으로 전환하여, 일상의
공간을 새롭게 지각하고 경험하도록 유도한다. 다시 말해 천대광의 작업은
단순한 사물이 아니라 관람자에게 새로운 세계를 제시하는 하나의 사건으로
존재한다.

On the Boundary of Sculpture and Architecture

Dreams of the Perfect City, a new work created for this exhibition, is a
continuation of the urban project on which Chen has been working
since the 2000s. Previous works in this series include *Building Collec-
tion*, *Berlin U-Bahn Project*, *Façade Project*, and *Traction City Project*.
Chen's works begin with study and exploration of the spaces and
locations in which they are to take shape. He considers the physical fea-
tures, environmental conditions, and unique historical, social and cul-
tural contexts of each location, combining them with his own personal
experiences, memories, and research into fields that interest him such
as religion and philosophy. Chen claims that his city projects, which he
may continue for the rest of his career, is an aesthetic experiment, tak-
ing into account visual environments only. But the process behind his
'architectural' works in fact reflects considerations of diverse aspects of
the city, including labor and art.[3]

Since his début in Germany with the work *Hearing Aid* (2001),
Chen has generally produced large-scale installation works that can be
entered by viewers. *Hearing Aid* was shaped like a trumpet standing
on its end, with a huge pipe on its roof that resonated when the wind
blew. When these sounds resonated, viewers inside the work were
able to hear the wind. In this way, Chen links environments, works
and viewers, creating new spaces for viewers to move through or stop
in. These working methods and strategies transform the locations in
which his works are displayed into new and unfamiliar scenes, allowing
viewers to perceive and experience everyday spaces in new ways. In
other words, Chen's works are not just objects but events that present
new worlds to their viewers.

천대광의 작업은 건축물을 닮았지만 건축 설계의 과정을 거치지 않는다. 드로잉을 그리듯 큰 기틀만 잡아놓은 후, 직관과 경험에 기반을 두고 즉흥적으로 세부 사항을 채워 나간다. 이 과정에서 작품이 놓이는 환경과 재료의 물질성이 영감의 원천이자 작품의 형상을 결정하는 요인이 된다. 이런 점에서 천대광의 설치 작업은 계획된 공정을 거쳐 만들어지는 건축이라기보다는 '건축적 조각'에 가깝다. <집우집주>를 구성하고 있는 개별 구조물의 제목에 '건축적 조각'이라는 명칭이 붙은 것도 '건축'보다는 '조각'을 강조하겠다는 작가의 의지를 엿볼 수 있는 대목이다.

미술사에서 '건축적 조각'이란 용어는 중세 건축 장식을 위해 쓰였던 조각을 위한 용어였지만, 1960년대 후반 미국 미술계에서 대지미술, 환경미술로 분류되는 일련의 미술운동을 통해 미술이 전시장 안에서 벗어나 실제 공간으로 확장되고, 이에 따라 조각의 의미와 규모가 함께 확장되는 과정에서 대규모 크기의 조각을 지칭하는 단어로 쓰이게 되었다.4 루시 리파드(Lucy R. Lippard)는 「복합체: 자연 속 건축적 조각(Complexes: Architectural Sculpture in Nature)」이란 글에서 건축적 조각을 "규모와 상관없이 건축적인 형태에 영향을 받은 조각"이라고 정의했다.5 '건축적인 형태'란 내부 공간이 있는 조각으로, 그는 이 공간을 여성의 신체 이미지로 보고 '은신처 조각(shelter sculpture)'으로 명명하기도 했다. 리파드의 분석으로 알 수 있듯이, 전통적인 조각은 일반적으로 외관의 조형성이 더 강조되는 반면 건축은 주거 공간으로서의 기능이 강조되는데, 조각이 내부에 공간을 갖는다는 것은 조각이 건축의 기능성을 반영한 것이라고 볼 수 있다.

서양 미술사에서 '건축적 조각'으로 분류되는 작품과 양식적으로 유사하기 때문에 천대광의 작품은 이들과 많이 비교되었지만, 정작 그는 이러한 범주로 묶이는 것에 전적으로 동의하지 않는다. 1960년대 후반부터 1970년대 당시 미국에서는 모더니즘에 대한 반발과 자본주의의 발달로 인한 미술의 상품화, 산업화에 따른 환경문제에 관한 관심 등이 복합적으로 작용하여 전시장을 벗어나 실제 생활 공간에 작품을 설치하게 되었다. 그러나 천대광은 기억을 바탕으로 자신이 겪은 경험을 시각화하는 데에 주력한다. 유년 시절의 기억, 독일에서의 유학생활, 작품이 설치되는 곳에서 느낀 감응 등이 그의 작업의 근거를 이룬다. 이런 이유로 천대광은 확고하고 세밀한 도면 설계식의 계획성보다 그때그때의 분위기, 아이디어, 즉흥성이 작품의 더 많은 부분을 차지한다.

이러한 작업의 동기는 실제 작품을 경험하는 관람자의 역할에도 영향을 미친다. 작품 내부에 들어왔을 때 개별자가 느끼는 감각과 정서가 중요하기 때문에 특정한 메시지를 전달하려고 노력하지 않는다. 오히려 그들의 자유로운 감상과 해석의 여지를 남겨 두고자 한다. 논리적이고 체계적으로 작품에 접근하기보다는 기존에 축적되어 있던 기억과 경험을 결합해 작품에 연금술을 부려보기를 기대한다. 그것이 허무맹랑하고 공상적이더라도 말이다. 어떤 기준에 맞추어 해석을 하게 되면 이제 창조라는 것은 더 이상 존재하지 않기 때문이다.6

Chen's works look like buildings, yet have never followed conventional processes of architectural design. As if creating a drawing, he first establishes a broad outline, then goes about filling it spontaneously with details, based on intuition and experience. In this process, the work's environment and the properties of its materials become both sources of inspiration and decisive factors in determining form. In this sense, Chen's installations are closer to 'architectural sculptures' than to buildings created through a planned process. The use of the term 'architectural sculpture' in the titles of the individual works in *Dreams of the Perfect City* also demonstrates the artist's will to emphasize 'sculpture' over 'architecture'.

The term, 'architectural sculpture' was originally a sculptural term, used to describe medieval architectural decorations. In the late 1960s, a series of artistic movements classified as land art or environmental art expanded the realm of artworks beyond the confines of the gallery; accordingly, the meaning and scale of sculpture also grew, gradually coming to encompass large-scale sculptures.4 In "Complexes: Architectural Sculpture in Nature," Lucy R. Lippard defines architectural sculpture as "work on any scale inspired by architectural forms."5 The term, 'architectural forms' refers to sculptures with internal space; Lippard saw such spaces as images of the female body and also sometimes labeled them 'shelter sculptures.' Seen from Lippard's perspective, traditional sculpture generally emphasizes external appearance, whereas architecture emphasizes the role of living space. In this sense, the acquisition of internal space by sculpture indicates that it is reflecting the functionality of architecture.

Chen's works are often compared with various historical artworks classified as 'architectural sculpture' due to their stylistic similarity. But he does not agree with the inclusion of his works within this category. In the late 1960s, a pronounced tendency began in the United States to escape the boundaries of the gallery and install works in actual space, due to a combination of opposition to modernism and interest in environmental issues resulting from the commercialization and industrialization of art through the development of capitalism. But Chen focuses on visualizing his own experiences, based on memory. Childhood memories, student life in Germany, and feelings prompted by the locations of his installation works form the basis of these works. For this reason, his works consist more of day-to-day moods, ideas and spontaneity than of solid, detailed architectural plans.

Chen's motivations also affect viewers as they experience his works. For him, what counts is prompting feelings and emotions on the part of viewers; he therefore works hard to avoid delivering any particular message as they enter his works. On the contrary: his intention is to leave room for free emotions and interpretations. He hopes that, rather than approaching his works with logic and order, viewers will apply combinations of existing, accumulated memories and experiences to alchemical effect. No matter how absurd or fanciful these may be. Because as soon as art is interpreted through a fixed set of criteria, creation ceases to exist.6

(왼)<산에는 나무, 물에는 물고기>, 2007, 목재, 조명, 400×500×350cm, 의재미술관, 광주

(Left) *Tree in Mountain, Fish in Water*, 2007, Timber, lighting, 400×500×350cm, Uijae Museum of Korean Art, Gwangju, Korea

(오)<푸른공간>, 2012, 목재, 모기장, 조명, 1100×1100×360cm, 《태화강국제설치미술제》, 울산

(Right) *Blue Space*, 2012, Timber, mosquito net, lighting, 1100×1100×360cm, *Taehwa River Eco Art Festival*, Ulsan, Korea

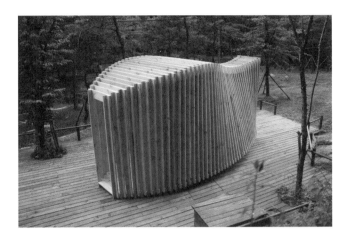

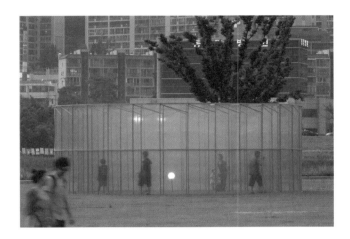

도시의 지층 읽어내기

"내가 보기에 자네는 지도 위의 도시들을 그곳을 직접 방문한 사람보다 더 잘 알고 있는 것 같군." [...]
"여행을 하면서 차이가 사라져가는 것을 깨닫게 됩니다.
각 도시는 다른 도시들과 닮아가고 있습니다.
도시들은 형식, 질서, 차이들을 서로 교환합니다."[7]

- 이탈로 칼비노, 『보이지 않는 도시들』

신작 <집우집주>는 집과 집이 만들어낸 이상 도시이자 소우주다. 역사상 인류는 늘 이상적인 사회를 실현하기 위한 열망을 품어왔다. 동양에서는 우주의 조화와 균형을 나타내는 불교의 만다라가, 중세 이탈리아에는 이상 도시인 '팔마노바' 등이 동서양을 막론하고 이상 도시가 인간의 욕망이었음을 보여준다. <집우집주>는 이상 도시의 은유적 표상으로, 한국 대종교 경전인 『천부경(天符經)』[8] 과 중세 유대교 신비주의 사상 '카발라'(Kabbalah)에 영감을 받아 제작되었다. 모두 우주의 원리와 이치를 설명하고 있는데, 전체적인 작품의 배치는 '카발라'에서 구전으로 내려오는 '지혜를 담은 생명의 나무' 도상에서 모티프를 얻었다. 입에서 귀로 '받는다'라는 의미의 카발라 체계에서 가장 핵심이 되는 것은 바로 우주, 즉 존재계의 상징인 '생명나무'(거꾸로 선 나무)이다. "진리는 무수한 단면으로 이루어진 보석과 같다"는 격언처럼 존재계란 어떤 하나의 기준만으로는 고찰 불가능한 무한성을 갖고 있음을 보여주는 것이다.[9]

Reading the Strata of the City

"I think you recognize cities better on the atlas than when you visit them in person," the emperor says to Marco, snapping the volume shut. [...]
And Polo answers, "Traveling, you realize that differences are lost: each city takes to resembling all cities, places exchange their form, order, distances, a shapeless dust cloud invades the continents."[7]

- Italo Calvino, *Invisible Cities*

Chen's new work, *Dreams of the Perfect City*, is an ideal city and a microcosm formed of multiple houses. Throughout history, humans have aspired to build ideal societies. In both east and West, creations such as East Asian Buddhist mandalas representing cosmic harmony and balance and the medieval Italian ideal city of Palmanova illustrate the human desire to build the perfect city. *Dreams of the Perfect City* is a metaphorical symbol for the ideal city, inspired by the by *Cheon Bu Gyeong* (The Scripture of Heavenly Code)[8], espoused by Korea's Daejongism faith, and 'Kabbalah', the medieval Jewish mystic school of thought. Both described the principles and logic of the universe; the motif of the work's overall layout is drawn from the iconography of the wisdom-filled Tree of Life that features in orally-transmitted Kabbalah. In the system of Kabbalah, which means 'reception' by ear, the most important thing is the Tree of Life, an upside-down tree that symbolizes the cosmos, or the existing world. Thus, as the proverb, "the truth is like a jewel with countless faces," suggests, the existing world is an infinite one that cannot be contemplated according to any single standard.[9]

앞에서 언급했듯이 <집우집주>를 구성하는 각각의 '집' 조각은 국내 및 아시아 국가를 여행하며 발견한 건축물을 모티브로 하여 변형하거나 새롭게 창조한 것이다. 작품의 내용에 따라 각 조각은 크게 '기억의 공간'과 '상상의 공간'으로 나뉜다. '기억의 공간'은 여러 국가에서 발견한 건물과 집기의 재료와 양식 등을 살펴봄으로써 정치, 경제, 과학, 문화 등 건축물에 가해진 외력의 흔적, 즉 건물이 경험한 기억을 고찰한다.

'기억의 공간'으로 분류할 수 있는 작업은 크게 아시아 국가와 국내 건축물에서 모티프를 얻어 제작되었다. 먼저 아시아 지역에서 영감을 받은 작업에는 <건축적 조각/다리 없는 집/캄퐁 플럭의 수상가옥 1-3>, <건축적 조각/수랏타니의 집>, <건축적 조각/크노르 벤치>가 있다. 이 작품들은 공통적으로 산업혁명 이후 서구 제국주의에 의해 무분별하게 이식된 자본주의가 만들어낸 현재의 혼종 사회를 조형적으로 보여준다. 서구의 산업화와 맞물려 시작된 개발은 오래지 않아 비서구 지역으로까지 범위를 넓히게 되었고, 서구에서 생산된 완제품을 안정적으로 소비할 수 있는 시장, 즉 식민지가 필요했다. 20세기 중반 이후에는 세계정세의 변화와 맞물려 식민 국가가 독립하기 시작했다. 그러나 제대로 준비할 수 있는 여유도 없이 급하게 독립하면서 서구의 근대국가 체제를 그대로 받아들이게 되었고 빈곤과 불평등은 오히려 갈수록 더 심해졌다.

<건축적 조각/다리 없는 집/캄퐁 플럭의 수상가옥 1-3>은 캄보디아 캄퐁 플럭(Kampong Phluk) 마을의 수상가옥을 모티프로 한 작업으로, 그곳에서 살아가는 사람들의 삶을 통해 진정으로 행복한 삶이란 무엇인지 질문한다. <건축적 조각/수랏타니의 집>은 태국 남부에 있는 도시인 '수랏타니'에 있는 건물을 모티프로 만든 작품으로, 태국의 종교와 기후 등 독특한 문화가 깃든 건축물을 재해석해 새로운 조각 작품을 만들었다. <건축적 조각/크노르 벤치>는 제목 그대로 집의 형태는 아니지만 공공 건축물 중 하나인 벤치로 제작된 작품이다. 이 작품의 제목인 '크노르'(knorr)는 다국적 기업 유니레버(Unilever)의 산하 브랜드 이름에서 가져온 것이다. 다채로운 파스텔 색감으로 사람들의 호감을 사는 천대광의 크노르 벤치는 그 이면에는 경제뿐만 아니라 전 세계의 문화와 일상 깊은 곳까지 잠식하고 있는 다국적 기업 자본의 보이지 않는 강력한 힘을 은유적으로 보여준다.

As mentioned above, the individual 'house' sculptures in *Dreams of the Perfect City* are new adaptations or creations based on motifs from buildings discovered during travels in Korea and other Asian countries. These can broadly divided, according to content, into 'spaces of memory' and 'spaces of imagination.' 'Spaces of memory' are based on observations of traces of external political, economic, scientific and cultural forces exerted upon buildings—the memories of the structures themselves—by examining buildings, furniture, materials and styles found in various countries.

Works classified as 'spaces of memory' are based on ideas gleaned from architecture in Korea and the rest of Asia. Asian-inspired works include *Architectural Sculpture / House without Legs / Kampong Phluk Floating House 1, 2 and 3*, *Architectural Sculpture / Surat Thani House*, and *Architectural Sculpture / Knorr Bench*. These works all give sculptural form to today's hybrid societies, created by a capitalism indiscriminately transplanted by Western imperialism since the Industrial Revolution. The development that began with Western industrialization soon spread beyond the West, while Western economies needed colonies as stable markets to consume the goods they produced. From the second half of the twentieth century, colonized countries began gaining independence in accordance with changing global political currents. But rushed independence, won with insufficient time to prepare, left former colonies accepting the systems of modern Western countries in unaltered form, leading to deepening poverty and inequality.

Architectural Sculpture / House without Legs / Kampong Phluk Floating House 1, 2 and 3 is based on a motif of the floating houses of the Cambodian village of the same name. Through the lives of the villagers, the work questions the meaning of genuine happiness. *Architectural Sculpture / Surat Thani House* is inspired by buildings in the eponymous southern Thai city, creating a new sculptural work that reinterprets architecture imbued with unique Thai cultural influences such as religion and climate. *Architectural Sculpture / Knorr Bench*, as indicated by its title, takes the form not of a house but of a bench, another kind of public structure. The 'Knorr' in its title refers to the brand owned by multinational corporation Unilever. Attractive for its bright pastel colors, Chen's Knorr Bench metaphorically reveals the existence of the invisible yet powerful force of multinational corporate money, encroaching deeply on not only economies but cultures and daily lives across the world.

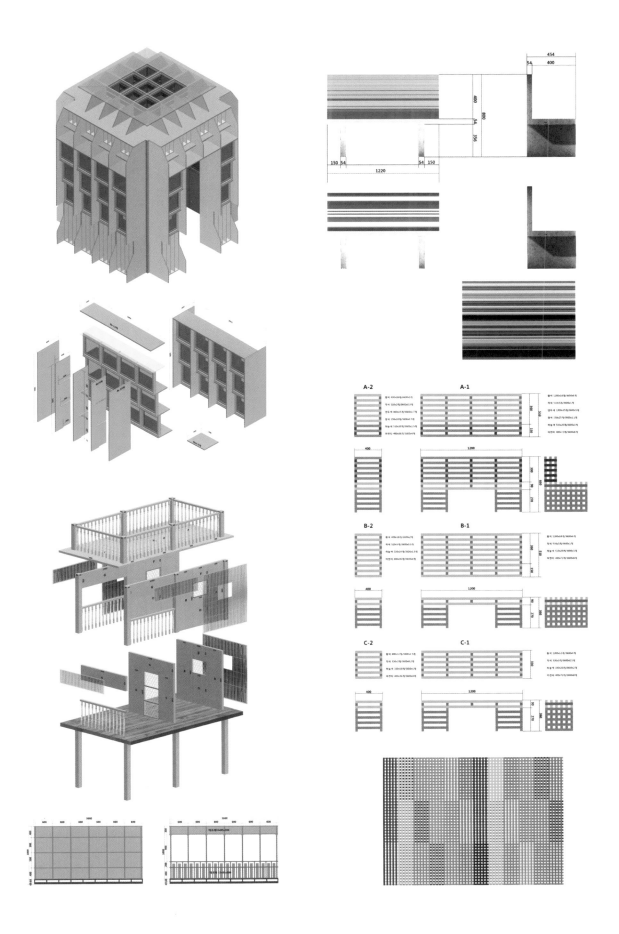

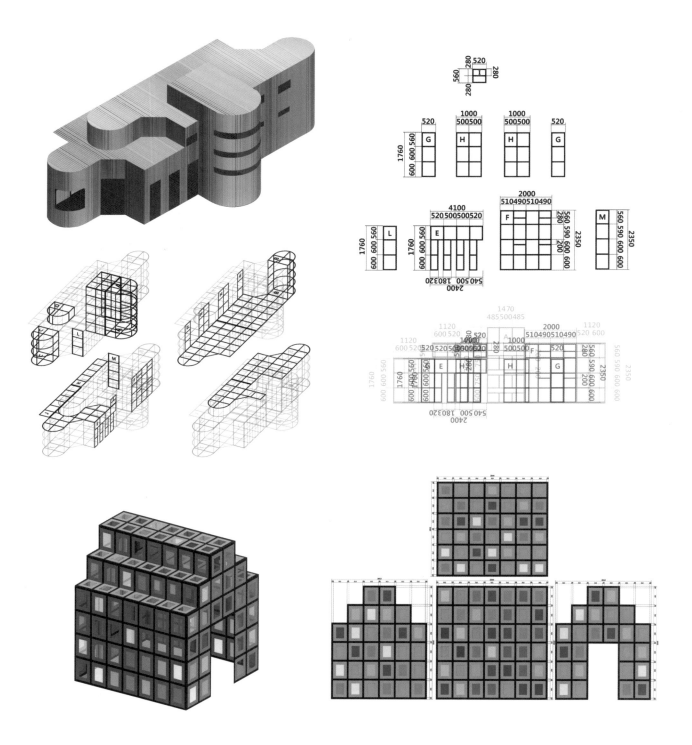

<집우집주> 아이디어 스케치, 2021

Idea sketches for *Dreams of the Perfect City*, 2021

국내 건축물에 영감을 받아 제작한 작품으로는 <건축적 조각/보잘것없는 집/가파리 240번지>, <건축적 조각/양평터미널>, <건축적 조각/후천개벽(後天開闢) 탑>이 있다. <건축적 조각/보잘것없는 집/가파리 240번지>는 '가파리 240번지'에 있는 창고 건물을 변형한 작업으로, 척박한 자연환경 속에서 살아가는 가파도민들의 고단한 삶이 화려하고 풍부한 색채 표현으로서 역설적으로 드러나는 작업이다. <건축적 조각/양평터미널>은 경기도 양평 버스터미널 외관의 형태를 활용하여 만든 작품이다. 양철지붕 집에서 유년기를 보낸 작가는 터미널이라는 공간과 골함석이라는 재료를 통해 경제와 기술의 급속한 발전으로 더 많은 물질적 풍요를 누리게 되었지만, 작가는 그 과정에서 우리가 잃어버린 것은 없는지 되묻고 있다. <건축적 조각/후천개벽(後天開闢) 탑>은 청주 탑동에 위치한 '탑동 양관(塔洞 洋館)' 제1호-제6호 중 민노아 선교사 가족이 살던 제3호 주택에서 모티브를 가져왔다. 불교와 근대기 서양 주택 양식이 혼합된 새로운 양식의 건축적 조각으로, 동서양 종교문화가 복잡하게 얽힌 양상을 조형적으로 보여준다.

'상상의 공간'은 이상 사회에 있을 법한 상상의 집으로, 작가의 내부에서 발현된 철학과 사상 등이 투영된 결과물이다. 기억과 상상, 과거와 현재를 교차해 가며 우리가 관계 맺고 있는 공간, 즉 '집'과 각종 가구의 형태로 보여준다. 이러한 예술 전략은 『천부경』이나 '카발라' 등의 종교 사상이 담고 있는 우주의 이치, 즉 자연과 생명의 순환과 조화, 인간 존중 등을 실천함으로써 이상 사회로의 꿈을 실현할 수 있다는 천대광의 신념에서 기인한다. <건축적 조각/공허한 빛의 집/RGBCMYK 유리집>은 세상에 존재하지 않는 가상의 집으로, 작가가 오직 6가지 색채만으로 구성된 집을 상상하여 제작한 것이다. 천대광은 이러한 색의 기본원리에 따라 6가지 색상의 반투명 아크릴을 격자 형태로 이어붙여 색채 공간을 창조했다. 6개의 색상은 세상 모든 만물이 생성되는 데 필요한 기본 요소와 우주의 메커니즘을 은유적으로 표상한다.

<집우집주>는 겉으로 보기에는 다채로운 색채와 형태로 인해 마냥 아름다워만 보이지만, 건축적 조각의 형태와 사용된 재료를 자세히 들여다보면 인류가 겪어온 근대화의 기억, 그리고 삶의 무게가 함축되어 있음을 확인할 수 있다. 그러나 이 조각들은 기념비적이거나 특별한 건축물이 아니다. 천대광이 역사적인 장소, 특별한 의미가 있는 명소가 아닌 일상 거리에서 볼 수 있는 익명의 건축물을 선보인 이유는 오랜 세월에 걸쳐 그 공간에 축적된 꾸미지 않은 다양한 삶을 들여다보기 위함이다. 우리의 삶이 가장 잘 녹아 있는 공간은 우리가 일상을 보내는 공간이다. 그리고 바로 이곳이 있는 그대로의 나를 보여주는 공간이며 더 나아가 인간의 의미를 찾을 수 있는 공간인 것이다. 이러한 맥락에서 천대광은 낯익은 일상 공간을 낯설게 바라보게 함으로써 일상 공간에 투영된 우리 삶의 양태를 섬세하게 살피고 성찰할 기회를 제공한다.

Architectural Sculpture / Good-for-Nothing House / 240 Gapa-ri, *Architectural Sculpture / Yangpyeong Terminal* and *Hucheongaebyeok (後天開闢) Pagoda* are works inspired by Korean buildings. *Architectural Sculpture / Good-for-Nothing House / 240 Gapa-ri* is a modified version of a warehouse located at the eponymous address on Gapa-do Island, offering a paradoxically bright and colorful depiction of the islanders' exhausting lives in a barren environment. *Architectural Sculpture / Yangpyeong Terminal* is based on the exterior of the bus terminal at Yangpyeong in Gyeonggi-do Province. Here, Chen, who grew up in a house with a tin roof, takes the bus terminal as a space and corrugated iron as a material to ask whether we have, in fact, lost something amid the increased material abundance brought by rapid economic and technological development. *Architectural Sculpture/ Hucheongaebyeok (後天開闢) Pagoda* is based on the third of six buildings, formerly home to the family of missionary F.S.Miller, in the complex of Western-style buildings known as Tapdong Yanggwan and located in Cheongju's Tapdong neighborhood. A new style of architectural sculpture blending Buddhist and modern Western residential styles, the work gives form to the complex entwinement of Eastern and Western religious cultures.

'Spaces of imagination' are imaginary houses that might be found in an ideal society, reflecting philosophy and ideologies manifested from the artist's inner world. Overlapping memory and imagination, past and present, these works use the forms of houses and furniture to show the spaces connected to our lives. This artistic strategy is rooted in Chen's belief that the dream of a perfect society can be realized by embodying the cosmic principles contained in religious ideas such as those of *Cheon Bu Gyeong* and the Kabbalah: cyclicality and harmony of nature and life, and respect for human beings. *Architectural Sculpture / House of Empty Light / RGBCMYK Glass House* is a non-existent, imaginary house, created by the artist while imagining a house composed solely of six colors. In accordance with the basic principles of color, Chen Dai Goang has joined translucent pieces of acrylic in six colors in a lattice formation, creating a chromatic space. These six colors metaphorically represent the essential elements needed to create all things in the cosmos and the mechanisms of the universe.

On the surface, the bright colors and unique forms of *Dreams of the Perfect City* give it a beautiful appearance. But a closer look at its forms and the materials it uses implicitly reveals memories of the modernization undergone by humanity, and the weight of life. But these sculptures are not monumental or special buildings. Chen focuses more on anonymous buildings found on everyday streets than on historic locations or famous sites, in order to peer into the diverse and unembellished lives accumulated over many years in those spaces. The spaces most deeply intertwined with our lives are those in which we spend our everyday existences: these are the spaces that reveal us just as we are; the spaces in which we find the meaning of humanity. In this context, by making us look at familiar everyday spaces through unfamiliar eyes, Chen offers us a chance to closely examine and reflect upon our lives as reflected in them.

공간(空間)이 아닌 공간(共間)으로

*"그렇습니다. 제국은 병들었습니다. 그리고 더 나쁜 것은
제국이 자신의 상처에 익숙해지려고 한다는 것입니다.
제 탐험의 목적은 이것입니다. 아직도 언뜻언뜻 보이는 행복의 흔적들을
자세히 찾아 나가면서 그것이 얼마나 부족한지를 측정해 보는 겁니다."* [10]

- 이탈로 칼비노, 『보이지 않는 도시들』

『보이지 않는 도시들』은 마르코 폴로라는 화자를 통해 행복과 질서와 더불어 불행과 무질서가 공존하는 공간, 선과 악이 얽혀 있는 질서와 혼돈이 공존하는 공간으로서의 도시를 보여준다.[11] 도시는 하나의 과정이라는 것, 그리고 장소는 과정이지 유일한 단 하나의 변경 불가한 정체성을 가지고 있지 않다는 것이다. 이 과정으로서의 도시 "공간은 정태적인 현실을 나타내는 것이 아니라 여러 상이한 집단들의 상호작용, 경험, 이야기, 이미지와 표현을 통해서 적극적으로 생산되고 또 변화되는 현실을 나타낸다"는 것을 의미하기도 한다.[12] 결국 완벽한 도시란 있을 수 없다.

대도시는 초고층 빌딩을 앞세우며 점점 더 화려하게 발전해 왔고, 그 과정에서 빈부의 격차는 더 벌어졌다. 세계화라는 흐름에 편승한 자본주의는 아시아와 아프리카 등지의 개발도상국에까지 손길을 뻗치게 되었고, 다국적기업은 개발이라는 명목 하에 가난한 국가의 노동력을 착취하고 산림 벌목, 야생동물 밀매 등을 감행한다. 개발이 애초부터 비서구권을 착취하면서 시작된 과정이라는 사실, 식민 지배를 통해 비서구 사회의 문화와 전통을 뒤흔들어놓고 인종적 멸시를 제도화하면서 시작된 과정이라는 사실은 개발을 금과옥조처럼 받들곤 하는 우리에게 많은 생각거리를 던진다.[13] 개발에 투영된 인간의 욕망은 이제 전염병이라는 부메랑이 되어 인간사회에 타격을 주고 있다. 코로나19가 촉발한 전염병에 따른 위기는 도시개발의 방침과 방향을 재점검하고, 도시에서 살아가는 우리의 삶의 방식을 전반적으로 재편하도록 촉구한다.

From Empty Space to Shared Space

*"Yes, the empire is sick, and, what is worse,
it is trying to become accustomed to its sores.
This is the aim of my explorations: examining the traces of happiness
still to be glimpsed, I gauge its short supply."*[10]

-Italo Calvino, *Invisible Cities*

Through Marco Polo, narrator of *Invisible Cities*, Calvino depicts cities as spaces where happiness and order coexist with misery and disorder; spaces where order and chaos coexist while intertwined with good and evil.[11] A city is a process; a place is a process, with no single, fixed identity. Such cities-as-processes signify that "space is something that manifests not a static reality but a reality actively produced or changed through the mutual interactions, experiences, stories, images and expressions of multiple different groups."[12] Ultimately, the perfect city cannot exist.

Megacities have developed in ever-more flamboyant ways, led by their skyscrapers and further increasing the gap between rich and poor in the process. Capitalism, riding on the back of globalization, has reached its tentacles into developing countries in Asia and Africa, while multinational corporations exploit the labor, fell the forests and traffic the wildlife of poor countries in the name of development. The fact that development as a process itself began with the exploitation of the non-Western world, a process of using colonial rule to undermine non-Western societies and traditions and institutionalize racial contempt, raises many issues for us to ponder as we revere development like a golden rule.[13] The human greed reflected in development has now become a boomerang in the form of a pandemic, flying back to hit human society. The crisis resulting from COVID-19 urges us to re-examine the policies and direction of urban development, and to comprehensively reform the lives we live in cities.

1
이탈로 칼비노, 『보이지 않는 도시들』
이현경 옮김, (서울: 민음사, 2007), 18.
Italo Calvino, *Le città invisibili* (Torino: Einaudi, 1972), 4.

2
이현경, 「미궁에 도전하는 글쓰기-이탈로 칼비노의 『보이지 않는 도시들』을 중심으로」『이탈리아어문학』제42집 (2014), 321.

3
김성은, 「견인도시 프로젝트-양평」『Chen Dai Goang』(서울: 서울문화재단, 2018), 210.

4
홍임실, 「20세기 후반 미국미술에 나타난 건축적 조각연구-로버트 스미슨과 낸시 홀트를 중심으로」『미술사문화비평』vol. 1 (2010), 121.

5
Lucy R. Lippard, "Complexes: Architectural Sculpture in Nature," *Art in America*, Jan.-Feb. (1979), 86.

6
천대광, 작가와의 인터뷰, 2021. 9. 13. 국립현대미술관 청주 미술품 수장센터, 청주

7
이탈로 칼비노, 『보이지 않는 도시들』174.

8
천부경은 81수로 구성된 경전으로, 1에서부터 10까지의 수로 우주의 형상, 존재의 구조를 논하고 있다. 즉 수의 이치를 통하여 진리를 표현한 것이다. 천부경이 '하나가 시작되었지만 시작된 하나가 없다(一始無始一)'에서 시작하여 '하나가 끝났으나 그 하나는 끝난 것이 아니다(一終無終一)'로 끝을 맺고 있는 것은 이러한 끝없는 순환을 상징한다. 이 끝없는 순환이야말로 자연의 존재 양식이며 우주의 메커니즘인 것이다. 조하선, 『베일 벗은 천부경』(서울: 창선사, 2005), 71 참고.

9
조하선, 『베일 벗은 천부경』32.

10
이탈로 칼비노, 『보이지 않는 도시들』76.

11
이현경, 「미궁에 도전하는 글쓰기- 이탈로 칼비노의 『보이지 않는 도시들』을 중심으로」340.

12
Mike Featherstone, "Globale Stadt, Informationstechnologie und Öffentlichkeit," in *Spiel ohne Grenzen?- Ambivalenzen der Globalisierung*, Claudia Rademacher, Markus Schoer, Peter Wiechens (Hgs), 182. 마르쿠스 슈뢰르, 『공간, 장소, 경계』 정인모·배정희 옮김 (서울: 에코리브르, 2010), 284 재인용.

13
조효제, 「전 지구적 개발의 개념들」 『어번 이슈: 함께 사는 도시를 위한 제안들』 정림건축문화재단 엮음, (서울: 프로파간다, 2017), 23.

14
천대광, 작가와의 인터뷰, 2021. 8. 4. 작가 작업실, 양평

천대광은 과거, 현재의 과거를 교차하며 여러 도시의 건축물을 우리에게 보여준다. 그러나 그의 작업은 사물에 대한 직접적인 묘사나 구체적인 사실에 근거를 둔 '현황 보고'식으로 정리하여 보여주지 않는다. 그는 시각 정보를 흡수해 해체하여 이리저리 조합도 해보고 다양한 색을 칠해보면서 자기 것으로 소화해 새로운 조형 작품으로 내놓는다. 그는 기존의 세계관을 해체하고 재구성하는 과정을 통해 새로운 관점에서 세계를 이해한다. 즉, 천대광은 도시 프로젝트를 진행하면서 도시의 과거와 미래를 반추하고, 오늘날 '지금, 여기'를 성찰한다. 그리고 천대광의 작품을 경험하는 관람자 또한 스스로 성찰해 보기를 요청한다. 무대세트처럼 알록달록하고 아름답게 보이는 '집'의 공간을 감각하고 체험하면서 능동적으로 해석하고, 보이는 세계에만 함몰되지 않도록 주체적 시각을 갖기를 제안하는 것이다.

《천대광: 집우집주》의 영문 제목은 국문과 달리 '이상 도시로의 꿈' (Dreams of the Perfect City)이다. '집우집주'라는 한자와 '집'과 '우주'의 관계를 적절히 표현할 수 있는 영어 표현을 찾지 못해 당초 작가가 부제로 고려하고 있던 '이상 도시로의 꿈'을 제목으로 택했다. 이상 도시는 어떤 도시일까? "'이상 도시로의 꿈'이라는 제목은 굉장히 진부한 이야기인데, 그냥 한 개인이 행복할 수 있는 도시…. 어쨌든 우리는 행복을 추구하잖아요. 행복을 추구할 권리가 헌법에도 있고. 모든 사람이 행복한 도시가 이상 도시겠죠."14 작가는 주저하며 말한다. 정답이 없는 질문이기 때문이다.

<집우집주>의 시선은 건축과 도시를 넘어 그 속에서 살아가는 사람을 향해 있다. 결국 집과 도시는 '어떤 삶을 살 것인가?'에 대한 질문과 직결되기 때문이다. 더 이상 사람이 살지 않는 텅 빈 '공간'(空間)이 아닌 함께 살아가는 사람들의 행복한 이야기로 채워진 '공간'(共間)의 의미가 더 중요하다는 것을 우리에게 말하고자 하는 것은 아닐까. 가파도, 양평, 캄퐁 플럭, 수랏타니…. 어쩌면 이상 도시는 멀리 있는 것이 아닐지도 모른다. 그것은 내가 발 딛고 있는 일상 그 어딘가에 숨어 있는 '보이지 않는 도시'일지도 모르겠다.

Chen overlaps past and present, showing us buildings from a variety of cities. Yet he does not arrange his works into any kind of 'situation report' based on direct descriptions of objects, or specific facts. He absorbs visual information, minutely divides it, experiments with various combinations of the pieces, paints them in various colors, makes them his own, and presents them as new sculptural works. Through a process of deconstructing and reconstituting existing world views, he understands the world from new perspectives. As he works on his city project, Chen reflects on urban pasts and futures, and on the here-and-now. He also asks that the viewers experiencing his works reflect upon themselves, actively interpreting the spaces of the beautifully-colored stage set-like 'houses' that they feel and experience, and adopting independent perspectives so as not to become overwhelmed by the visible world alone.

The original Korean title of this exhibition, Jibu Jipju, alludes to the way wuju, the Sino-Korean word for 'cosmos,' is composed of two characters (宇 and 宙) that both originally mean 'house.' Since neither the English word 'cosmos' nor 'universe' is related to the word 'house,' this title cannot be directly translated into English. The artist therefore decided to use the exhibition subtitle he had been considering—'Dreams of the Perfect City'—as the main English title. What kind of place is the 'perfect city'? "As a title, 'dream of a perfect city' sounds extremely banal, like a city where one individual can be happy," says Chen, hesitatingly. "In any case, we seek happiness. The right to seek happiness is enshrined in our constitution. I suppose the perfect city is one in which everyone is happy."14 In the end, the question is unanswerable.

The scope of Dreams of the Perfect City extends beyond architecture and the city, encompassing also the people that live within it. Ultimately, the house and the city are directly related to the question: "What kind of life should we lead?" Perhaps Chen is trying to tell us that shared space, defined by communal living and happy stories, is more important than empty space, lived in by nobody. Gapa-do, Yangpyeong, Kampong Phluk, Surat Thani…. Maybe the perfect city is not so far away. Maybe it's an invisible city, hidden somewhere within our daily lives.

1
Italo Calvino, Invisible Cities, trans. William Weaver (San Diego, New York, London: Harcourt Brace & Company, 1978), 10-11.

2
Lee Hyun Kyung, "Writing as a challenge to the maze in Invisible Cities by Italy Calvino," Italian Literature, vol. 42 (2014), 321.

3
Kim Sungeun, "Traction City Project -Yangpyeong," in Chen Dai Goang (Seoul: The Seoul Foundation for Arts and Culture, 2018), 210.

4
Hong Imshil, "A Study on Architectural Sculpture in American Art since late 20th Century: Robert Smithson and Nancy Holt," Art History, Culture, Critique, vol. 1 (2010), 121.

5
Lucy R. Lippard, "Complexes: Architectural Sculpture in Nature," Art in America, Jan.-Feb. (1979), 86.

6
Chen Dai Goang, 'Interview with Hyun OhAh,' 13 September, 2021 at MMCA Cheongju Art Storage Center

7
Italo Calvino, Invisible Cities, 137.

8
Please see, Jo Ha-seon, The Cheon Bu Gyeong Unveiled (Seoul: Changcheonsa, 2005), 71.

9
Jo Ha-seon, Ibid, 32.

10
Italo Calvino, Invisible Cities, 59.

11
Lee Hyun Kyung, "Writing as a challenge to the maze in Invisible Cities by Italy Calvino," 340.

12
Mike Featherstone, "Globale Stadt, Informationstechnologie und Öffentlichkeit," in Spiel ohne Grenzen?-Ambivalenzen der Globalisierung, Claudia Rademacher, Markus Schoer, Peter Wiechens (Hgs), 182. Markus Schroer, Räume, Orte, Grenzen (Space, Site, Boundaries), Translated into Korean by Jung Inmo, Bae Junghee (Seoul: Ecolivre, 2010), 284.

13
Jo Hyoje, "Concepts of global development," in Urban Issues: Suggestions for the city we live together, Junglim Foundation (ed.) (Seoul: Propaganda, 2017), 23.

14
Chen Dai Goang, 'Interview with Hyun OhAh,' 4 August, 2021 at Artist Studio in Yangpyeong

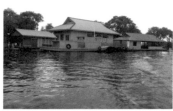
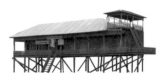
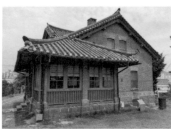
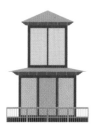
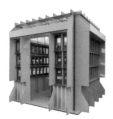
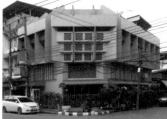

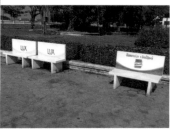
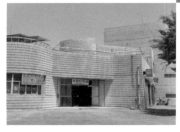

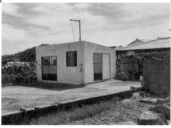

<집우집주> 아이디어 스케치 및
작품의 모티브가 된 건물 이미지

Idea sketches and photos of
the buildings that became the motif of
Dreams of the Perfect City

'이상 도시로의 꿈'이라는 제목은 굉장히 진부한 이야기인데,
그냥 한 개인이 행복할 수 있는 도시... 어쨌든 우리는 행복을 추구하잖아요.
행복을 추구할 권리가 헌법에도 있고. 모든 사람이 행복한 도시가 이상 도시겠죠.

- 천대광

As a title, the dream of a perfect city sounds extremely banal,
like a city where one individual can be happy... In any case, we seek happiness.
The right to seek happiness is enshrined in our constitution.
I suppose the perfect city is one in which everyone is happy.

– Chen Dai Goang

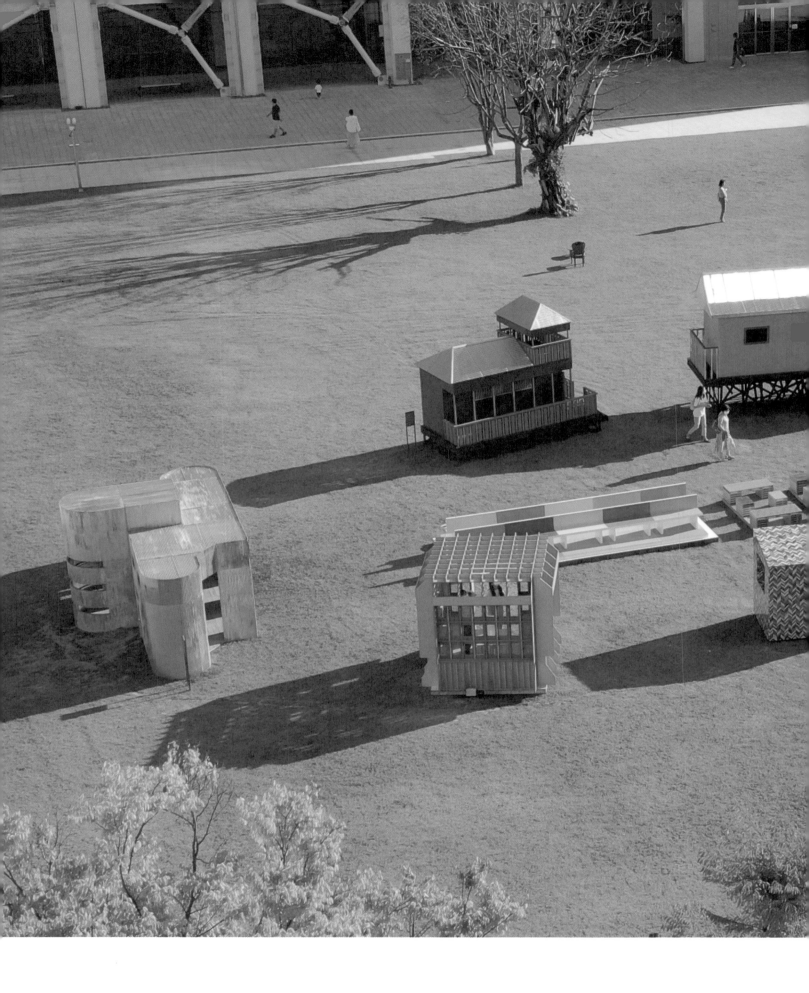

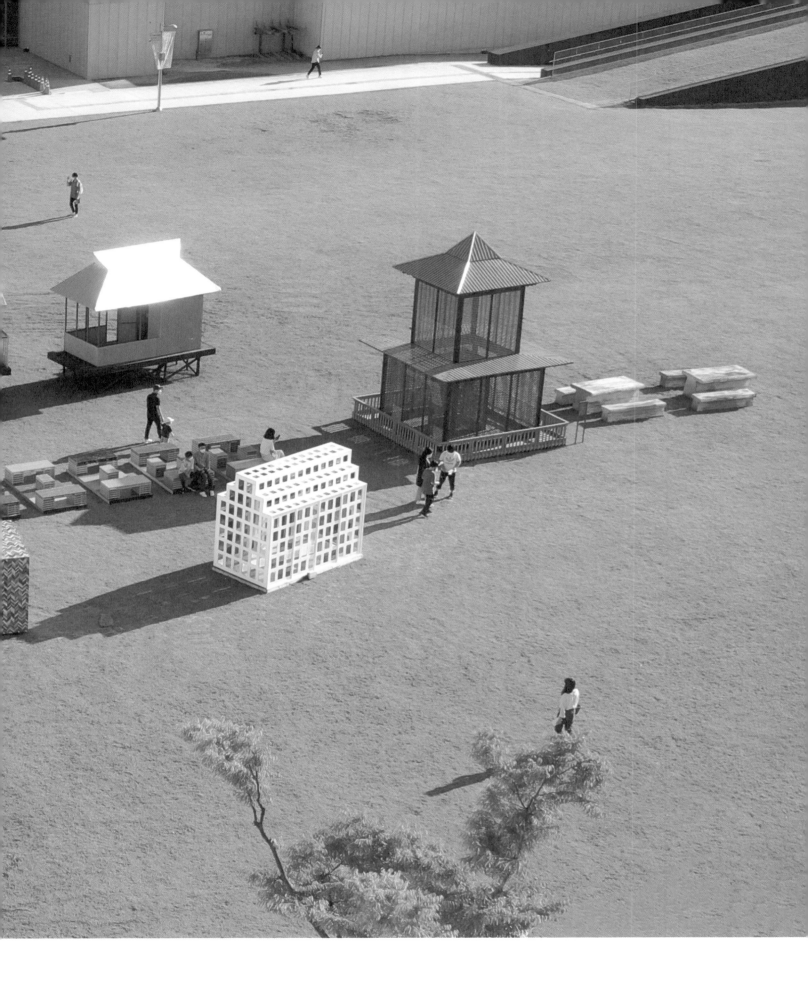

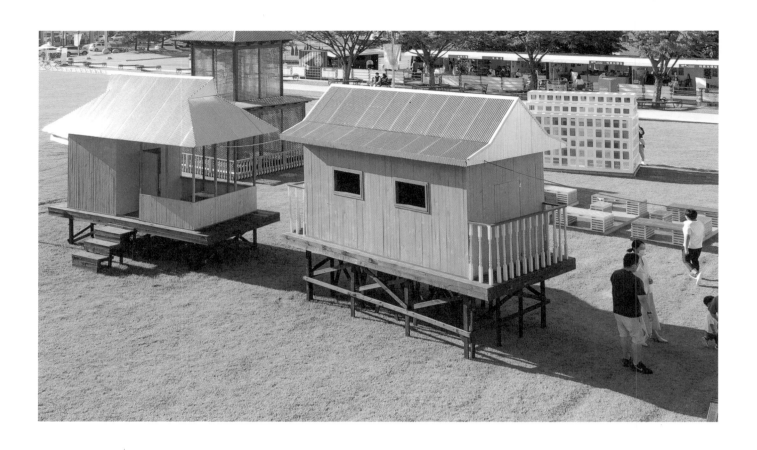

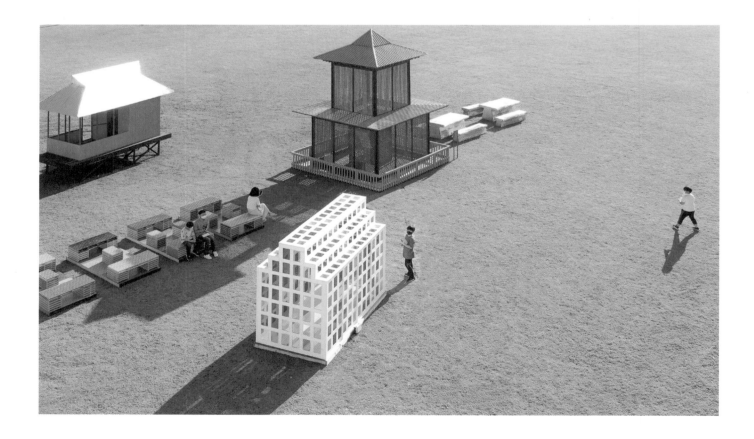

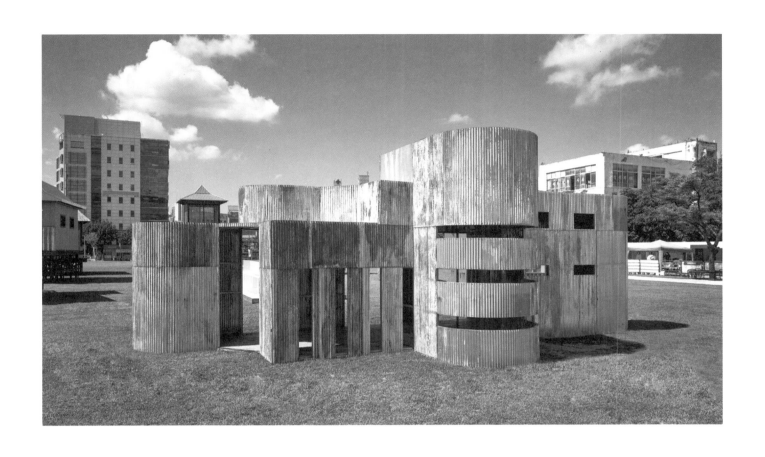

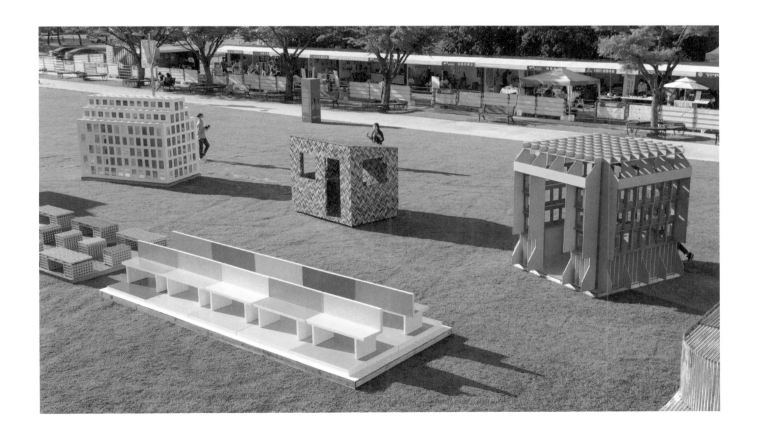

건축적 조각/양평터미널

경기도 양평버스터미널 외관의 형태를 활용하여 만든 작품이다. 10여 년의 독일 생활을 청산하고 양평에 거주하며 활동을 이어온 작가는 '터미널'이라는 장소가 도시인의 삶을 상징적으로 보여주는 건물이라고 여긴다. 유동 인구가 많은 이점 때문에 건립된 터미널 백화점과 종합쇼핑몰, 식당과 카페 등은 한 곳에서 모든 것을 빠르게 해결하는 현대인의 생활 방식을 고스란히 보여준다.

이 작업에서 양평터미널은 골함석으로 재탄생되었다. 골함석은 아연 도금 철판으로, 우리에게는 '양철 지붕'의 재료로 더 친숙하다. 19세기 영국 군대가 작전 수행 시 이동하기 쉬운 집을 만들고자 가볍고 튼튼한 골함석을 사용하기 시작한 후로 점차 전 세계로 퍼져나갔다. 한국에서는 1970년대부터 쓰이기 시작했는데, 새마을 운동의 일환으로 지붕개량 사업이 추진되면서 슬레이트, 함석, 시멘트 같은 자재가 지붕에 많이 사용되었다.

1970년대에 양철 지붕 집에서 유년기를 보낸 작가는 터미널이라는 공간과 골함석이라는 재료를 통해 현대인의 삶을 여러 층위에서 성찰한다. 이제 골함석 지붕은 거의 찾아보기 어렵다. 골함석은 또 다른 신소재로 대체되었다. 우리는 경제와 기술의 급속한 발전으로 더 많은 물질적 풍요를 누리게 되었지만, 작가는 그 과정에서 우리가 잃어버린 것은 없는지 되묻고 있다.

Architectural Sculpture / Yangpyeong Terminal

This building borrows the external form of the bus terminal at Yangpyeong in Korea's Gyeonggi Province. Chen, who lived for a decade in Germany before moving back to Korea to live and work in Yangpyeong, regards transport terminals as symbolizing the lives of urban dwellers. The department stores, shopping arcades, restaurants and cafés built at terminals to take advantage of their high floating populations offer a faithful illustration of the contemporary lifestyle in which all needs can be rapidly met in a single place.

In this work, Yangpyeong Terminal is reborn in corrugated sheet iron. To us, this zinc-galvanized material is familiar for its use on roofs. Since the British army began using light yet strong corrugated iron to build easily movable huts during military operations in the 19th century, the material has gradually spread throughout the world. It was used in Korea from the 1970s, when materials such as slate, galvanized sheet steel, and cement were used for improving roofs as part of the New Village Movement.

Chen, who grew up in a house with a steel roof in the 1970s, considers various layers of contemporary life through the bus terminal as a space and corrugated sheet iron as a material. Today, corrugated iron roofs are a rare sight. The metal sheets have themselves now been replaced by other new materials. Rapid economic and technological development have brought us greater material abundance, but Chen now asks what we might have lost in this process.

<건축적 조각/양평터미널>, 2021, 철, 골함석, 조명 등, 375×830×300cm

Architectural Sculpture / Yangpyeong Terminal, 2021, Steel, corrugated sheet iron, lighting, etc., 375×830×300cm

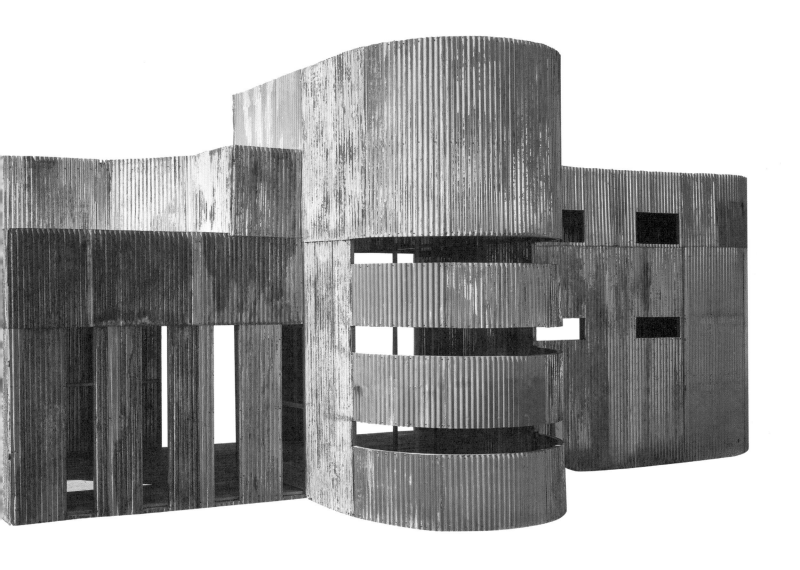

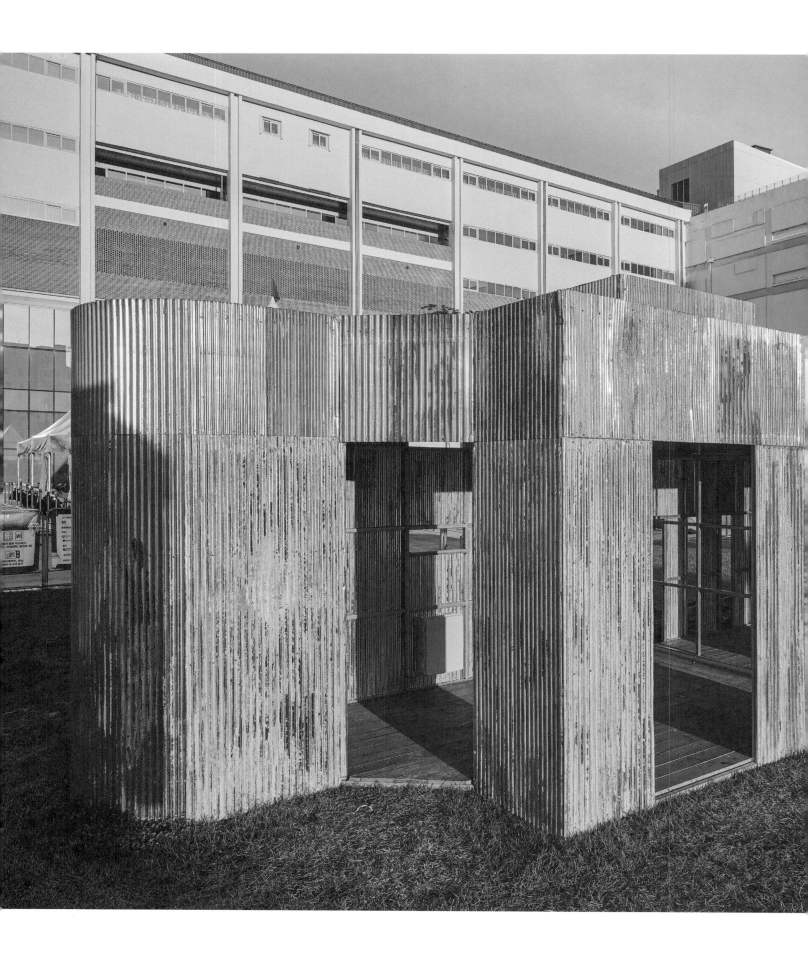

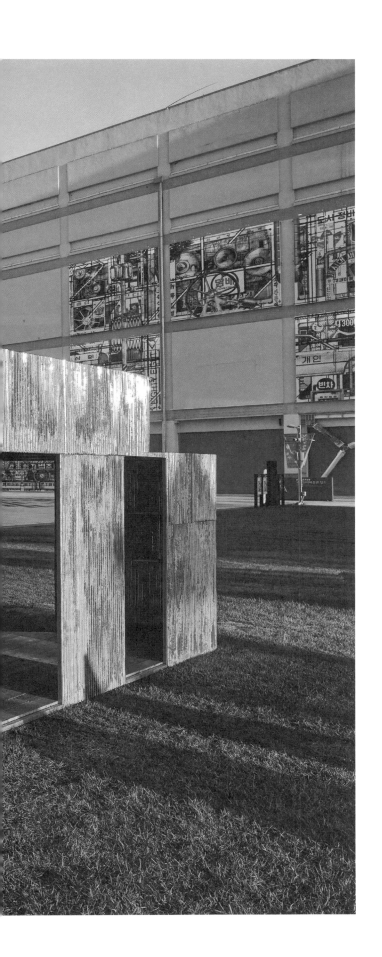

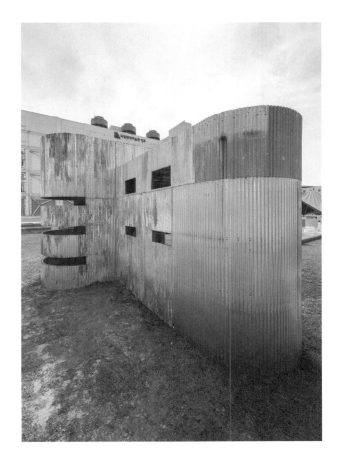

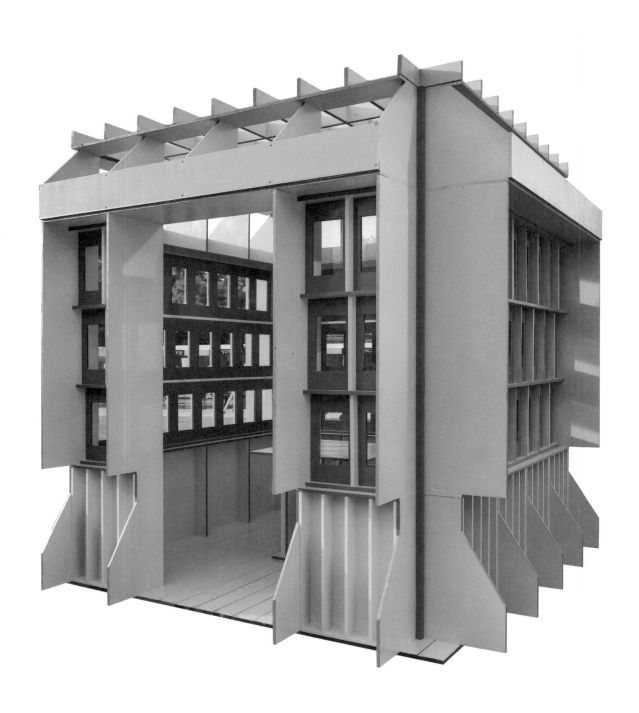

건축적 조각/수랏타니의 집

<건축적 조각/수랏타니의 집>은 태국 남부에 있는 도시인 '수랏타니'에 있는 건물을 모티프로 만든 작품으로, '수랏타니'는 '좋은 사람들의 도시'라는 뜻이다. 아시아 국가에서 유일하게 식민 지배를 받지 않은 태국은 자생적인 문화와 정서를 발전시켜 왔다. 천대광은 수랏타니 시내에 있는 한 익명의 건물에서 태국의 종교와 기후 등 독특한 문화를 발견하고, 이를 반영한 새로운 조각작품을 재창조했다.

독특한 색상과 장식이 눈에 띄는 이 건물은 연중 높은 기온에 강수량이 많은 태국의 기후를 잘 반영하고 있다. 특히 창문 양옆으로 벽이 튀어나오도록 해 뜨거운 직사광선을 피할 수 있도록 한 부분은 그런 특징을 잘 보여준다. 전통적인 가옥의 경우 바닥을 땅에서 띄우고 통풍이 잘되도록 창을 크게 만들었지만, 건축 기술이 발달함에 따라 에어컨이 보급되면서 점차 현대식으로 바뀌었다.

더불어 이 건물은 불교의 영향력을 보여준다. 태국은 국민의 95%가 불교를 믿고, 헌법에도 '국왕은 불교도이며 모든 종교의 수호자이다'라고 명시할 만큼 태국은 명실공히 불교국가다. 정면을 장식하고 있는 불교의 도상이 그 영향을 잘 보여준다. 그리고 밝은 오렌지색에 파란색은 태국 고유의 색채관을 보여주는데, 태국에서는 칠일불(七日佛) 즉, 각기 다른 일곱 부처가 일곱 색을 상징하고, 요일을 관장하여 수호한다는 믿음이 있어 복식이나 주거 문화에 생활 전반에 많은 영향을 끼치고 있다.

Architectural Sculpture / Surat Thani House

Architectural Sculpture: Surat Thani House is based on buildings located in the southern Thai city of the same name. Surat Thani means 'city of good people.' Thailand, the only Asian country not to have been colonized, has developed its own autogenous culture and sentiment. In one anonymous building in downtown Surat Thani, Chen discovered unique elements of Thai culture, including religion and climate, reflecting and re-creating them in this new sculptural work.

With its unique and eye-catching colors and decoration, this building reflects the Thai climate of year-round high temperatures and rainfall. The walls protruding on either side of the windows, shielding them from direct sunlight, are a good example of such features. Traditional houses were raised off the ground and had large windows in order to allow better ventilation, but developments in architectural technology and the spread of air conditioning have led to a gradual shift towards modern designs.

This building also shows influence from Buddhism. Thailand is a truly Buddhist country, with 95% of its population adhering to the faith and its constitution explicitly stating that the king is a Buddhist and defender of all religions. The Buddhist iconography decorating the façade of the building illustrates the influence of this faith. The use of blue on bright orange shows Thailand's unique sense of color. Thailand uses so-called Buddha Images for the Seven Days of the Week, with each Buddha representing one of seven colors and supervising and protecting his respective day of the week. These colors are strongly influential in all aspects of life, from clothing to lifestyle culture.

<건축적 조각/수랏타니의 집>, 2021, 목재, 아크릴, 페인트, 조명 등, 284×284×266cm

Architectural Sculpture / Surat Thani House, 2021, Timber, acrylic, paint, lighting, etc., 284×284×266cm

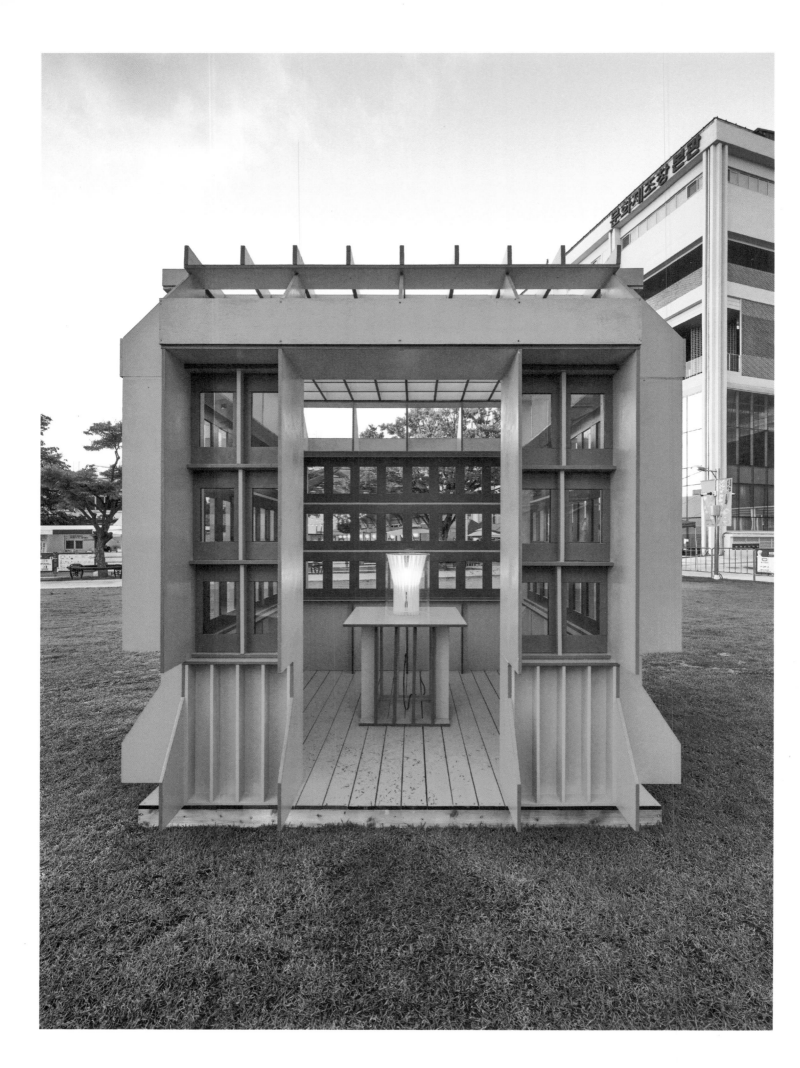

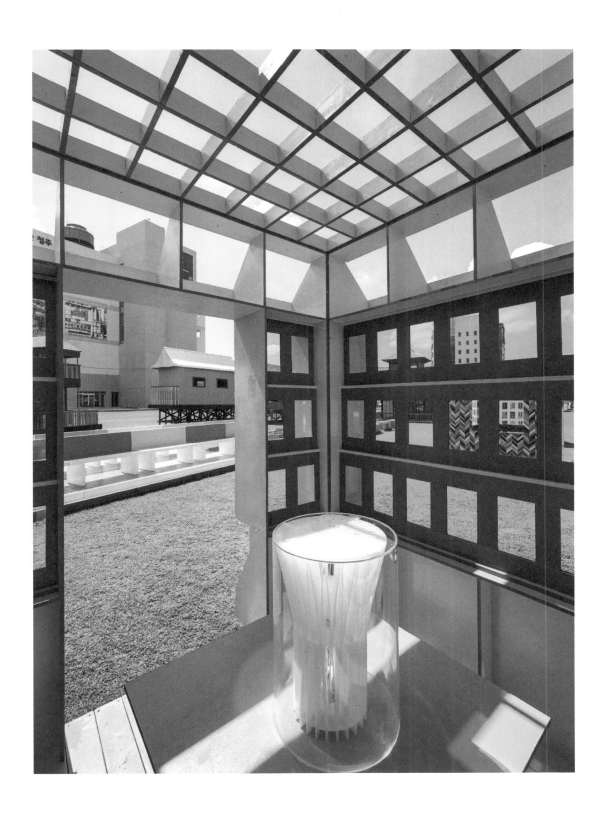

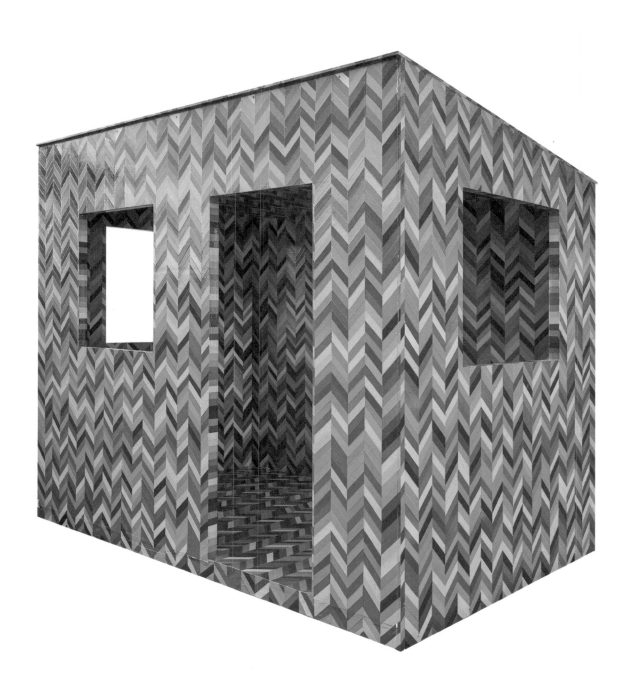

건축적 조각/보잘것없는 집/가파리 240번지

가파도는 우리나라 최남단 마라도와 제주도 본섬 사이에 있는 작은 섬이다. 산이 없는 평탄한 지대에 청보리밭이 아름답게 펼쳐져 있어 관광지로 주목을 받는 곳이다. 그러나 가파도 해역은 예로부터 거센 바람과 파도가 높은 수역으로, 주변을 지나는 외항선들의 표류와 파선이 잦았던 곳이다. 이러한 지리적, 기후적 특성으로 인해 우리나라가 서양에 처음 알려지게 된 곳이 바로 가파도라는 추정도 있다.

　'가파리 240번지'에 있는 창고 건축물은 아무런 장식도, 문양도, 지붕도 없는 단일한 형태로, 거센 바람과 많은 양의 눈과 비를 견딜 수 있도록 설계되었다. 가파도를 방문한 천대광은 가파도에서 연상되는 낭만적인 단어(청보리밭, 바다, 제주 등)와 달리, 그곳의 건축물들과 함께 거친 환경에서 억척스럽게 살아가는 섬마을 사람들의 강인하면서도 외로운 삶을 목격하고, 이 작업에 대한 아이디어를 구상했다. 척박한 자연환경 속에서 살아가는 가파도민들의 고단한 삶이 화려하고 풍부한 색채 표현으로서 역설적으로 드러나는 작업이다.

Architectural Sculpture / Good-for-Nothing House / 240 Gapa-ri

Gapa-do is a small island located between Jeju Island and Mara-do, the southernmost island in Korea. With its flat, mountain-less terrain covered in forage barley fields, the island is a notable tourist destination. But the waters off Gapa-do are home to strong winds and high waves, and once frequently wrecked passing ocean ships that drifted off course. Because of these geographical and climatic characteristics, some assume that Gapa-do was the first place in Korea to become known to the West.

　The storage building at 240 Gapa-ri is simple in form, with no decoration, patterns or roof. It is designed to withstand strong wind and large amounts of snow and rain. When visiting the island, Chen noticed the tough and lonely lives of its inhabitants, living relentlessly in their barren environment along with their buildings and in contrast to the romantic words that the island commonly evokes (barley fields, sea, Jeju, etc). Here, the hard lives of the islanders in their barren natural environment are paradoxically manifested in bright, rich colors.

<건축적 조각/보잘것없는 집/ 가파리 240번지>, 2021, 목재, 썬팅지, 조명 등, 162×246×210cm

Architectural Sculpture / Good-for-Nothing House / 240 Gapa-ri, 2021, Timber, window tint film, lighting, etc., 162×246×210cm

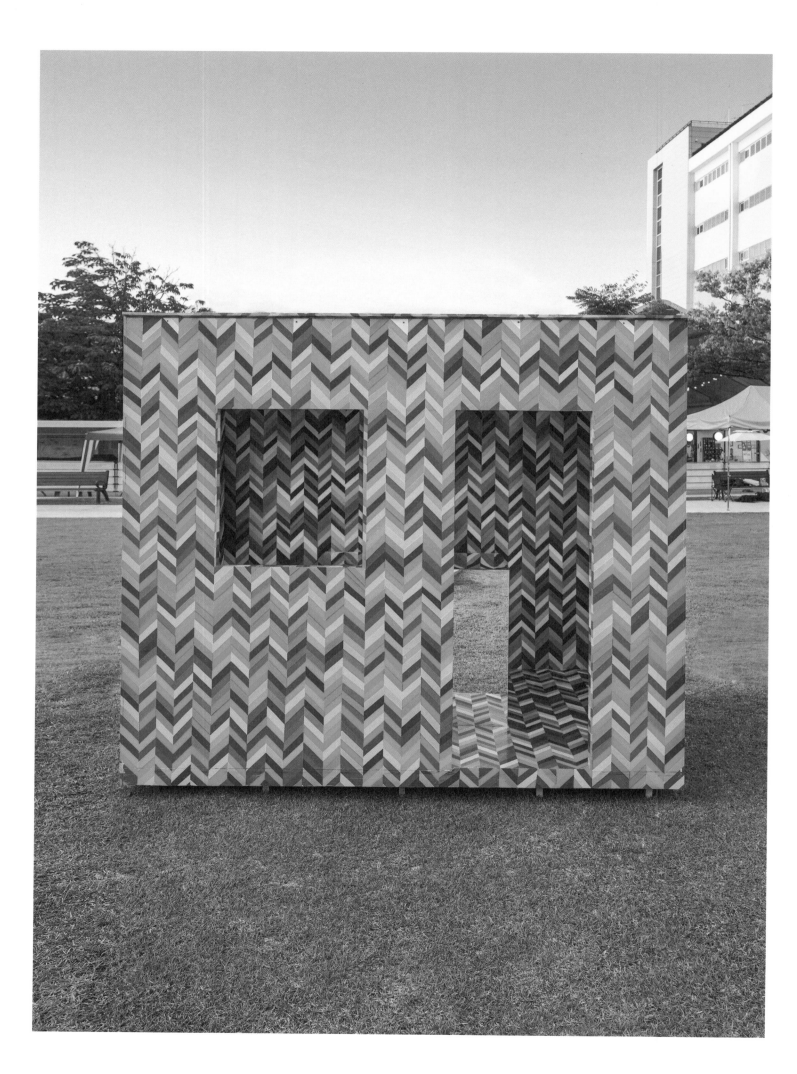

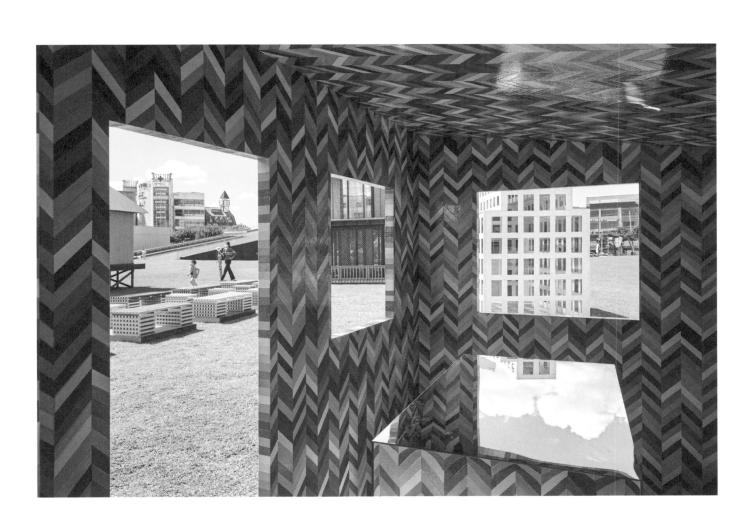

건축적 조각/공허한 빛의 집/RGBCMYK 유리집

이 작품은 세상에 존재하지 않는 가상의 집으로, 작가가 오직 6가지 색채만으로 구성된 집을 상상하여 제작한 것이다. RGB는 빛의 삼원색인 빨강(Red), 초록(Green), 파랑(Blue)을, CMYK는 파랑(Cyan), 자주(Magenta), 노랑(Yellow), 검정(Key=Black)의 약자를 말한다. RGB는 빛의 색이기 때문에 색을 모두 혼합하면 흰색에 가까워지고, CMYK는 인쇄용 잉크나 물감 색에 해당하기 때문에 색을 섞을수록 검정에 가까워진다.

천대광은 이러한 색의 기본원리에 따라 6가지 색상의 반투명 아크릴을 격자 형태로 이어붙여 색채 공간을 창조했다. 6개의 색상은 세상 모든 만물이 생성되는 데 필요한 기본 요소와 우주의 메커니즘을 은유적으로 표상한다. 관람자는 서 있는 위치에 따라 달라지는 중첩된 색을 보며 낯선 공간에 와 있는 듯한 경험을 할 수 있다.

Architectural Sculpture / House of Empty Light / RGBCMYK Glass House

This work is a non-existent, imaginary house. The artist created it by imagining a house made up only of six colors. RGB stands for the three primary colors, red, green, and blue, while CMYK stands for cyan, magenta, yellow and key (= black). Because RGB comprises colors of light, the three colors produce something close to white when combined. And because CMYK is used with printing ink and paint, the three colors, when mixed together, create a shade close to black.

In accordance with these basic principles of color, Chen Dai Goang has joined translucent pieces of acrylic in six colors in a lattice formation, creating a chromatic space. The six colors metaphorically represent the basic elements needed to create all things in the universe, and the mechanisms of the universe. Viewers see different layers of colors according to where they stand, experiencing the feel of an unfamiliar space.

<건축적 조각/공허한 빛의 집/RGBCMYK 유리집>, 2021, 목재, 철, 아크릴, 페인트, 조명 등, 325×713×260cm

Architectural Sculpture / House of Empty Light / RGBCMYK Glass House,
2021, Timber, steel, acrylic, paint, lighting, etc., 325×713×260cm

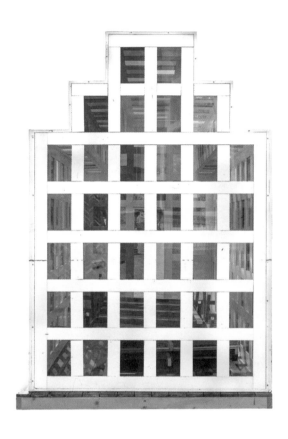

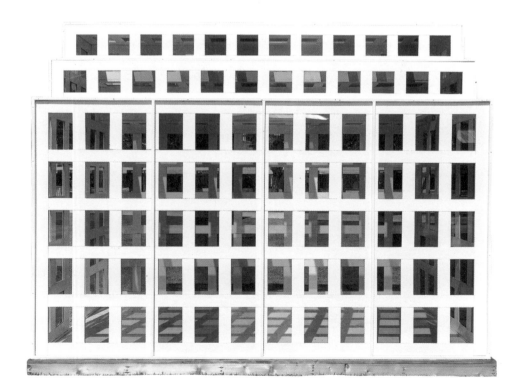

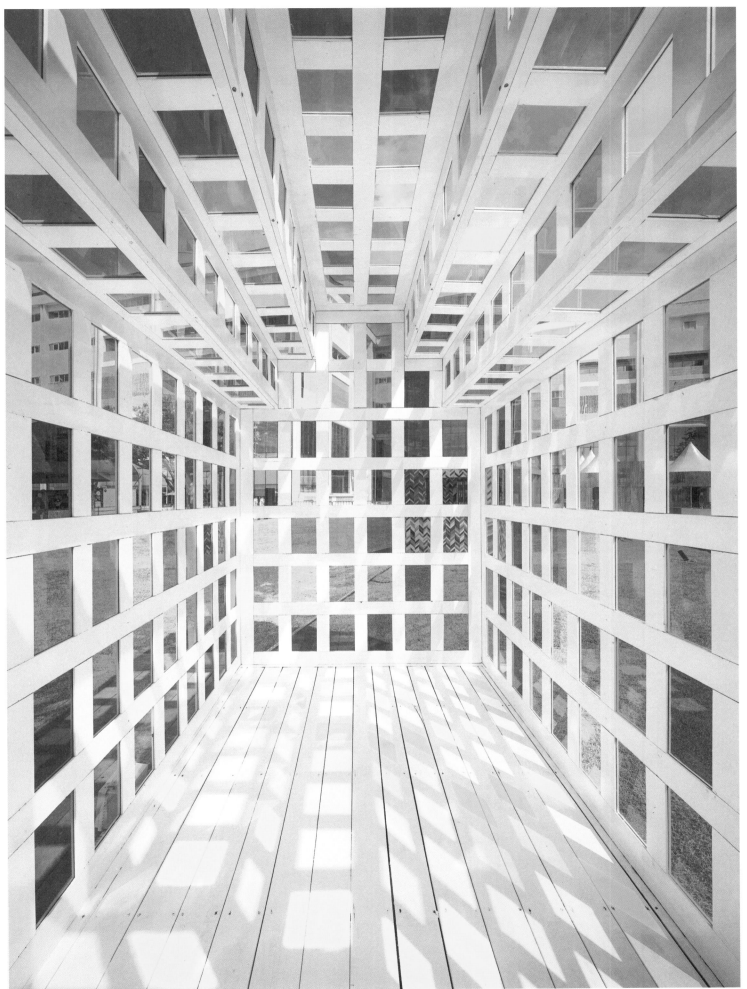

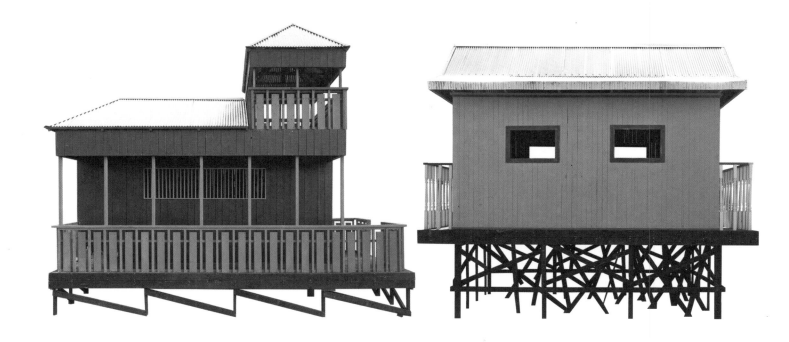

건축적 조각/다리 없는 집/캄퐁 플럭의 수상가옥 1-3

이 작품은 캄보디아 캄퐁 플럭(Kampong Phluk) 마을의 수상가옥을 모티프로 한 작업이다. 강수량에 따라 수위가 달라지는 수상가옥의 모습을 다양한 형태로 보여주고 있다. 캄퐁 플럭은 캄보디아 시엠립(Siem Reap) 주(州)에서 남동쪽으로 약 16km 떨어진 톤레삽(Tonle Sap) 호수에 있는 수상 마을이다. 톤레삽 호수는 건기에는 2,600㎢, 우기에 최대 13,000㎢까지 늘어나는 호수로 동남아시아에서는 규모가 가장 크다. 강의 큰 규모 때문에 캄퐁 플럭은 건기일 때는 일반 마을이지만, 우기에는 수면이 3m 정도 높아져 물 위에 떠 있는 마을이 된다.

캄퐁 플럭은 독특한 수상가옥과 아름다운 일몰을 내세운 낭만적인 관광 상품으로 유명하다. 그러나 역사적으로 수상 마을은 힘없고 가난한 약자들의 피신처이기도 했다. 12세기 인도네시아계 참파 왕국이 크메르 제국과의 전쟁에서 패전하면서 땅을 잃고 밀려난 사람들이 유입되었고, 베트남 전쟁(1954~1975)이 발발하면서 캄보디아로 피난 온 베트남 난민들이 찾아들었다. 어떤 국가에도 속하지 않는 강 위는 오갈 데 없는 난민과 이주민들이 숨 쉴 수 있는 마지막 희망의 공간이다.

그들의 삶은 일몰처럼 환상적이지도 않고, 여유롭지도 않다. 매일 흙탕물에 그물을 던져 고기를 잡고, 보트를 타고 학교에 가며, 물건을 팔러 다닌다. 저렴하고 가벼운 양철 지붕과 값싼 목재로 지어진 가옥은 찜통같이 덥고 환경오염으로 줄어든 어획량으로 벌이는 시원치 않다. 하루하루 고단한 생존의 현장이다. 그러나 자연에서 필요한 것을 얻고 큰 걱정 없이 노동하며 살아가는 캄퐁 플럭 사람들의 표정은 어둡지만은 않다. 더 많은 것을 가지려는 욕망으로 고군분투하는 도시의 삶보다 캄퐁 플럭에서의 소박한 삶이 어쩌면 더 풍요롭고 행복한 것은 아닐까. 작가는 수상가옥과 그곳에서 살아가는 사람들의 삶을 통해 진정으로 행복한 삶이란 무엇인지 질문한다.

"수면의 윗부분은 다듬어지고 정리되어 있다. 이것을 코스모스라 하자. 물속의 건축물 기둥은 얼기설기 아무렇게나 축조되어 혼돈 그 자체다. 카오스다. 역사는 코스모스와 카오스를 하나의 사이클로 가지고 있다. 수탈과 착취를 통해 이루어낸 식민주의 근대사는 피식민지의 고통을 기반으로 한다. 캄퐁 플럭의 수상가옥처럼. 수면 위와 수면 아래…"

– 천대광

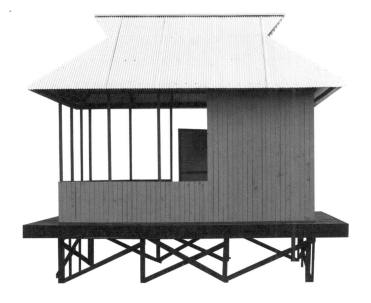

<건축적 조각/다리 없는 집/캄퐁 플럭의 수상가옥 1>,
213×453×400cm
<건축적 조각/다리 없는 집/캄퐁 플럭의 수상가옥 2>,
213×453×420cm
<건축적 조각/다리 없는 집/캄퐁 플럭의 수상가옥 3>,
213×453×400cm
각 2021, 목재, 골함석, 페인트, 조명 등

*Architectural Sculpture / House without Legs /
Kampong Phluk Floating House 1,*
213×453×400cm
*Architectural Sculpture / House without Legs /
Kampong Phluk Floating House 2,*
213×453×420cm
*Architectural Sculpture / House without Legs /
Kampong Phluk Floating House 3,*
213×453×400cm
2021, Timber, corrugated sheet iron,
paint, lighting, etc. (each)

Architectural Sculpture / House without Legs / Kampong Phluk Floating House 1-3

These works are based on the motif of Kampong Phluk, a floating village in Cambodia. It depicts the village, where water level varies in accordance with rainfall, in a variety of forms. Kampong Phluk is located on Tonle Sap, a lake approximately 16km to the south-east of Siem Reap Province. Tonle Sap fluctuates in size from 2,600km² in the dry season to up to 13,000km² in the wet season, making it the largest lake in Southeast Asia. Because of the large size of its river, Kampong Phluk is a normal village in the dry season but becomes a floating settlement during the wet season, when the water level rises by approximately three meters.

Kampong Phluk is famous as a romantic tourist 'product' with its unique floating houses and beautiful sunsets. But historically, the village has served as a place of refuge for poor and vulnerable people. In the 12th century, the area saw an influx of the dispossessed following the defeat of the ethnically Indonesian Champa Kingdom by the Khmer Empire. It also took in Vietnamese refugees fleeing from their own country to Cambodia with the outbreak of the Vietnam War (1954~1975). Floating on the river, belonging to no country, the village was a place of last hope, offering breathing space for homeless refugees and migrants.

The villagers' lives are not easy, or as fantastically beautiful as a sunset. Every day, they cast nets into the murky waters to catch fish, go to school by boat, or travel around selling things. Their homes, built of cheap, light tin roofs and inexpensive timber, are swelteringly hot, while reduced fishing yields due to pollution make life hard. Each day is a hard struggle for survival. But the expressions of Kampong Phluk villagers, obtaining what they need from nature and living and working with no major worries, are not entirely dark. Perhaps the simple life here in the village is actually more abundant than those of city dwellers struggling to get more and more stuff. Through the floating homes and the lives of their inhabitants, the artist asks what makes a genuinely happy life.

"The parts above the water are clean and tidy. Let's call them the cosmos. The building columns below the waterline are put up all higgledy-piggledy—the epitome of confusion. This is chaos. History contains cosmos and chaos as part of a single cycle. Modern colonial history, created through plunder and exploitation, is built on the pain of the colonized. Like the floating houses of Kampong Phluk. Above the water, and below the water…"
– Chen Dai Goang

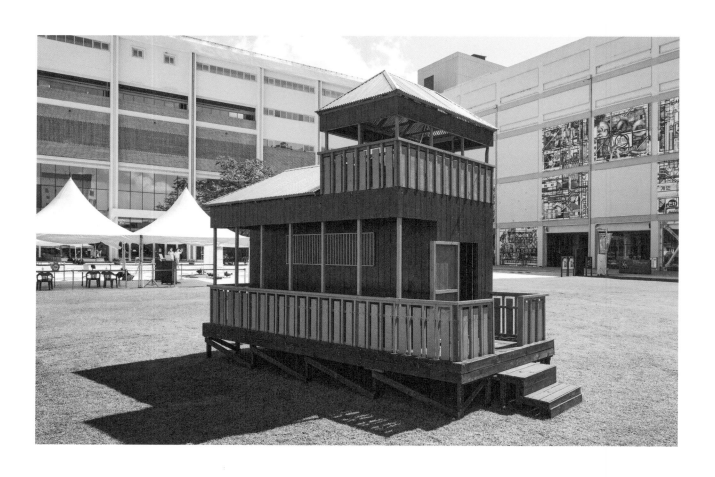

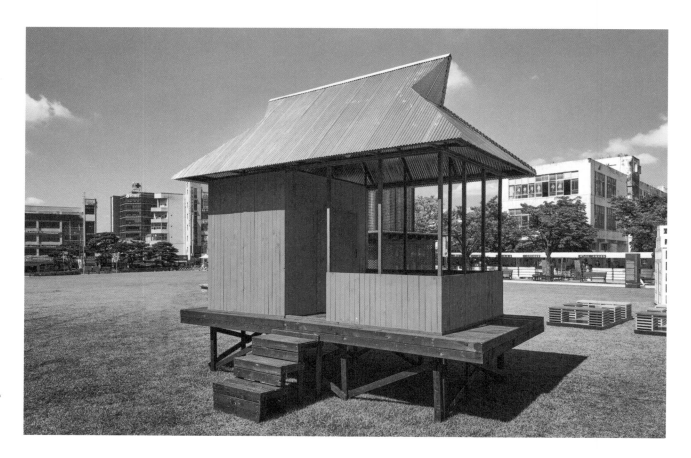

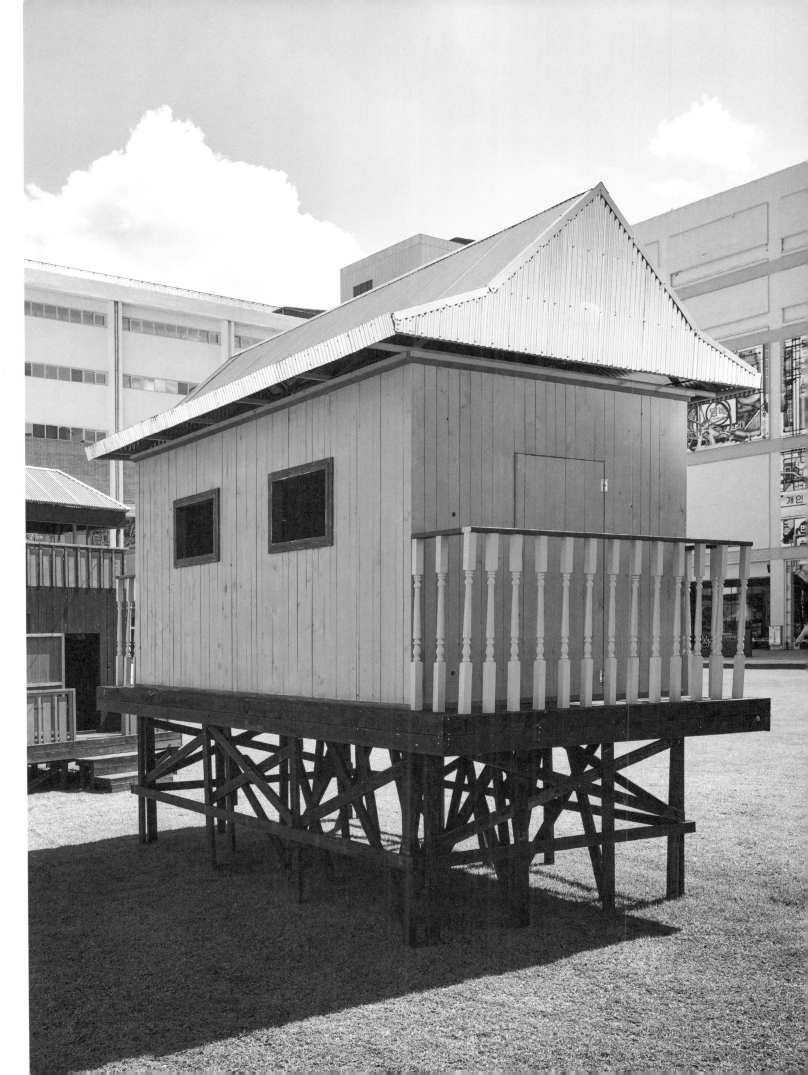

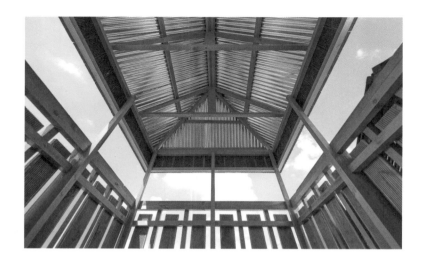

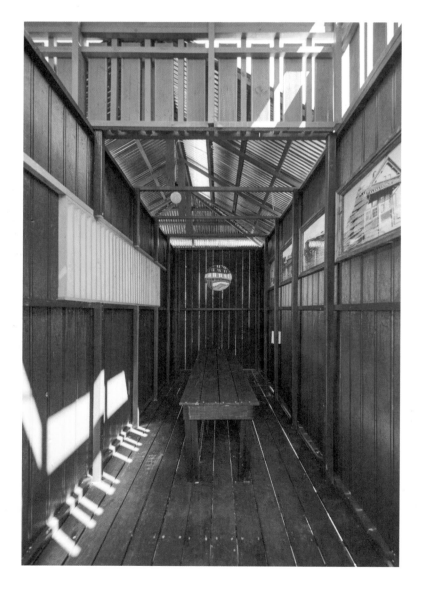

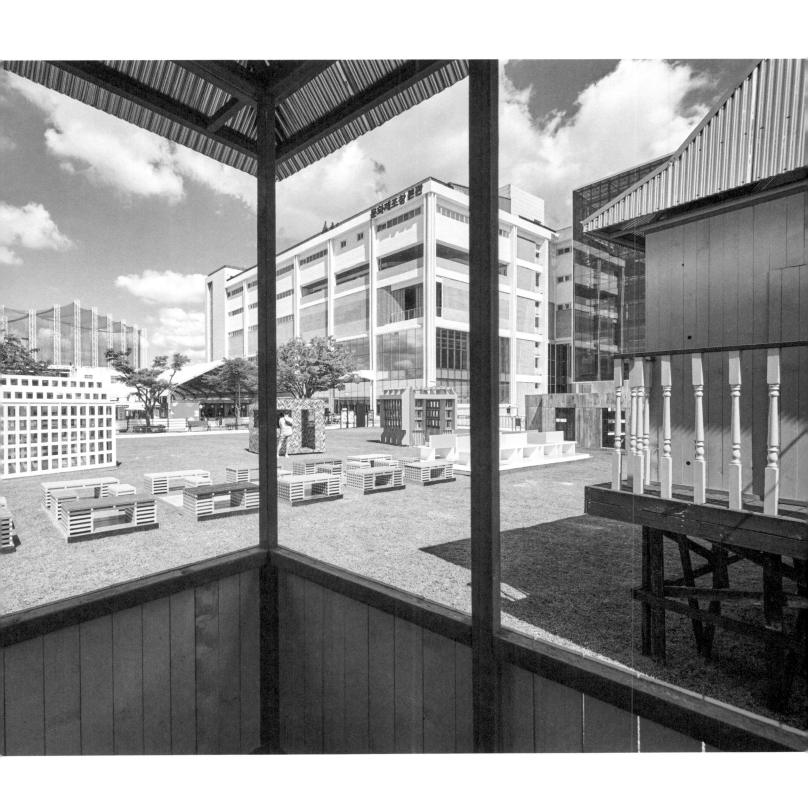

건축적 조각/후천개벽(後天開闢) 탑

<건축적 조각/후천개벽(後天開闢) 탑>은 청주 탑동에 위치한 '탑동 양관'(塔洞 洋館)의 양식과 '후천개벽'이라는 사상을 담아낸 조각이다. 불교와 근대기 서양 주택 양식이 혼합된 새로운 양식의 건축적 조각으로, 동서양 종교문화가 복잡하게 얽힌 양상을 조형적으로 보여주고 있다.

총 여섯 채의 탑동 양관은 일제 강점기에 건립된 서양식 주택으로, 건립 시기에 따라 서로 다른 건축적 특징을 나타내고 서양식 건물의 초기 특징을 잘 보여준다. 양관이 건립될 당시 우리나라에서 제조하지 못했던 유리를 비롯한 스팀 보일러, 벽난로, 수세식 변기, 각종 창호와 철물류 등 많은 수입 자재가 사용되었다.

이 작품에는 1911년 건립된 제3호 양관(민노아 기념관)이 부분적으로 활용되었다. 제3호 양관은 붉은색 벽돌에 전통 한옥의 기와지붕으로 덮여 있고, 밝은 녹색의 창틀과 테라스가 있어 고즈넉하면서도 생기 있는 분위기를 자아내는 것을 특징으로 한다.

'후천개벽'은 하늘과 땅이 열린다는 뜻으로 천지가 새로 생기고 어지러운 세상이 뒤집혀 다시 평화로워진다는 개념이다. 천지 우주가 순환하고 변화하는 절대 섭리 깨닫고, 자연과 조화를 이루어야 인간이 성숙하고 결실을 맺을 수 있다는 의미를 담고 있다. 이번 전시에서 선보이는 천대광의 탑은 이러한 사상을 기반으로 '더 나은 새로운 시대'가 오기를 바라는 염원을 담고 있다.

Architectural Sculpture / Hucheongaebyeok (後天開闢) Pagoda

This work is based on Tapdong Yanggwan, a building located in Cheongju's Tap-dong neighborhood, and a thought called 'Hucheongaebyeok' (後天開闢). A new style of architectural sculpture blending Buddhist and modern Western residential styles, the work gives sculptural form to a complex tangle of Eastern and Western religious cultures.

The total of six houses of Tapdong Yanggwan is a Western-style house built during Japan's occupation of Korea. It shows different architectural features from multiple eras, providing a good illustration of the early features of Western-style buildings. The house was built from a large number of imported materials that could not be manufactured in Korea at the time, from glass to a steam boiler, fireplaces, a flush toilet, and various windows and fittings.

This work makes partial use of the Miller Memorial Hall, the third western building at the site, which was built in 1911. The building features red brick walls topped with the tiled roof of a traditional Korean *hanok* house, and has bright green window frames and terraces, producing a quiet yet vibrant ambience.

The Sino-Korean term 'Hucheongaebyeok' signifies the opening of the heavens and the earth: that they will be renewed; that the current world of chaos will be overturned; and that peace will return. The phrase implies that humans can only reach maturity and bear fruit once they realize the absolute principle whereby heaven, the earth and the universe are constantly circulating and changing, and achieve harmony with nature. Chen Dai Goang's pagoda embodies a longing for a new and better age, based on this ideology.

<건축적 조각/후천개벽(後天開闢) 탑>, 2021, 목재, 페인트, 조명 등, 410×410×750cm

Architectural Sculpture / Hucheongaebyeok (後天開闢) Pagoda, 2021, Timber, paint, lighting, etc., 410×410×750cm

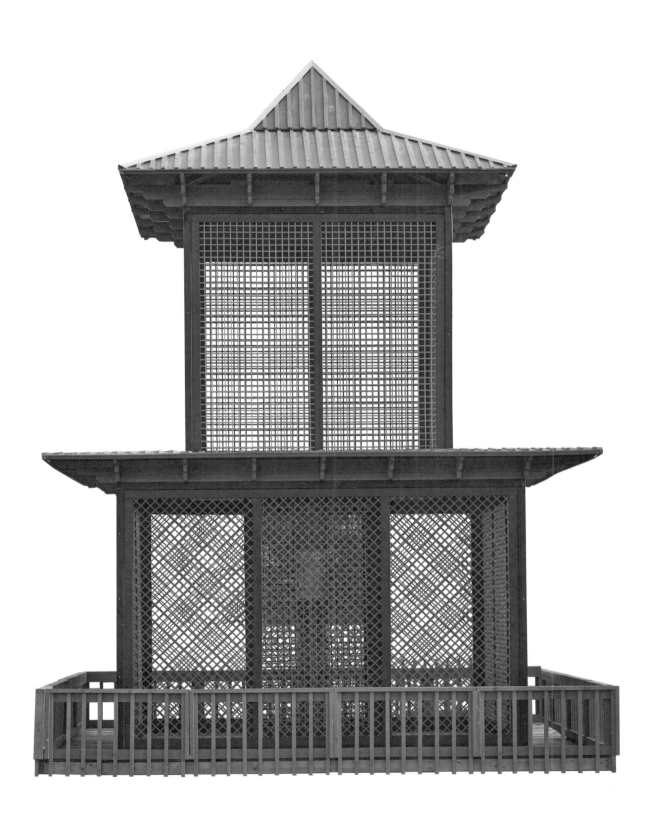

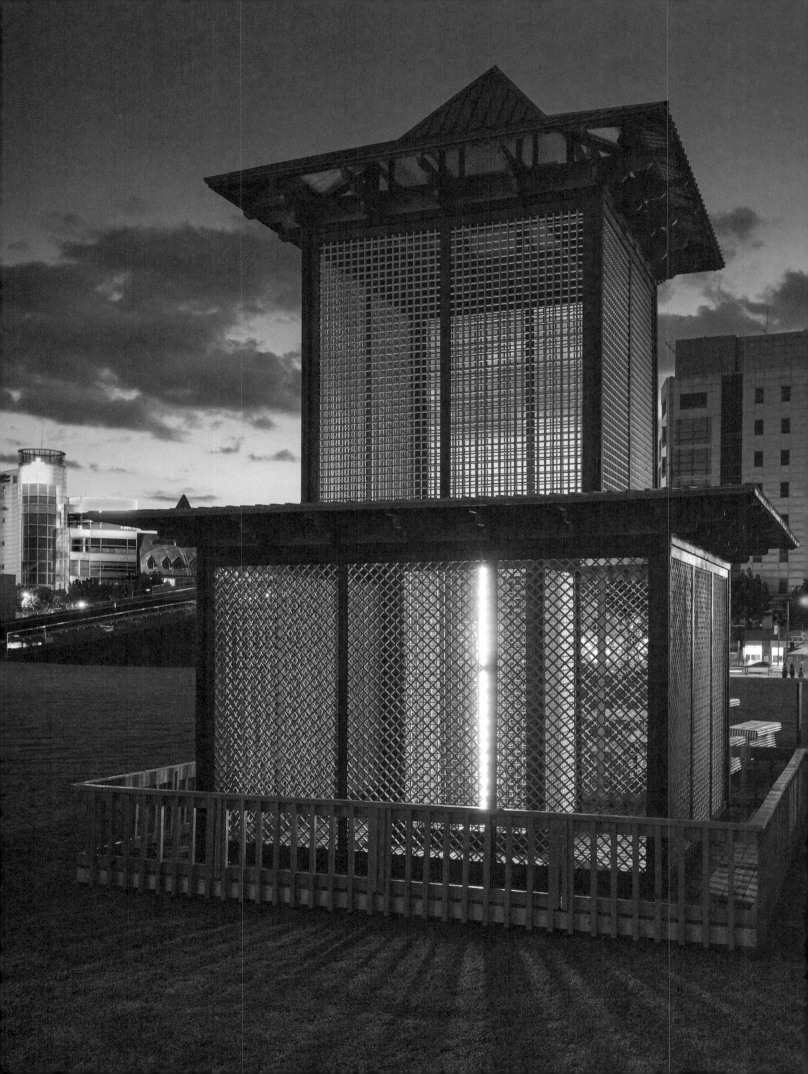

건축적 조각/크노르 벤치

이 작품의 제목인 '크노르'(knorr)는 다국적 기업 유니레버(Unilever)의 산하 브랜드 이름에서 가져온 것이다. 크노르는 주로 소스와 육수, 수프, 파우더 제품을 생산하는 식품 제조기업으로, 태국, 베트남 같은 동남아 국가의 동네 마트에서 쉽게 구매할 수 있을 정도로 현지에서는 대중화에 성공한 브랜드이다. 1838년 동명의 독일 사업가에 의해 세워졌다가 1958년 미국의 옥수수 정제회사를 거쳐 2000년에 유니레버로 인수되었다.

유니레버는 1929년 마가린 시장을 석권하던 네덜란드의 마가린 유니에(Margarine Unie)와 영국의 비누 제조업체 레버 브라더스(Lever Brothers)가 합병해 탄생한 기업이다. 합병 당시 유럽 국가들은 제국주의를 앞세워 아시아와 아프리카 지역에 식민지를 확장하고 있었고, 자신의 식민지로부터 저렴한 가격에 원료를 사들이기 위해 당시 사상 최대 규모의 합병을 단행했다.

<건축적 조각/크노르 벤치>의 다채로운 파스텔 색감은 크노르사와 유니레버 계열사들의 로고 색과 동남아 건축물들의 색을 임의로 추출해 반영한 것이다. 브랜드 로고는 지워지고 다소 '귀여운' 색으로 칠해진 벤치 이면에는 경제뿐만 아니라 전 세계의 문화와 일상 깊은 곳까지 잠식하고 있는 다국적 기업 자본의 보이지 않는 강력한 힘이 존재한다.

Architectural Sculpture / Knorr Bench

The 'Knorr' in the title of this work is the name of a brand owned by multinational corporation Unilever. Knorr is a food manufacturer that mainly produces sauces, stocks, soups and powder-based products. It has won local popularity worldwide, to the extent that its products can easily be found in local shops in Southeast Asian countries such as Thailand and Vietnam. Founded in 1838 by a German businessman of the same name, Knorr was acquired by an American maize refining company in 1958, then by Unilever in 2000.

Unilever itself was born in 1929 through the merger of Dutch margarine producer Margarine Unie and British soapmaker Lever Brothers. At this time, European states were expanding their colonies in Asia and Africa in the name of imperialism, and the Unilever merger, the biggest in history at the time, took place in order to enable the purchase of raw materials at low prices from national colonies.

The diverse pastel colors of *Architectural Sculpture / Knorr Bench* randomly extract and reflect colors in the logos of Knorr and other Unilever subsidiaries, and in Southeast Asian buildings. Behind the bench, painted in somewhat 'cute' colors and with brand logos erased, lies the immense hidden power of multinational corporate money, deeply penetrating not just economies but cultures and daily life across the world.

<건축적 조각/크노르 벤치>, 2021, 목재, 페인트, 조명 등, 122×122×85(10개)cm

Architectural Sculpture / Knorr Bench, 2021, Timber, paint, lighting, etc., 122×122×85(10ea)cm

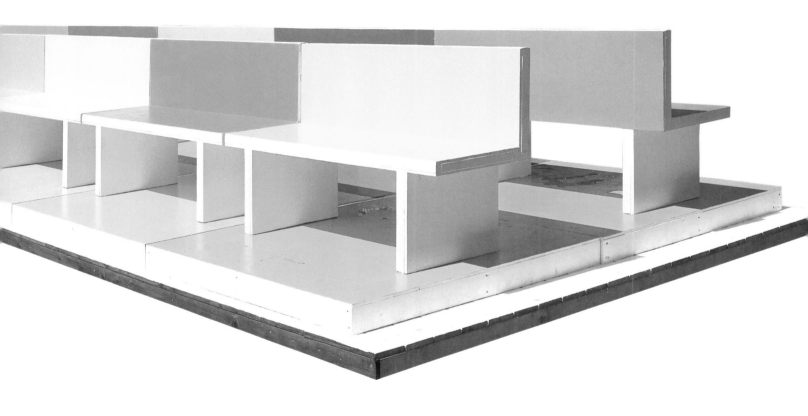

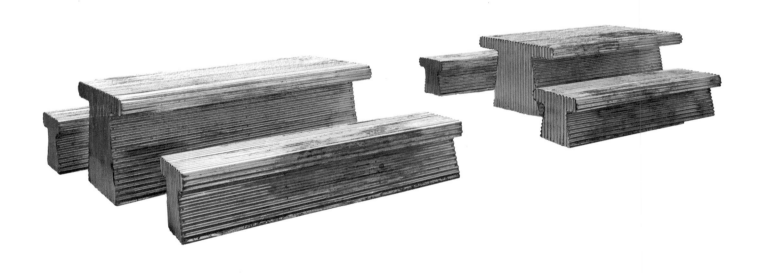

<건축적 조각/판 밖의 사람들을 위한 탁자·벤치>, 2021, 철, 골함석, 탁자: 97×182×71cm(2개), 벤치: 45x182x51cm(4개)

Architectural Sculpture / Tables and Benches for People Outside the Site, 2021, Steel, corrugated sheet iron,
Table: 97×182×71cm (2ea), Bench: 45x182x51cm (4ea)

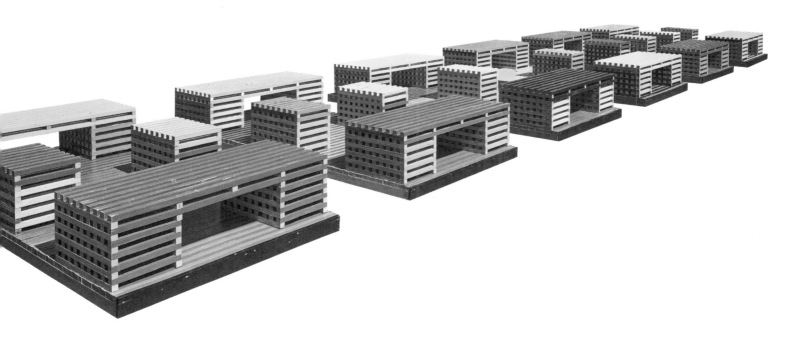

<건축적 조각/색동 벤치>, 2021, 목재, 페인트 등, 48×120×34.5cm(12개), 32×48×34.5cm(10개)

Architectural Sculpture / Saekdong(stripes of many colors) Bench, 2021, Timber, paint, etc.,
48×120×34.5cm (12ea), 32×48×34.5cm (10ea)

남방의 건축을 '역사의 양피지'로 재체험하는,
회억((回憶) 속에서 비전이 재출현하는 건축술 ─ 천대광론

On Chen Dai Goang's Work: The Technique of Architecture to Re-experience the Architecture of the South, the Technique of Architecture Where Vision Reappears in Remembrance[1]

김남수
(안무비평)

Kim Nam Soo
(Choreography Critic)

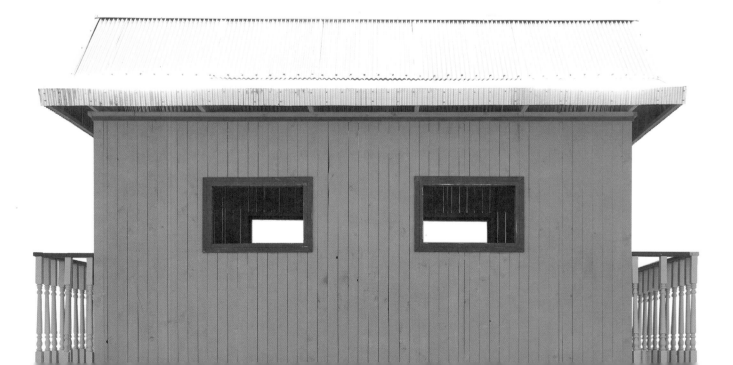

#1. "티쿤(tikkun) ― 『유대백과사전』의 '카발라' 항목에서 ― 은 만물이
처음 상태로 회귀하는 것으로서의 구원을 뜻한다."

-미카엘 뢰비(Michael Löwy), 『발터 벤야민: 화재경보』 중에서

#2. "고통을 다룬다는 것은 항상 에너지를 발전시키는 것이다. 그리고 고난
의 기억을 다룰 수 있기 위해서 하나의 형식을 발견하는 것이다."

-아티스트 사르키스(Sarkis Zabunyan)

우주론적 건축과 삶의 건축

천대광 작가의 작품 <집우집주>는 국립현대미술관 청주관 야외 공간에 다수
의 목구조 건축물들로 구성되고 배치되어 있다. 그런데 작품 제목에 나타나듯
'공간적 우주'(宇)로서의 집 개념과 '시간적 우주'(宙)로서의 집 개념, 이렇게
시공간으로 조합되는 '우주'라는 말은 물리학에서 말하는 시공간 연속체보다
큰 뜻을 품고 있다. 과거 동아시아 전근대 사회에서 천하(天下), 즉 "하늘 아래
온 세상"이라는 삶의 시공간 개념을 깔고 있으면서도 그보다 상위의, 어쩌면
형이상학적인 집의 의미망을 갖춘 시공이다. 그렇다면, 천대광 작가가 제작한
그 집(들)에 살고 거주하거나 머무르며 노는 존재자들은 삶의 차원에 있으면
서도 그 이상을 본의 아니게 엿보는 차원에 동시에 속해 있을지 모른다.

　　가령, 별들이라면 어떤 조건의 것이 될 것인가. 만일 별들이 그 천대광 작
가가 설정한 '우주' ― 실상은 청주관 앞의 잘 관리된 잔디광장이 될 테지만 ―
에 존재하는 것이 가능하다면, 진수열장(辰宿列張) 즉 "별자리들이 벌려 베
풀어져 있는" 광경을 말하는 것이 될 여지가 있다. 물론 이때 별들은 매우 평
평한 천구(天球)의 일정한 표면에 균질하게 달라붙어서 무리를 이루게 된다.
어쩌면 이곳에 널려 있는 집들을 이러한 식으로 '우주'를 보는 일종의 수간[竪
看, 위에서 홀리스틱하게 내려다보는 이기론(理氣論)적 응시]의 입장에서 바
라본다면 어떻게 될까. 위상학적 관점으로는 별들의 타오르는 위치들을 점하
고 있는 것을 보게 되고, 에너지적 관점으로는 그 별들의 위치로 올라가기 전
에 이곳 땅에 살았던/사는 사람들(!)의 삶의 체취, 생활의 습관, 흔적들이 집의
형식으로 구축되어 있는 것을 보게 되는 것이 아닐까. 위치는 높이, 한없이 높
이 올라간 우주적 위상에서 성립하고 있으나, 그 구체적인 감각은 이곳의 낮
은 삶의 터전 밑으로 일견 복속되듯 하면서 동시에 온전히 그렇지는 않은 것이
다. 고로, 이 집들은 마치 우주론적-지리학적 배치처럼 버티고 서 있으며,
그럼으로써 이중의, 복선(複線)의 이야기를 담고 있다는 예감과 함께 묘한 역
설이 감돌기 시작한다.

　　가령, <건축적 조각/다리 없는 집/캄퐁 플럭의 수상가옥> 시리즈는 캄보
디아 지방에서 물 위에 지어진 목구조 가옥을 참조하여 만들어진 것이다. 그
지역의 수상가옥들이 얼핏 보기에는 호소 지역의 아름다운 일몰 빛과 어우러
진 시각적 즐거움이 있지만, 그것은 관광(觀光)이라는 시선에 포획되어 있는
현실이다. 실상은 12세기 때 이미 크메르(현 캄보디아) 제국에 패배당한 채
수세기 동안을 '예외상태'에 처한 난민으로 살아가는 이들의 힘든 삶의 거처
이다. 관광이라는 그러한 시선으로는 그 고통스러운 역사의 내력과 이후 국
가폭력의 연대기를 꿰뚫어볼 수 없다. 그러면서도 물과 습지라는 조건에서
최대한 민중적 건축, 건축가 없는 건축의 지혜로서 지어졌다는 것은 이 건축
물 옆과 안쪽에서 거주함으로써 천천히, 자연히 알게 된다. 아시아 남방의 문
화는 열대우림의 기후와 풍토로부터 삶의 쾌적성을 좇아 이런 자연지(自然
智)를 활용하되, 건축은 그러한 자연지가 담긴 모나드[單子, 창 없는 밀도 공
간]처럼 온축해 있기 마련이다.

#1. "[the] article 'Kabbala' in the Encyclopedia Judaica (1932), tikkun:
redemption as the return of all things to their primal state."

-Michael Löwy, Fire Alarm: Reading Walter Benjamin's 'On the Concept of History'

#2. "To deal with pain is always to develop energy. And it is to find a
form to deal with the memory of suffering."

-Sarkis Zabunyan (artist)

Cosmological Architecture and Architecture of Life

Chen Dai Goang's artwork Dreams of the Perfect City is composed of
and arranged with a number of wooden structures in the outdoor space
of MMCA Cheongju. The work's title in Korean reads Jib-wu Jib-ju. It
implies the concept of a house as a 'spatial universe' (宇) and a 'temporal
universe' (宙), which are to be combined as 'Wuju,' a word that contains a
greater meaning than the spacetime continuum in physics. The concept
is based on the concept of heaven and earth in the pre-modern society
of East Asia, which is the concept of space and time of life that describes
"the whole world under the sky." At the same time, it indicates space-
time that has a higher, or perhaps a metaphysical network of meanings
of a house. Then, the beings that live, reside, or stay and play in the
house(s) created by Chen Dai Goang may stay in the dimension of life
and the dimension where they unintentionally gaze at what is beyond
that dimension.

　　For example, if there were stars, what kind of stars would they be
with what conditions? If the stars could exist in the 'universe,' which
in fact would be the well-maintained lawn plaza in front of MMCA
Cheongju, then there would be a possibility that the scene could
observe "stars and lodges spread in place" (辰宿列張). At this time, of
course, the stars are evenly attached to the constant surface of the
celestial surface to form a cluster. What would happen if the houses
dispersed in front of MMCA Cheongju are seen from the perspective of
a vertical viewing [竪看, a holistic view from above in the sense of Li Qi
theory (理氣論)] towards the 'universe'? Wouldn't we then come to see
that they occupy the burning positions of the stars from a topological
point of view, and in terms of energy, wouldn't we come to see that the
traces of the lives of the very people(!) that inhabit/ed this land, their
habits, and other trails are built in the form of houses? Although they
are established in a high position, which is a cosmic phase that has risen
infinitely towards above, but their concrete sense seems to be subor-
dinated to the low ground of living in this place while not completely
degraded into such a place. Therefore, these houses stand as if they are
placed as a cosmological-geographical arrangement, thus generating a
strange paradox with a premonition that foreshadows different stories.

　　For example, the Architectural Sculpture / House without Legs /
Kampong Phluk Floating House series is created with reference to wood-
en stilt houses on water in Cambodia. At first glance, the floating houses
in the region offer a visual pleasure that harmonizes with the beautiful
light of sunset in the wetland. However, it is a kind of reality captivated
by a touristic gaze. In fact, wooden stilt houses are a place of a difficult
life for those living as refugees under the 'state of exception' for centuries
after being defeated by the Khmer Empire (now Cambodia) in the 12th
century. With such a viewpoint of tourism, it is impossible to see through
the details of the painful history and the ensuing chronology of national
violence. Nevertheless, by living next to and inside such buildings, one
gradually and naturally comes to learn that they are built as the people's
architecture at best under the conditions of water and wetland through
the architectural wisdom without architects. The culture of Southern

이러한 거주함의 시간, 좀 더 나아가면 삶과 살아감의 시간 동안 이 건축물을 보게 되는 일종의 횡간[橫看, 곁에서 구체적으로 살면서 저절로 간파되는 이기론(理氣論)적 응시]의 입장에서 수상가옥들은 남루하고 가난하며 어쩌면 비극적인 서사를 가진 사람들의 거처로 서서히 나타나고 관람객들에게 '역사의 양피지'로 의식되기 시작할지 모른다. 톰 울프(Tom Wolfe)는 "설명서가 필요한 것이 현대미술이다. 왜? 어려워서."라고도 했지만, 이 수상가옥의 겉보기 등급으로 쓰인 양피지 표면 아래에 지우다가 남아있는 실제의 현실은 희미하게, 그러나 환하게 드러나게 된다. 이때 작가가 말하듯 관람객의 그 몸으로써 거주하는 사건으로 충분한 것이 아닐까. 물론 작가는 이러한 막연한 기대와 몽상에만 기댈 수 없다는 듯 그러한 나타남의 사건을 촉발하는 매체로서 구사하는 것이 있으니, 다름 아닌 빛의 환술(幻術)이다. 이것은 <집 우집주> 작품 전반 — 모나드 공간으로서의 집, 그 안과 바깥 — 을 관통하는 장치인데, 그러한 빛은 액면가의 진실을 담고 있지 않으며 그 빛을 투과하는 건축의 파국적 현실에 귀를 기울임으로써만 환술을 벗겨낼/구사할 수 있다고 여겨진다. 판타지 상태로 존재하는 것에 결코 만족하지 못하는 리얼리티가 눈이 부신 색의 빛 속으로 섞여 들어가 있지만, 그렇게 숨는 방식은 역설적으로 다시 나타나는 방식이 된다.

예를 들어, 작가에게 삶을 배반하되, 창조적으로 배반하지 못하는 이 빛들은 따라서 필연적으로 공허할 수밖에 없는데(<건축적 조각/공허한 빛의 집/RGBCMYK 유리집>), 바로 그렇기 때문에 겉보기에 보잘것없어 보이던 삶의 거처가 머무르는 시간의 어느 순간 뜻밖에, 우연히, 언뜻 내비치는 억척스러운 의지는 되레 외피적 색채, 색빛의 도안으로 환하게 건축물을 감싸게 된다(<건축적 조각/보잘것없는 집/가파리 240번지>). 이 빛의 성격은 흔히 우리가 건축물에서 기대하는 스펙터클의 속성을 위반하며, 진보주의의 무정형한 경향성으로 귀착되는 모더니티의 규범을 무시하고자 한다.

물론 캄퐁 플럭의 수상가옥이든, 가파도의 장식, 문양, 창문이 일절 없는 닫집 형태의 창고 건물이든 혹은 태국 수랏타니의 집 — 이 집은 불교의 극락세계를 장식하는 칠보 중에서 가장 밝은 청옥(靑玉, blue crystal)을 지붕의 채광창으로 모델화했다 — 이든 거기에는 이미 모더니티의 세계적인 조류가 쓰나미처럼 휩쓸고 지나간 영향 관계에서 자유롭지 못하다. 그럼에도 불구하고 그러한 근대의 계몽적 빛, 모든 곳에 내리쬐는 햇볕 같은 빛에 의한 변화를 환술로 취급하는 철학자 베냐민(Walter Benjamin)처럼 작가는 아주 오래되었으면서도 새로운 비전을 재발명해 내는 것이라고 하겠다. 경제적이고 기술적인 진보의 통속적 이념 속에서 숙명론적 포기나 자기 체념에 그치는 비관이 그 빛의 환술 속에서 필연적으로 배태되어 있는데, 이는 그 명랑한 색채 감각의 지배적인 시간 사이에서 어느 순간적인 균열로, 혹은 균열된 틈 사이의 무엇인가로 본래의 실재를 드러낸다. 그것은 무엇일까. 수간(竪看)이라는 수

Asia utilizes the natural wisdom in pursuit of the comfort of life from the weather and climate of the rainforest, while architecture is accumulated like a monad (a dense space without any window).

From a kind of horizontal viewing [橫看, a gaze in the sense of Li Qi theory where one spontaneously comprehends something by living next to it], the wooden stilt houses on water might gradually emerge as a dwelling for people with tragic narratives and start being recognized as 'a parchment of history.' There is an old saying by Tom Wolfe that contemporary art is something that requires a manual because it is difficult, but the actual reality that remains under the surface of the parchment emerges in a faint yet obvious manner. Then, as the artist says, wouldn't the event of dwelling through the body of the viewer be enough? Of course, the artist exercises a medium to trigger such an event of emergence as if he knew he could not rely upon these vague expectations and dreams, which is none other than the illusion of light. This is a device that penetrates *Dreams of the Perfect City* as an artwork—the house a monadic space and its inside and outside—in its entirety. Such light does not carry the truth at face value, and it is thought that one could only remove/exercise the illusion of light only by closely listening to the catastrophic reality of architecture that is penetrated by the light. While the reality that is never satisfied with remaining in a state of fantasy blends itself into the dazzling color of light, such a way of hiding paradoxically becomes a way to reappear.

For example, these lights, which betray life but not in a creative way, are inevitably empty (*Architectural Sculpture / House of Empty Light / RGBCMYK Glass House*). And that is the reason why the resolute will, which is unexpectedly, accidentally, and suddenly exposed while one stays in a seemingly insignificant dwelling place of life, rather envelopes the buildings with the exterior colors and the designs of colors and light (*Architectural Sculpture / Good-for-Nothing House / 240 Gapa-ri*). The nature of this light often violates the properties of spectacle we expect from architecture, and it tries to ignore the norms of modernity that return to the amorphous tendencies of progressivism.

Of course, whether it was a stilt house in Kampong Phluk, a warehouse in Gapa-do without any decoration, pattern, and window, or a house in Surat Thani, Thailand, which takes blue crystal among the seven treasures that decorate the Buddhist paradise into its shape of a skylight on the roof, there are already the remains of the global tsunami of modernity that none is free from their influences. Nevertheless, like the philosopher Walter Benjamin who treated all the changes by such enlightening light of modernism and the light that resembles sunlight as a technique of illusion, the artist is reinventing a very old yet novel vision. In the secular ideology of economic and technological progress, there is an inevitable embodiment of pessimism that ends up being a fatalistic abandonment or resignation within the technique of illusion through light. And it reveals its actuality as a temporary gap or something be-

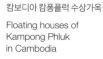

캄보디아 캄퐁플럭 수상가옥

Floating houses of
Kampong Phluk
in Cambodia

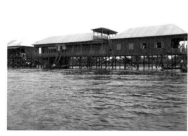
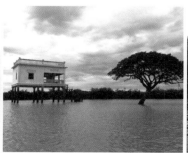
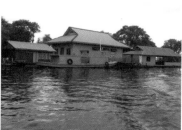

직적 통일성의 세계로만 보이던 이 전시가 그 명랑성의 스펙터클 내지는 가족 단위의 오락 공간이면서도 갑자기 횡간(橫看)이라는 수평적으로 가로지르는 시선을 따라 건축물들에 숨은 그림을 찾듯이 비의적 감각에 사로잡히게 하는 것은?

회억하기와 원시반본(原始反本)

거주함, 혹은 머무름의 시간 — "신체의 감각적 경험을 통해 인식의 전환을 유도하기 위한 예술적 실험"(천대광)의 시간 — 이 어느 정도인지는 모르지만, 자신의 '몸-있음'이 이 아시아 남방의 건축물들과 함께 '한-참' 동행할 때, 범속한 각성의 순간이 가장 순수하게 발현될 여지가 있다. 아이러니하게도 관광(觀光)하고 오락하는 시간이라는 그 범례적이고 통속적인 시간과 겹쳐서 머무르는 동안에. 마치 마술에 걸린 집의 측면과 정면에서 대낮의 밝음이 지나치게 밝아서 순간적으로 안맹(眼盲) 상태의 어둠(暝)이 밀려올 때, 무엇인가가 보이듯이.

건축의 문화적 코드를 읽는 것은 쉬운 일이며, 천대광 작가가 동남아의 낯선 도시 건축물과 가파도의 건축물, 양평터미널 건물 등을 공공미술 차원에서 청주관 앞마당에 번안하고 있다고 보는 것은 지나치게 쉬운 일이다. 그는 이렇게 말하고 있었다. "작품은 바로 기억에서의 어두운 그 지점에 의식을 맞추고 있다. 인간은 성장하면서 자신이 원하지 않는 기억의 편린들을 마치 그것이 실재가 아니었던 것처럼 뇌의 표면에서 지워 버린다고 한다. 작품을 통해 인간의 잠재의식 속에 잠들어 있는 내면의 우울하고 고통스러운 기억들을 깨울 수 있기를 기대한다."(2011년)

골함석 재료의 야금술과 건축술, 다국적 기업의 힘을 암시하는 파스텔톤과 서서히 섞여 있는 동남아 고유의 색채술, 아무도 돌보지 않는 무능(無能)한 건물로서의 '그저 서 있기'의 건축술, 물과 햇볕 그리고 가난을 조율하는 건축술 등등이 엿보이지만, 작가는 그렇게 해서 지어진 건축물의 안과 밖에서 그리고 지속과 순간에서 무엇인가를 체험하는 영역으로 이 집들의 비의적 세계를 가로질러 볼 것을 암시하고 있다. 그리고 그것은, 그 세계는 우리가 현재주의적으로 살고 있는 삶보다 앞선, 작가가 직접 스스로 겪고 다시 건축의 구성과 배치, 그 우주론적-지리학적 배치 속에 밀어 넣어둔 '이전 삶'의 기억들을 우울하고 고통스럽게 환기하기를 기대한다.

tween the cracks within that time that is dominated by the cheerful sense of color. What is it then? What makes this exhibition, which has been seen through the vertical unity of vertical viewing (竪看), to be captivated by the esoteric senses as if it was a spectacle of such cheerfulness or an entertainment space for family units, which suddenly invites the viewers to search for hidden pictures between buildings along with the horizontally traversing gaze of a horizontal viewing (橫看)?

Remembrance (Eingedenken) and Unsibanbon (原始反本)[2]

Although it is not clear how long the time of dwelling or sojourning, which the artist describes as the time of "an artistic experiment to induce a change of perception through the sensory experience of the body," there is a room for the purest manifestation of the general awakening when the artist's body-being is accompanied by the Southern Asian architecture for a prolonged period of time. Ironically enough, it is while it stays overlapped with the general and conventional time of touring and entertainment. It is as if one can see something when the darkness in the state of blindness suddenly surges since the brightness of daylight is overly intense on the front and side of an enchanted house.

It is easy to read the cultural code of architecture, and it is too easy to see that the artist is adapting unfamiliar urban buildings in Southeast Asia, buildings in Gapa-do, and a bus terminal in Yangpyeong, among others in the front yard of MMCA Cheongju in the dimension of public art. The artist once said, "The work sets consciousness on that dark point in memory. It is said that as humans grow up, they erase unwanted fragments of memories from the surface of their brains as if they were not real. It is hoped that my work will awaken the gloomy and painful memories that are dormant in the human subconscious." (2011)

It is possible to have a glimpse that there are the metallurgy of galvanized wave-shaped iron sheets, the technique of architecture, the authentic Asian color technique in a gradual mix with pastel colors that implies the power of multinational corporations, the architecture of 'merely standing' as an incompetent building, and the technique of architecture that coordinates water, sunlight, and poverty. Yet, the artist hints at crossing the esoteric world of these houses from their inside and outside and approaching them as a field to experience something in duration and moment. And, that world anticipates us to call our attention to the memories of the 'previous life,' which has happened before the presentist lives we live and which the artist has experienced by himself and put into the architectural composition and arrangement that is cosmological-geographical, with melancholy and pain.

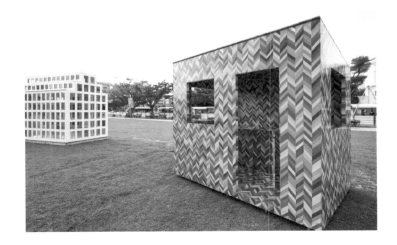

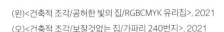
(왼)<건축적 조각/공허한 빛의 집/RGBCMYK 유리집>, 2021
(오)<건축적 조각/보잘것없는 집/가파리 240번지>, 2021

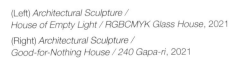
(Left) *Architectural Sculpture /
House of Empty Light / RGBCMYK Glass House*, 2021

(Right) *Architectural Sculpture /
Good-for-Nothing House / 240 Gapa-ri*, 2021

여기에 보들레르(Charles-Pierre Baudelaire)가 말한 "감각과 어스름한 시간"의 '상응'(相應, correspondence)이 거주함 혹은 머무름의 시간 속에서 일어나도록 빛의 환술이 마법을 부리기 시작할 것이다. 현재 시점으로 투사 되는 삶의 체취, 생활의 습관, 흔적들이 건축물에는 구체적으로 깃들어 있지 않음에도. 하지만 작가는 이 건축의 '우주론'적 투사를 기획하고 다시 가까운 미래로 전이되어 등장하는 유토피아의 시간, 모던과 국가장치에 의해 막혀버 린 과거에 '상응'하는 시간을 보냄으로써 한 톨의 기억도 잃어버리지 않고 '회 억'(回憶, Eingedenken) — 현재화함으로써 윤리적이며 실천적인 태도를 취 하며 "우리는 이제 무엇을 해야 하는가"라는 질문을 던지는 행위 —을 감행하 게 한다. 이렇게 정중한 제안을 품고 있으면서도 공공미술의 손쉽고 통속적 인 웰빙의 외양을 띤 공간으로 얼핏 착시되는 것이 이 작품들의 재미이자 미 스터리인데, 이는 엄밀하게 완전히 끝난 듯이 보이는 과거 희생자들, 배제된 자들 그리고 '예외 상태'에 처해 있는 이들의 고통을 다시 '종결되지 않은 상 태'로 바꿀 수 있다. 회억되는 것은 직접 모습을 드러내지 않은 그 실재의 과 거지만, 사실 따지고 보면 이곳 여기, 혹은 한반도의 현실도 아니다. 그럼에도 불구하고 이 건축물에 깃든 희미하면서도 약한 느낌 안에서 아주 작은 회억 의 가능성을 거주함 혹은 머무름, 나아가 오락으로서 뛰어놀기, 아무것도 모 르고 즐기기 같은 행위 속에서 포착하는 것으로 이 집들의 '우주성'은 결집되 어 있다고 하겠다.

그 집들의 화엄적(華嚴的) 형식 — 집 속에 수많은 집들이 빼곡하게 깃든 우주 같은 형식 — 속에 보존되어 있거나 잔존해 있는 것들에는 짐짓 엄숙하 게 가닿는 선택으로 그 계기들이 열리지 않으며, 오히려 무지와 대낮의 일상 으로 찾아온 건축 공간에서 무심히 뛰어놀기, 즐기기로부터 갑자기 그 장소 와 불합치하는 요소, 한순간, 낯선 직관이 출현하기로 예정되어 있는 셈이다. 투박하고 물질적인 건축은 이미 우위에 서서 사람들이 자기도 모르게 회억하 는 균열의 순간을 맞이하기를 기다린다.

#3. "이제 개벽 시대를 당하여 원시로 반본 하느니라."

- 사상가 강증산

There, the technique of illusion would yield its magic to make the 'correspondence' of what Baudelaire mentioned as "senses and twilight hours" occur within the time of dwelling or sojourning. It will happen although the traces of life, everyday habits, and trails as such are not concretely embedded in the buildings. However, the artist plans a 'cosmological' projection of this architecture and spends time of a utopia that is transferred back to the near future and of 'correspondence' to the past that has been blocked by the state apparatus. By doing so, he does not lose a single fragment of memory and endeavors to take on remembrance (Eingedenken), which is an act of taking an ethical and practical attitude by presentizing something and thus asking the question, "What shall we do now?" The fun and mystery of these works are that they are mistaken as a space with the easy and banal appearance of well-being seen in public art, although they carry such respectful proposals. This can change the sufferings of the victims of the past, those that are excluded, and those in the 'state of exception' whose pain had been ended in obvious terms, into the 'unfinished state' once again. The subject of remembrance is the actuality of the past that has not revealed itself. In fact, however, it is also not the reality of here or of the Korean peninsula. Nevertheless, the 'cosmicity' of these houses is concentrated in the dwelling or sojourning within the slightest possibility of remembrance in the faint and weak feeling that is embedded in the buildings, and further accumulated by capturing it within actions such as playing as entertainment or enjoying without any knowledge about the houses.

What is kept or remained in the Huayan (華嚴, the Flower Garland) aspect in the format of the houses—a format that resembles a universe where countless houses are densely embedded within houses—does not open up such opportunities as purposely solemn choices. Rather, sudden incoherent elements, moments, and unfamiliar intuitions are expected to emerge from the actions such as casually playing and enjoying in the architectural space that came into one's everyday life without any knowledge and as part of one's ordinary day. The coarse and material buildings are already standing above us, waiting for the moment of rift that people are unknowingly take on remembrance.

#3. "Now that we are at the time of Gaebyeok, we exercise Unsibanbon (原始反本)."

-Kang Jeungsan (thinker)

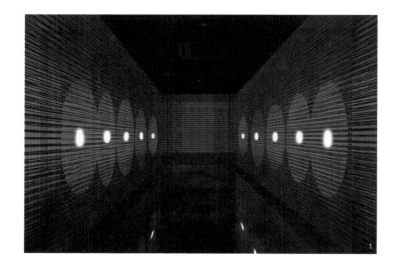

벤야민의 '회억'이란 이 낯선 용어를 천대광 작가는 똑같은 비의의 권능을 담은 '원시반본'(原始反本)으로 바꿔서 사용한다. 이는 19세기 수운 최제우(1824-1864)의 동학(東學)에서 배태되어 20세기 신사상가에 의해 설파된 중요 개념이다. 그런데 이는 서구의 근대적 시간관 자체가 소멸될 무렵, '근대에 대한 근대적 비판'(미카엘 뢰비)으로 베냐민이 던진 유대적 시간의 신비로서 '만물이 본래 상태로 되돌아가는 식의 구원'을 의미하는 '티쿤'(tikkun) 개념과 완전히 일치한다. 그리고 진화론적 실증주의로 치달리면서 진보라는 개념이 주류 지배자의 승리와 포개지는 역사의 위선적 흐름이 항상 뻔한 반복 속에서 멸망하고 있는 것과 달리 이 '티쿤'/'원시반본'은 만사의 화해와 더불어 과거로의 회귀가 다시 미래의 시제 속에서 진정으로 새로워진다는 의미의 구원이다. 그리고 복구되고, 구제되며, 상처가 회복된 상생의 존재들이 별처럼 다시 빛나기 시작한다. 물론 이것은 <집우집주> 작품의 유토피아적 씨앗들을 발견하고, 실천적으로 깨닫기 시작하는 이들의 몫이다.

이러한 '원시반본'의 사건을 천대광 작가의 장광설 속에서는 상당히 중요한 근본 개념으로 지목할 수 있으며, 그가 신종교적 편견의 울타리 너머에서 살펴보는 것은 문화적 기득권자들, 계층들에 의해 독점되고 세탁되며 박제시키면서 왜곡 굴절시키는 것들을 은밀하게 전복하는 계획이다. 그래서 그는 고독하며 이 지금 시대에 이해받지 못할 위험을 감수하는 작가일 수밖에 없다. 그러한 위험성을 체현하고 있는 것은 <건축적 조각/후천개벽(後天開闢) 탑>이다.

'후천개벽'(後天開闢), 즉 뒷하늘 열리는 결정적 전환이란 역시 우리의 신종교적 편견이란 벽을 허물기 위해 우회한다면, 비판이론가 막스 호르크하이머(Max Horkheimer)가 말하는 "(살해당한 자들의) 역사의 미종결을 진지하게 받아들인다면 우리는 '최후의 심판'을 믿어야 합니다."라는 어조와 거의 동일하다. 고통받는 삶의 모든 씨, 기억, 삶의 한 톨까지도 빠뜨리지 않고 회억하는 사태는 분명히 신학적인 태도이면서도 그 '회억' 자체로 만족하는 것이 아니라 보다 결정적인 사태, 즉 '최후의 심판'이라는 모든 시간(들)의 위도가 극점에서 완전히 압축되는 동시에 소멸하는 한 시점의 파국적 사태를 예비하고 있다. 물론 동아시아에서는, 특히 한국에서 거의 유일하게 '후천개벽'이 그 파국적 사태의 문턱(limen, 임계 영역)이란 점에서 '최후의 심판'과 흡사한 모든 시간(들)의 결절점을 움켜잡고 있기도 하지만, 동시에 '최후의

With regards to Benjamin's unfamiliar term 'Eingedenken' (remembrance), Chen Dai Goang uses it by changing it to 'Unsibanbon' (原始反本, returning to the origin), a term that carries the same esoteric authority. Unsibanbon is an important concept conceived by Suwoon, the founder of Donghak (東學) movement in the nineteenth century, which was also propagated by thinkers of the new thought movement in Korea in the twentieth century. However, this is completely consistent with the concept of 'tikkun' as 'redemption as the return of all things to their primal state' in the sense of Jewish mysticism presented by Benjamin as a "modernist critique of modernism" (Michael Löwy) at the time when the modernist perspective of time itself was at the brink of extinction. Unlike the concept of progress that drives itself to evolutionary positivism under the hypocritical flow of history that overlaps with the triumph of those that rule as the majority, which always perishes in the obvious repetition, the 'tikkun/Unsibanbon' is salvation in the sense that the return to the past is truly renewed in the future tense along with the reconciliation with everything. Then shine the beings of coexistence that are restored, saved, and healed from their wounds once again like stars. Of course, this is the responsibility of those that discover the utopian seeds of the artwork *Dreams of the Perfect City* and begin to realize them in practice.

The incident of this 'return to the origin' can even be pointed out as a very important fundamental concept in Chen Dai Goang's lengthy explanations of his work. What he observes beyond the boundaries of prejudices towards new religions is a plan to clandestinely subvert things that are monopolized and laundered by the cultural establishments and classes, fixating, distorting, and refracting their subjects. Therefore, Chen Dai Goang has no choice but to be an artist in loneliness, taking the risk of not being understood in the present era. *Architectural Sculpture / Hucheongaebyeok (後天開闢) Pagoda* is a work that embodies such a danger.

Hucheongaebyeok (後天開闢, The Later Heaven Gaebyeok) which is a critical transition that opens the back of the heaven, if one is to bypass the barrier of prejudices of new religion, has the same tone of speech with what the critical theorist Horkheimer said, "If one takes the lack of closure [of the murdered] entirely seriously, one must believe in the Last Judgment." The incident of remembrance (Eingedenken) where one remembers every seed, memory, and grain of life in pain obviously exercises a theological attitude. However, it does not merely

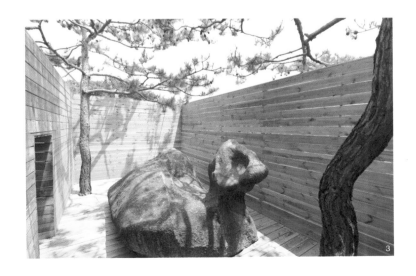

1 《어두운 기억들》전시 전경, 2011, 경기창작센터, 안산

2 《isopink Nr.1》전시 전경, 2014, 스페이스 K, 과천

3 2020 야외설치미술 프로젝트 《공간실험展》전시 전경, 2020, 양평군립미술관, 양평

1 Exhibition view of *Dark Memories*, 2011, Gyeonggi Creation Center, Ansan, Korea

2 Exhibition view of *isopink Nr.1*, 2014, Space K, Gwacheon, Korea

3 Exhibition view of *Outdoor Installation Art Project 1: Space Experiment*, 2020, Yangpyeong Art Museum, Yangpyeong, Korea

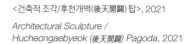
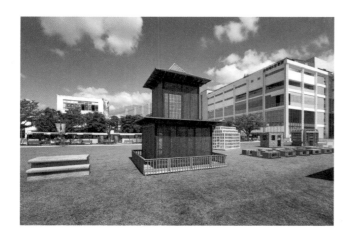

심판'이라는 종말 의식과 달리 종시(終始), 즉 '끝인가 하니 다시 시작'이라는 새로운 세계의 선천(先天)이란 뜻이 의미심장하게 깃들어 있는 셈이다.

아닌 게 아니라 <건축적 조각/후천개벽(後天開闢) 탑>은 삶의 우울한 측면을 예민하게 의식하는 자들이 어떻게 그 비굴해 보이는 삶의 외양 속에서 영웅적인 측면을 드러내는가 하는 전환으로서의 개벽, 모든 과거가 태초의 시점으로 돌아가 다시 미래화 되는가 하는 유토피아의 현실화로서의 개벽이 강하게 추동하는 작품이다. 아래층과 위층, 두개 층으로 이루어진 이 탑 양식은 남방불교의 건축 양식과 서구의 건축 양식이 기묘하게 습합(褶合, syncretism)되어 있는데, 이번에는 빛의 붓다가 가진 무량광명의 환술, 혹은 청색 톤과 보라 톤의 변성의식 상태(altered states)에 가까운 빛의 장치를 통해 뒷하늘을 여는 천지와 우주의 상서로운 공사가 어떻게 일어날지를 예감케 한다. 동시에 그러한 예감은 즐거운 유머이기도 하여 탑은 복선화된다. 또한 이 탑은 19세기부터 20세기 전근대의 억압당한 자들, 살해당한 자들이 신비한 방식으로 회억되면서 그들의 존재 의미를 환기시키는 매개지만, 그런 내색 하나 없이 은미(隱微)하면서 화려할 따름이다. 기념비적이지 않으면서. 즉 너무 직접적으로 모습을 드러내지 않고, 곧잘 그 권능을 눈 밝은 이의 각성에 근거하여 실천적으로 바꾼다는 것이다.

이 작품은 다시 <건축적 조각/수랏타니의 집>에서 그 불교의 극락세계에서 칠보들의 빛을 강화하는 청옥의 분광하는 지붕과 풍토적으로 대응한 창문 그리고 상위의 공간을 활용하는 건축 양식과 연결되어 있다. 즉 천대광 작가의 이 건축적인 방식의 '원시반본'은 삼교회통, 아니 기독교까지 포함하여 사교회통(四敎回通) — 이 회통을 이룬 이는 탄허 선사(1913-1983)이다 — 중에서도 불교적 빛의 미디어가 수승(殊勝)하다고 하겠다. 달리 말하면, 루돌프 슈타이너(Rudolf Steiner)의 좌파로서 청색 계통 — 보라색 계통으로 이어지는 색채의 비의한 힘을 감안하고 있다고 하겠다.

find satisfaction in the remembrance itself. Rather, it anticipates a catastrophic event of the 'Last Judgment' in which the latitude of all time(s) is completely compressed at its extreme and becomes extinct at the same time. Certainly in East Asia, especially in Korea, the 'Later Heaven Gaebyeok' is the only threshold (or limen) of a catastrophic event. In this sense, it holds the nodal points of all time(s) similar to the 'Last Judgment.' At the same time, it is the beginning and end (終始) that is different from the eschatological ritual of the 'Last Judgment', which is tied with the significant meaning of Seoncheon (先天, The First Heaven Gaebyeok) of a new world as in 'the beginning starts at where it ends.'

Really, *Architectural Sculpture / Hucheongaebyeok (後天開闢) Pagoda* is a work that is strongly driven by the notion of Gaebyeok as a transition in how those that keenly realize the melancholic aspects of life reveal the heroic side in the seemingly servile appearance of life and as a realization of a utopia where all the past return to the point of origin. The format of a two-story pagoda shows a strange syncretism of the Southern Buddhist architecture and Western architecture, which makes one anticipate how the technique of infinite light (無量光明) possessed by the Amitābha Buddha or the device of light that is close to the altered states in blue and purple tones to open up the back of the heaven and the universe would lead to an auspicious occasion. At the same time, such a premonition is presented as cheerful humor, becoming a foreshadowing of different stories. In addition, the pagoda is a medium through which the oppressed and murdered in the nineteenth and twentieth centuries before the advent of modernity are recalled in a mysterious way with their meaning of existence. However, it maintains subtlety and splendor without expressing any of them. And it keeps itself as not monumental. In other words, it does not reveal itself too directly, and it immediately changes the authority into practice based on the awakening of those with keen eyes.

The work is also connected with *Architectural Sculpture / Surat Thani House* in relation to the spectrum of light through the roof made of blue crystal, one of the seven treasures of the Buddhist heaven that strengthens the light of other treasures, and the windows that correspond to the weather, and the architectural style that connect spaces that exist above the work. In a word, the 'Unsibanbon' of the architectural style implemented by the artist shows the superior dominance of Buddhist media of light in the sense of the reconciliation of four religions (四敎會通) including Christianity—which is realized by the Monk

항상 이미 무르익은 '우주' 세계

천대광 작가는 이러한 '회억'과 '티쿤'/'원시반본' 그리고 '최후의 심판'/'후천개벽' 같은 개념들을 이번 전시에서만 구사해온 것이 아니었다. 그는 앞에서도 말한 바와 같이 19세기와 20세기 조선 구체제의 몰락 직전 회광반조(廻光返照) 하듯이, 그러나 너무나 섬광처럼 눈부시게 빛을 발한 새로운 사상이 식민지 시기까지 여행하면서 어느덧 신종교의 형식으로 탈바꿈한 과정의 몫까지 받아들여 자신의 예술적 사유의 언어로 옮기는 것에 일정한 부담을 느꼈던 것으로 보인다. 하지만 그의 조형적인 언어는 그러한 신종교에 대한 편견과 상관없이 수승하며, 그의 사유의 언어는 그러한 조형적인 건축술에서 모음 없는 언어처럼 입 안과 머릿속에서 미발(未發)의 내폭발을 일으키듯 굉장한 폭발력을 이미 함장하고 있다고 하겠다. 앞서 살펴본 바와 같이.

《어두운 기억》(2011),《아이소핑크 Nr.1》(2014),《공간 실험展》(2020)의 전시에서도 항상 이미 무르익은 '우주'로서의 집, 즉 '집 우 집 주' 같은 시간적 공간적 '우주론적' 집, 혹은 머무르는 장소로서의 회억과 이후의 윤리적 환기가 감도는 건축 공간을 조형하고 배치하여 보여줬다. 가령, 근대의 아이들이 강제수용되고 국가적 폭력으로 이어진 장소에서는 관객들이 심리적 진입장벽이 있는 공간 입구, 죽은 영령들의 호흡처럼 다가오는 싸늘한 내부 온도, 어둠 속에서 본의 아니게 머무르는 시간적 조건들이 보다 하드코어적으로 의도된 건축 공간을 연출하기도 했다. 또한 아이소핑크라는 단열소재의 재료로 만든 집은 수천만 년의 지층구조를 가진 땅의 횡단면을 드러내는 만곡(彎曲) 상태의 공간으로 걸어 들어가는 관람 체험이 촉발되었고, 인공물에 의한 만곡의 비선형적이고 비정형적인 장소 연출 안에서 자연스러운 감각적 혼란이 변성 의식적으로 작동하여 어쩌면 수월하게 '회억'되는 기획이었던 듯싶다.

그런가 하면, 양평의 야외 공간에서는 점이 지대처럼 나무 재료들이 어긋나는 발걸음의 박자에 맞추는 공간, 하나의 내부 공간 안에 도사린 또 다른 작은 내부 공간, 안쪽에서 보는 응시와 바깥쪽에서 보는 응시가 날카롭게 갈등하는 공간 등 언뜻 보기에는 공공미술의 개방적 수월성에 공헌하는 건축술인 듯하면서도 내밀하게 길항하면서 문득 생경해지는 공간을 조형하기도 했다. 사실 이 가장 후자의 공간에서는 가장 안쪽의 영역에 돌무더기 몇 개가 있었는데, 이는 그곳에 기존 설치된 돌무더기 주변을 에워싸는 형식으로 진행된 것이었다. 그런데 이 돌의 표면에는 마치 지렁이 문자, 혹은 고대의 문자처럼 보이는 조형이 있어서 천대광 작가의 어떤 지향과 묘하게 '응상'하는 느낌을 강하게 받았다. 즉 '원시반본'하는 언어, 그러한 비의적 회귀가 일어나는 언어 일반에 대한 관심 말이다.

"어찌 보면 우리의 보편적 이야기이다. 근대사와 현재를 관통하는 역사는 장소와 시간의 차이에 따라 리듬의 차이가 있을지언정 지구 전체를 흐르며 각 나라마다 일련의 엇비슷한 역사를 만들어 낸다."

– 천대광

1
Translator's note: 'Eingedenken', translated as remembrance in English, is a neologism employed by Walter Benjamin in translation of Proust's 'mémoire involontaire'. In the course of the 1930s, the concept became associated with a 'Copernican revolution' in the philosophy of memory in relation to the experience of modernity, positing an obligating to the past as the means of activating the present.

2
Translator's Note: 'Unsibanbon' (原始反本) literally means returning to the origin. It is one of the main teachings of Kang Jeungsan. The first two characters 'Wun' (原) and 'Shi' (始) mean the origin or beginning, and the latter half with 'Ban' (反) and 'Bon' (本) respectively means 'opposite' and 'origin'.

Tanheo (吞虛)—that goes beyond the reconciliation of three religions of Taoism, Confucianism, and Buddhism. In other words, it considers the esoteric power of color that from blue to violet from Rudolf Steiner's leftist perspective.

The World of 'Universe' That Is Always Mature Already

Such concepts of 'recalling,' 'tikkun'/'Unsibanbon,' and the 'Last Judgment'/'Later Heaven Gaebyeok' have not only been implemented by the artist in the current exhibition. As explained earlier in this essay, it seems that the artist had felt a certain pressure in embracing the overall progress of thoughts where the new idea, which shined dazzlingly like a flash of light in the nineteenth century and in the early twentieth century before the fall of the old system of Joseon as if the light returned with reflection (廻光返照), traveled through the colonial period, and transformed itself into the form of a new religion, ultimately turning them into the language of artistic thought. However, his formative language excels regardless of prejudices against such a new religion. His language of thought is already leading to a tremendous power of explosion as if a language with no vowels causes internal combustion to explode within one's mouth and mind. It is as we have seen earlier in this essay.

In the earlier exhibitions *Dark Memories* (2011), *isopink Nr.1* (2014), and *Space Experiment* (2020), the artist consistently presented houses as an already mature 'universe,' which were the 'cosmological' houses in terms of space and time symbolized in the characters Wu (宇) and Ju (宙), and formulated and arranged architectural spaces embedded with the recalling of dwelling and the ensuing ethical awakening. For example, in a place where children were forcibly taken in and exposed to the state violence, the artist strongly intended an entrance to which the visitors would feel a psychological barrier, a chilly temperature inside the space that felt like the breathing of the dead spirits, and the temporal conditions in which people unintentionally had to stay longer inside the space. In Addition, a house made of an insulating material named Iso Pink triggered a viewing experience of walking into a curved space that reveals a cross-section of strata with tens of millions of years. It seems that the project readily 'recalled' the sensual confusion, which was natural in the amorphous staging of space, to function as a metamorphous conscious.

On the other hand, he arranged an outdoor space in Yangpyeong like a transitional zone where wooden materials matched the rhythm of steps that were out of sync, a small interior space within an existing interior space, and a space where gazes from the inside and outside poignantly conflicted with each other, among others. As such, Chen Dai Goang formulated spaces that seemingly contributed to the excellence of open public art while intimately challenging it to build unexpectedly unfamiliar spaces. In fact, the last space had a few piles of stones in the innermost area, which were installed in the form of enclosing the existing piles of stones. However, on the surface of the stones, there were shapes resembling certain meandering characters or ancient letters, giving an impression of strange 'correspondence' with the artist's certain intentions. In other words, it's the artist's interest in the language exercises 'Unsibanbon' and the language in general where such esoteric return occurs.

"In a way, this is our universal story. History penetrates modern history and the present. Although there might be differences in rhythm depending on the difference of time and place, it flows through the entire globe and creates a series of similar histories for each country."

-Chen Dai Goang

집우집주, 집들 사이로 우주의 바람을 불러들이다

The Houses in Wu (宇) and Ju (宙):
Calling in the Cosmic Wind through the Houses

이진경
(서울과학기술대학교 교수)

Yi-Jinkyung
(Professor, Seoul National University of Science and Technology)

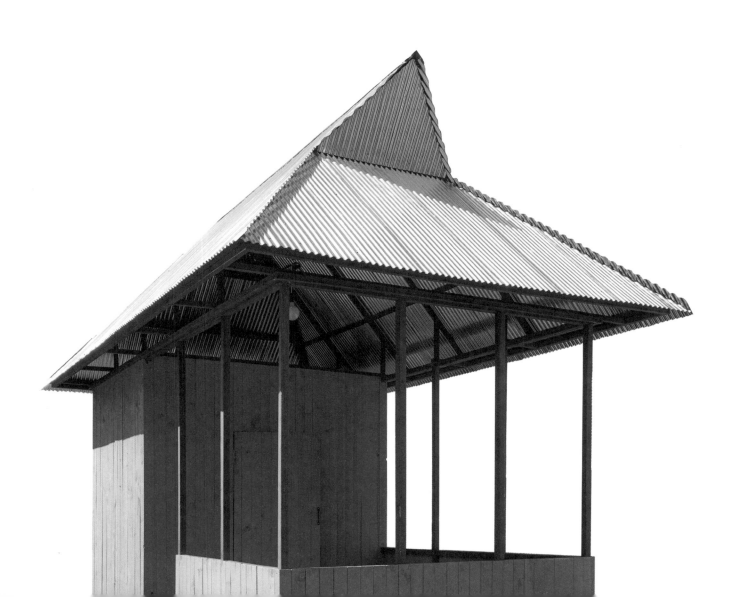

1

세계란 사람과 사물이 즉자적으로 병렬된 집적체가 아니라, 어떤 질서를 구성하는 방식으로 통합되어 정렬된 하나의 전체다. 집은 가장 작은 크기로 축소된 세계다. 집을 짓는 것은 세계를 짓는 것이다. 전통적 양식의 집을 짓는 것은 전통이라 불리는 과거에 속한 세계를 만드는 것이고, 새로운 양식의 집을 짓는 새로운 종류의 세계를 만드는 것이다. 부재하는 집을 짓는 것은, 따라서 부재하는 세계를 짓는 것이다. 이전에 그것이 없던 삶 속으로 그것을 불러내는 것이다. 천대광이 부재하는 집을 짓는 것은, 이를 위해 지어지지 않을 집을 짓는 것은, 이 때문일 것이다.

물론 그는 부재하는 집을 짓기 위해 오래된 집들을 끌어들인다. 세계 각지를 돌며 눈여겨보았던 집들을, 그 집을 둘러싸고 있는 기억을 끌어들인다. 그렇게 하나의 집에 깃들어 있던 삶을 불러낸다. 영매가 신을 불러내듯이. 그러나 영매가 오래된 신을 불러낼 때조차 그는 단지 그것이 과거에 있었음을 상기시키기 위함이 아니며, 지워진 기억을 복구하고자 함이 아니다. 현재의 삶 속에서 발생한 어떤 병통을 치유하기 위하여, 그 병통을 야기한 원인을 찾고 제거하기 위하여, 아니 꼬인 매듭을 풀어 멀리 떠나보내기 위하여 그리한다.

과거의 기억이 역력한 집들을 불러내는 것 역시 그럴 것이다. 그것은 어느 하나 있는 그대로 불려 나오지 않는다. 변형되고 다른 것과 섞이고 다른 재료에 다른 색으로 칠해져 다른 집으로 불려 나온다. 이제까지 없던 집으로, 부재하는 집으로 불려 나온다. 이제까지 없었음을 강조하기 위해 작가는 비현실적 색깔과 형상을 부여한다. 그처럼 부재하는 집을 지으며 그는 부재하는 세계를 세우고자 함일 게다. 과거를 통해 미래를, 아니 도래할 시간을 불러내려는 것일 게다.

2

집이라는 건축물에 누구보다 심오한 철학적 의미를 부여한 것은 하이데거(Martin Heidegger)였다. 집이란 단지 사람이나 동물이 추우나 더위, 비나 바람, 혹은 적의 공격으로부터 자신의 생명을 방어하기 위해 만드는 기능적 구조물이 아니라, '존재'(Sein)가 거(居)하는 장소이고 존재의 빛이 드는 장소다. 또한 그런 존재의 의미를 묻고 그럼으로써 존재론적 삶을 사는 '현존재'(Dasein)의 거처(居處)가 집이다. 그런 점에서 그는 집을 '주거-기계'(르 코르뷔지에)라고 보았던 현대 건축의 기능적 사고방식에 대해 강한 거부감을 표명한다.[1]

그렇기에 그는 거주함을 단지 가옥을 소유한다고 보는 통념을 비판하며, 본래적 의미의 거주, 탁월한 거주에 대해 말한다. 그것은 "인간은 시적으로 거주한다"는 횔덜린(Friedrich Hölderlin)의 말로 요약된다. 물론 이는 시를 지으며 살라는 문학적 요구가 아니다. 그는 역으로 시를 짓지만, 시적으로 거주하지 못하는 것이 지금 시인들의 삶이라고 할 것이다. 시적으로 거주함이란, '거주함'이라는 사건이 일어남이다. 존재자의 삶을 떠받치고 잉태하며 견디어내는 자로서의 땅과 별들이 떠돌고 낮과 밤, 사계절이 바뀌며 존재자들을 감싸는 하늘을 가늠하며 보살피고, 그사이에 존재하는 신적인 것들, 그들의 눈짓을 알아채는 '죽을 자'로서의 인간이 하나로 합일된 삶, 그것이 거주하는 사건이다.[2] 그런 방식으로 시원적인 삶의 성스런 터전을 '짓는' 그런 거주다. 농사를 짓고, 집을 짓고, 밥을 짓고, 이름을 짓고, 짝을 짓고, 글을 짓듯이, 집을 짓는 것이다.[3] 이런 이유에서 그는 '건축하다'(bauen)란 동사의 본래적 의미는 거주함이라고까지 말한다.[4] 건축함이란 돌봄과 건립함이다.

1

A world is not an aggregate of people and things that are immediately juxtaposed but a whole that is integrated and arranged in a way that constitutes a certain order. A house is a world that is reduced to its smallest scale. To build a house is to build a world. To build a house in a traditional style is to create a world that belongs to the past called tradition, and to build a house in a new style is to build a new kind of world. To build an absent house is, therefore, to build an absent world. It is to call it into a life in which it did not exist before. It might be because of this reason that Chen Dai Goang builds houses that are absent and houses that are not to be built.

He of course brings in old houses to build the ones that are absent. He brings in the houses he took note of while traveling around the world and his memories about them. In such a way, a life inherited in a house is called forth. It is done as if a spirit medium summons a spirit. However, even when the medium summons the aged spirit, it is not just to remind that it existed in the past, nor is it to restore erased memories. It is to heal a certain ailment that occurred in the present life, find and eliminate the cause that led to the ailment, or untie and send off a twisted knot.

It would also be the same for recalling the houses with obvious traces of past memories. None of them come out as they are. They are transformed, mixed with others, and painted in different colors on different materials, being called forth as different houses. They are summoned as houses that have never existed before and houses that are absent. The artist gives unrealistic colors and shapes to them in order to emphasize that they have never existed before. As such, he might be trying to build an absent world by building absent houses. He might be trying to summon the future or the time to come through the past.

2

Heidegger gave the most profound philosophical meaning to a house as architecture than anyone else. A house is not just a functional structure that people or animals build to protect their lives from cold or heat, rain or wind, or enemy attacks. It is where 'Sein' (being) resides and the light of existence shines through. It is also a dwelling place of 'Dasein' (being there) that inquires about the meaning of such existence and thereby lives an ontological life. In this regard, Chen expresses a strong objection to the functional mindset of modern architecture, which considered the house as a 'dwelling-machine' (as in Le Corbusier).[1]

Therefore, he criticizes the notion that dwelling merely means owning a house and speaks of dwelling in its original meaning and dwelling in excellence. It is summed up in Hölderlin's words: "Man dwells poetically." Of course, this is not a literary demand to live by writing poetry. In opposite, he would say that the life of poets now is that they cannot live poetically although they write poetry. Dwelling poetically means the occurrence of an event of 'dwelling.' The event of 'dwelling' is a life in which the earth and stars as those that support, conceive, and endure the lives of beings drift, night and day and the four seasons change to measure and care for the sky that surrounds beings, and humans have become one as 'mortal beings' that notice the godly beings in between and their gaze.[2] It is a sense of dwelling that 'builds' a sacred ground for primordial life. It is to build houses as one would farm, cook meals, make names, mate with others, and write texts.[3] For this reason, Heidegger even says that the original meaning of the German verb 'bauen' (to build) is to dwell.[4] To build is to care and construct.

따라서 하이데거에게 집이란 '세계'(Welt)다. 아니, 차라리 세계란 하나의 집이라고 해야 할 것이다. 왜냐하면 그에게 집이 단지 숙소를 뜻하지 않듯이, 세계란 지금이라면 지구 전체로 확대된 삶의 공간을 뜻하지 않기 때문이다. 세계란 심려(Sorge)와 배려(Besorge)의 시선으로 인간이 돌보아야 할 거주의 장소, 아니 그 이전에 개개의 인간을 돌보고 그로 하여금 존재할 수 있게 떠받쳐 주는 것들 전체이다. 세계란 지금은 미디어의 눈을 통해 마음이 가닿는 영역 전체가 아니라, 나를 존재하게 해주는 고향이고 집이다. 고립된 '나'를 통해 사유했던 데카르트(René Descartes) 생각과 달리 인간이란 항상-이미 그러한 세계 속에서 사는 존재란 점에서 세계-내-존재다.5 반면 돌이나 통상의 사물들에겐 세계가 없다. 동물들은 빈곤한 세계만을 갖는다. 인간만이 세계를 온전히 갖고 있다.6 그래서 그는 인간만이 탁월하게 존재하는 존재자라고 말한다.

우리는 그처럼 세계 '안에-있다'(In-Sein). 하지만 '안에-있다' 함은 공간적인 관계를 뜻하지 않는다. 내 몸 안에 있는 것에 대해 내가 친숙하고 편안함을 느끼듯 우리는 세계 안에 있는 것이다. '친숙하다', '돌봐주다', '사랑하다'를 함축하는 의미에서 그 안에 '거주하고' 있는 것이다.7 이렇게 우리는 세계로부터 집으로, 존재가 거하는 곳으로서의 '집'으로 돌아온다. 물론 앞서 말했던 것이 스스로 '전회'라 명명했던 것 이후, 즉 후기 하이데거에 속한다면, 방금 말했던 것은 초기 하이데거에 속한 것이란 점에서 역전되었음을 지적할 수도 있을 것이다. 중요한 것은 전기나 후기나 이처럼 집은 세계이고, 세계란 곧 집이란 점이다. 우리는 그처럼 집을 짓고 세계를 지으며, 또한 집에 의해 지어지고 세계에 의해 지어지는 존재자다.

3

하이데거는 하늘과 땅, 신적인 것들과 죽을 자인 인간을 사방(四方)이라 하면서, 그 사방이 합일된 지점에서, 세계로서의 집을 위치 짓는다. 그런 눈으로 보면, 세상 대부분의 집들은 집이 아니다. 하늘과 땅을 돌보고 신들의 눈짓을 보면서 사방이 합일된 삶을 지키는 파수자의 삶은 그가 좋아하던 숲과 시골에 가도 보기 힘들다. 그가 말하는 존재론적 거주는 존재의 거처는 될지 모르지만, 사람들의 거처가 되긴 힘들다.

천대광은 하이데거의 하늘과 땅 대신 『천부경(天符經)』이나 '카발라'(Kabbalah)를 끌어들이고, 하이데거의 신적인 것들 대신 식민지와 근대화의 별 볼 일 없고 누추한 기억들을 불러들여 집을 만든다. 그의 집은 '사방'을 모아들이는 중후함과 반대로 가볍고, 정신없는 색들로 휘황하고, 인스턴트 음식 상표처럼 부실해 보인다. 존재의 탁월한 거주를 위해 배경이 되고 마는 '아무것도 아닌 것들'의 삶이야말로 집이 있어야 할 자리라고 말하려는 것일까? 집이란 무겁고 진지한 존재의 거처가 아니라, 이렇게 잡다한 것들이 모여들며 만들어지는 삶의 장소라고 말하려는 것일까? 그 또한 집을 지으며 세계를 짓지만, 그 세계란 합일된 전체가 아니라 각자가 속해 있던 곳에서 떼어낸 재료들로 지어지는 이질적이고 '잡스러운' 것이라고 말하려는 것 같다. 어떻게 말하든, 천대광의 시도는 모든 것을 존재론, 즉 철학의 관점에서 보려 했던 하이데거보다는 "나는 학문을 예술의 광학으로 보고, 예술을 삶의 광학으로 본다"고 한 니체(Friedrich Wilhelm Nietzsche)에 가까운 듯 보인다.8

Thus, for Heidegger, a house is a 'Welt' (world). No, it would rather be proper to say that the world is a house because the world now does not mean an extended living space throughout the world as a whole, just as a house does not mean an accommodation to him. The world is a place of dwelling for humans to care through the eyes of 'Sorge' (care) and 'Besorge' (concern), or it is the whole that that cares for individual humans and supports them to exist. The world is now not the entire territory that can be reached through the eyes of the media. It is a home and a house that makes oneself exist. Contrary to Descartes' thinking through the isolated 'self,' human beings are beings-in-the-world in that they already live in such a world.5 On the other hand, stones or such ordinary things do not have a world. Animals only have an impoverished world. Humans are the only ones that have the world as a whole.6 Thus, Heidegger says that humans are the only beings that exist with excellence.

We are 'In-Sein' (being in) the world in such a way. However, 'being in' does not imply a spatial relationship. We exist in the world as we feel familiar and comfortable with what is in our bodies. We 'dwell' in the world in the meaning of 'feeling familiar,' 'caring for,' and 'loving.'7 As such, we return from the world to a house, which is a 'house' as a dwelling place for beings. Certainly, what has been described earlier belongs to the later philosophy of Heidegger after what he himself mentioned as his 'turning.' And it might be possible to point out that what has just been mentioned is reversed in that it belongs to Heidegger's early philosophy. What is important is that the house is the world and vice versa in both the early and later philosophy of Heidegger. In such a way, we are beings that build houses, build the world, and are also built by houses and the world.

3

Heidegger described heaven and earth, godly beings, and mortal humans as the four corners of a quadrant, placing the house as the world on the point where the four corners are united as one. Seen from that perspective, most houses in the world are not houses. The life of a watchman who keeps the life of the four corners in union, taking care of the heaven and the earth and watching the eyes of the gods, is one that is even difficult to see in the countryside along the forest that Heidegger liked. The ontological dwelling that Heidegger refers to can be a dwelling place of beings. However, it is difficult to become a dwelling place for humans.

Chen Dai Goang builds houses, bringing in *Cheon Bu Gyeong* (The Scripture of Heavenly Code) or 'Kabbalah' in place of Heidegger's notion of heaven and earth; humble and shabby memories of the colonization and modernization in place of Heidegger's godly beings. His houses radiate light and dazzling colors, as opposed to the sophistication that gathers the 'four corners,' and they look weak and feeble like instant foods. Is he trying to say that the life of 'those that are nothing,' which serve as the background of the excellent dwelling of beings, is the very place where a house should exist? Or is he trying to say that a house is not a dwelling place of a weighted and serious being but a place of life that is built by the gathering of such miscellaneous things? It seems that he is also trying to say that he builds a world by building a house, but the world is not a united whole but a heterogeneous and 'miscellaneous' thing that is built with materials removed from where they belonged. Either way, Chen Dai Goang's attempts seem closer to the thoughts of Nietzsche, who said he saw "science through the optics of art, and art as the optics of life,"8 than Heidegger, who tried to see everything from the viewpoint of ontology, that is, philosophy.

<하늘거리는 풍경>, 2021,
비닐, 철, 1200×1200×200cm,
《공공미술프로젝트: 월암별곡》,
왕송호수변, 의왕

A Fluttering Structure,
2021, Korean-style agricultural
vinyl house materials, steel,
1200×1200×200cm
*Public Art Project: Woram
Rhapsody*, Wangsong Riverside,
Uiwang, Korea

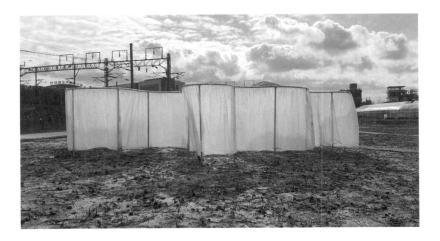

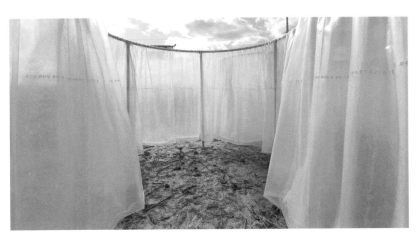

4

'제행무상'(諸行無常), 오직 무상한 변화만이 존재한다는 말을 믿든 말든, 우리는 무상한 변화 속에서 산다. 모든 것을 떠받치는 저 단단해 보이는 땅 아래에는 식물들의 뿌리를 연결하는 거대한 균사의 네트워크가 있고, 그것들을 통해 전달되는 화학물질들의 끝없는 변화가 있다. 텅 빈 듯 보이는 대기, 혹은 저 넓은 하늘에는 박테리아와 바이러스를 비롯한 수많은 미생물들이 우리로선 지각할 수도 없는 무상한 변화 속에서 생멸하고 있다. 우리의 신체 속 또한 그러하다. 세포들의 탄생과 죽음은 끝없이 이어지고, 그것들이 생존하기 위한 화학적 통신이 잠시도 쉬지 않고 이어진다. '중중무진'(重重無盡), 무한한 속도로 변하는 카오스가 거기에 있다. 과학이 아무리 빠르게 쫓아가도 그 무상한 변화를 따라잡을 순 없다. 우리는 두 개의 카오스 속에서 산다. 우리의 신체 바깥에 존재하는 거대한 카오스의 우주와 우리의 신체 안에 존재하는 카오스의 신체.

우리는 이 카오스를 견디기 위해 반복되는 것을 찾고, 반복의 규칙을 찾는다. "우리는 카오스로부터 우리를 보호하기 위해 다만 얼마만큼의 질서를 요구하는 것뿐이다."9 반복되는 것들을 통해 내 생존의 영토를 만든다. 집을 짓고, 세계를 만든다. 낯선 것들의 끝없는 흐름을 견디기 위해 익숙한 것들을 골라내고 배열한다. 집이란 낯선 것들로부터 나를 보호하기 위해, 낯선 것이 들이치지 않도록 내 주변에 둘러친 벽이다. 세계란 익숙해진 것들을 연결하여 만들어진 하나의 전체다. 로렌스(D. H. Lawrence) 식으로 말하면, 내 주위에 둘러친 벽과 천장에 그린 우주의 그림이다. 내가 포착한 한순간에 멈춘 우주의 그림이다.

4

In Buddhism, it is said that everything changes (諸行無常). Whether we believe it or not, we live in permanent changes. Beneath the seemingly solid ground that holds everything up, there is a huge network of hyphae that connects the roots of plants. There is a never-ending change of chemicals that are delivered through the hyphae. In the seemingly empty atmosphere or vast sky live and die countless microorganisms such as bacteria and viruses within ephemeral changes that we cannot even perceive. The same is true with what happens in our bodies. The birth and death of cells endlessly continue, and chemical communication for their survival continues without ever pausing for a moment. There lies chaos that changes with infinite speed in an endless chain of interpenetration (重重無盡). No matter how fast science pursues it, it cannot keep up with the fleeting changes. We live in two chaoses, which are the great chaotic universe that exists outside our bodies and the chaotic body that exists within our bodies.

We find repetition and the principle of the repetition to endure this chaos. "We are only asking for some order to protect us from chaos."9 We build the territory of our survival through these repeated things. We build houses, and we make a world. We select and arrange what we are familiar with in order to endure the endless stream of unfamiliar things. A house is a wall around oneself for protection from strangers by preventing them rushing into a place. The world is a whole that is made by connecting things that have become familiar. In D.H. Lawrence's terms, a house is a picture of the universe on the walls and the ceiling that one builds around the self. It is a picture of the universe that is a suspended moment that one has captured.

건축적 조각 및 가구 디자인 아이디어 스케치(2002 ~ 현재)

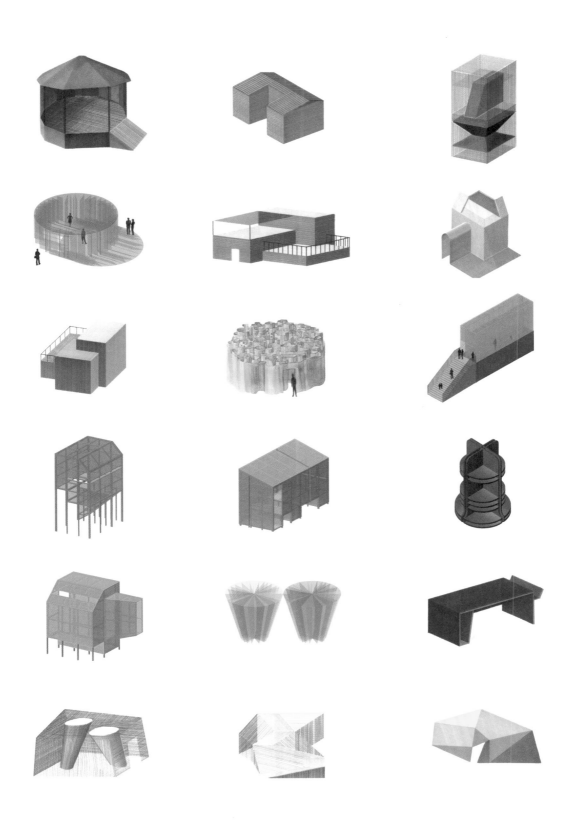

Idea sketches for architectural sculptures and furniture designs (2002 ~ ongoing)

그것은 분명 내가, 혹은 탁월한 감각을 갖고 뛰어난 지식을 가진 인간이 한순간의 우주를 나름의 정확성을 갖고 포착한 그림이기에, 우주의 실상에 대한 하나의 근삿값이다. 그러나 아무리 작은 오차의 그림이라 해도 우주가 끝없는 변화 속에 있는 한 이미 과거의 것이 된 순간의 그림이며, 따라서 실상에서 어긋난 그림이다. 그래도 그것 없이는 살 수 없기에, 실상이 아니란 점에서 허구지만, 유용한 허구고 피할 수 없는 허구다. 그러나 시간이 지날수록 실상과 멀어지는 허구다. 카오스의 끝없는 낯섦을 견디기 위해, 그 익숙한 질서의 세계 속에서 우리는 산다.

로렌스는 예술가란 벽과 천장에 그린 저 우주의 그림에 균열을 내어 카오스의 바람을 집 안으로, 세계 속으로 불러들이는 자들이라 했다.[10] 그렇게 카오스의 바람을 불러들이지 않는 한, 익숙한 세계는 이내 익숙한 거짓이 되고, 우리를 오도하는 지도가 된다. 이전에는 탁월하고 멋진 그림이었지만, 더는 유용하지 않은 그림이 된다. 예술가란 어떤 대상이나 세상의 '아름다움'을 예찬하는 자가 아니라 차라리 그림을 다시 그리게 하고, 세계를 다시 만들게 하는 자다. 캔버스에 예리하게 칼집을 낸 루치오 폰타나(Lucio Fontana)의 그림은 이런 사명을 천명하는 하나의 선언문이라 할 것이다. 라이너 마리아 릴케(Rainer Maria Rilke) 또한 이 익숙한 방에서 나가 세계를 다시 세우자고 한다. 「형상시집」의 '서시'에서 그는 이렇게 쓴다.

네가 누구라도, 저녁이면
네 눈에 익은 것들로 들어찬 방에서 나와보라:
먼 곳을 배경으로 너의 집은 마지막 집인 듯 고즈넉하다:
네가 누구라도.
지칠 대로 지쳐, 닳고 닳은 문지방에서
벗어날 줄 모르는 너의 두 눈으로
아주 천천히 너는 한 그루 검은 나무를 일으켜
하늘에다 세운다: 쭉 뻗은 고독한 모습. 그리하여
너는 세계 하나를 만들었으니, 그 세계는 크고,
침묵 속에서도 익어가는 한 마디 말과 같다.[11]
　　　　　　　　- 라이너 마리아 릴케, 「형상시집」 '서시' 중에서

아름다운 나무가 아니라 '검은 나무'인 것은 익숙한 집 바깥에서, 어둠으로 빚은 나무이기 때문이다. 익숙한 집의 바깥, 하이데거가 예찬했던 친숙한 세계의 바깥, 그것은 '세계'와 대비되는 의미에서 '우주'이다. 질서화된 세계와 대비되는 카오스의 우주이다. 로렌스 말에서 짐작할 수 있듯이, 예술가의 천사들은 그가 사는 세계의 바깥에 산다. 우리의 눈과 귀는 친숙하고 익숙한 것 안에 있지만, 천사들의 눈과 귀는 그것 바깥에 있다. 그래서 아무리 크게 소리쳐도, 익숙한 것들은 그들에게 들리지 않는다. 사실 우리도 그렇지 않은가. 다 아는 얘기에 귀 기울이는 이는 없으며, 매일 보던 것들에 우리는 눈길을 주지 않는다.

예술이란 저 바깥에 있는 천사가 예술가를 덮쳐올 때 발생하는 사건이다. 시인을 덮쳐오는 시처럼 말이다. 그렇게 시가, 부재하는 감각이 덮쳐올 때, 예술가 안에 있던 '누군가'가 죽는다. 필경 그때까지 '나'라 불리던 자의 익숙한 감각이 죽는다. 모리스 블랑쇼(Maurice Blanchot)는 이를 '비인칭적 죽음'이

The picture is one with its own accuracy, which has clearly been captured by oneself or a human being with excellent sense and knowledge. Thus, it is actually an approximation of the reality of the universe. However, no matter how small an error the picture has, it is a picture of a moment that has already become a thing of the past as long as the universe is in constant change. Hence, it is a picture that is out of joint with reality. Nevertheless, since we cannot live without it, it is fictional in the sense that it is not real. But it is a fiction that is useful and unavoidable. However, it is a fiction that becomes more distant from reality as time goes by. We live within the world of familiar order to endure the endless unfamiliarity of chaos.

Lawrence described artists as those who crack the cosmic picture on the walls and ceilings, bringing the winds of chaos into their houses and the world.[10] Unless the winds of chaos are brought in, the familiar world soon becomes a familiar untruth and a map that misleads us. It becomes a picture that is no longer useful, which used to be excellent and wonderful. An artist is not a person who praises the 'beauty' of an object or the world. Rather, he is a person who makes a picture be redrawn and the world be remade. Lucio Fontana's paintings with sharp cuts on the canvas are a declaration of this mission. Rilke also asserts that we would get out of the familiar room and rebuild the world. In the "Entrance" of his *The Book of Images*, he writes:

Whoever you are: in the evening step out
of your room, where you know everything;
yours is the last house before the far-off:
whoever you are.
With your eyes, which in their weariness
barely free themselves from the worn-out threshold,
you lift very slowly one black tree
and place it against the sky: slender, alone.
And you have made the world. And it is huge
and like a word which grows ripe in silence.[11]
　　　　　　　　-Rainer Maria Rilke, "Entrance" in *The Book of Images*

The tree in the poem is not a beautiful tree but a 'black tree' because it is a tree made in the darkness outside a familiar house. The outside of the familiar house, which is the outside of a familiar world that Heidegger has praised, is a 'universe' in contrast to the 'world.' It is a universe of chaos against the world in order. As one can assume from Lawrence's words, an artist's angels live outside the world in which he lives. Our eyes and ears stay within the familiar and intimate, but the eyes and ears of the angels are outside it. Thus, no matter how loud one shouts, the angels do not hear familiar things. In fact, we are also like that. Aren't we? No one listens to what everyone knows, and we do not pay attention to the things we see every day.

Art is an event that occurs when angels out there hold up an artist. It is like poetry that presses on a poet. When poetry comes, when a sense of absence arises, 'someone' that had been inside an artist dies. After all, the familiar sense of a person that had been called 'I' up until that point dies out. Maurice Blanchot calls this 'impersonal death.'[12] This death is one that involves a familiar world to which 'I' belonged to until that moment. In *Duino Elegies*, Rilke depicts the engulfment of angels

라 명명한다.[12] 이 죽음은 그때까지 '나'가 속해 있던 친숙한 하나의 세계의 죽음이다. 「두이노의 비가」에서 릴케는 천사가 덮쳐오는 사건과 누구든 두려워하지 않을 수 없는 이 죽음을 더할 수 없이 아름답게 묘사한다.

내가 이렇게 소리친들, 천사의 계열 중 대체 그 누가
내 목소리를 들어줄까? 한 천사가 느닷없이
나를 가슴에 끌어안으면, 나보다 강한 그의
존재로 말미암아 나 스러지고 말 텐데.
아름다움이란 우리가 간신히 견디어내는 무서움의 시작일 뿐이므로.
우리 이처럼 아름다움에 경탄하는 까닭은, 그것이 우리를
파멸시키는 것 따윈 아랑곳하지 않기 때문이다. 모든 천사는 무섭다.[13]
　　　　　　　　　　　　　　-릴케, 「두이노의 비가」 '제1 비가' 중에서

그러나 카오스의 어둠 그 자체를 산다는 것은 불가능한 것이다. 시인이 자기를 끌어안은 천사의 아름다움에 경탄하면서도 간신히 견딜 수 있을 무서움을 지우지 못함은 이 불가능성에 기인하는 것일 테다. 그래서 그 어둠 속에서 그 경탄할 아름다움을 따라가며 다시 그림을 그린다. 새로이 집을 만들고 새로이 세계를 만든다. 다시 불어올 우주의 바람에 쓰러지길 반복할 운명을 기꺼이 수긍하며. 습관과 기억이 재생산하는 과거의 그림을 지우고 어둠의 대기와 함께 도래할 미래의 그림을 그린다. 우리의 얼굴을 파먹어 들어가고, 우리의 신체를 잠식하며 그려질 새로운 세계를 그린다.

... 우리에게 남은 건 어제의 거리와, 우리가 좋아하는
습관의 뒤틀린 맹종, 그것은 남아 떠나지 않았다.
오 그리고 밤, 밤, 우주로 가득 찬 바람이
우리의 얼굴을 파먹어 들어가면, 누구에겐들 밤만 남지 않으랴.
　　　　　　　　　　　　　　-릴케, 「두이노의 비가」 '제1 비가' 중에서

질 들뢰즈(Gilles Deleuze)와 펠릭스 가타리(Félix Guattari)는 이를 약간 다른 방식으로 서술한다.[14] 그들에 따르면 예술가란 메를로퐁티(Maurice Merleau-Ponty)가 '살'이라고 불렀던 질료들이 흘러내리지 않도록 그 속에 뼈대를 세워 넣고 집을 만드는 이들이다. 자신의 스타일로 벽을 만들고 지붕을 올린다. 자신의 영토를 만드는 것이다. 그러나 어떤 집도 문이나 창문이 없을 순 없다. 문이나 창문은 집과 그 바깥이 통하고 드나드는 곳이다. 그 열린 문과 창문을 통해 예술가의 감각은 우주를 향해 집을 벗어나고, 역으로 그것을 통해 우주의 바람이 집 안으로 밀려 들어온다. 밀려드는 그 바람에 때로는 집이 흔들리고 부수어지기도 하고, 때로는 그 바람에 파먹히며 사람들의 얼굴이 뭉개지고 찌그러지기도 한다. 프란시스 베이컨(Francis Bacon)의 많은 그림들처럼. 뭉개지고 찌그러진 얼굴을 더 밀고 들어가면 우리는 다시금 살에 도달할 것이다. 아직 어떤 기관도, 어떤 표정도 없는 살덩어리, 그 살덩어리 위를 흐르는 강도=0의 흐름들. 이를 그들은 '기관 없는 신체'라 명명한 바 있다.[15] 그 살덩어리의 표면에 다시금 어떤 강도의 분포를 새겨 넣으며 예술가는 새로운 얼굴을 만들고, 새로운 집을 만든다.

and this fearful incident for anyone in the most beautiful way.

Who, if I cried out, would hear me among the Angelic Orders?
And even if one were to suddenly
take me to its heart,
I would vanish into its stronger existence.
For beauty is nothing but the beginning of terror,
that we are still able to bear, and we revere it so, because
it calmly disdains to destroy us. Every Angel is terror.[13]
　　　　-Rainer Maria Rilke, "The First Elegy" in *Duino Elegies*

However, it is impossible to live in the darkness of chaos itself. It might have been because of this impossibility that the poet admired the beauty of the angel who embraced him but could not get rid of the fear that he could barely endure. He thus follows the marvelous beauty in the dark and redraws a picture. He creates a new house and builds a new world, gladly accepting the fate of repeating himself to be destroyed by the cosmic wind that will blow once again. He erases the picture of the past, which is reproduced by habits and memories, and paints a picture of the future to come with the atmosphere of darkness. What he depicts is a new world to be drawn by engulfing our faces and encroaching upon our bodies.

... there remains to us yesterday's street,
and the thinned-out loyalty of a habit that liked us,
and so stayed, and never departed.
Oh, and the night, the night, when the wind full of space
wears out our faces,
whom the solitary heart with difficulty stands before.
　　　　-Rainer Maria Rilke, "The First Elegy" in *Duino Elegies*

Deleuze and Guattari describe this in a slightly different way.[14] According to them, an artist is a person who builds a house by setting a skeleton in the material that Merleau-Ponty called 'flesh,' preventing it from running down. He builds walls in his own style and places a roof on top of them. In that way, he creates his own territory. However, no house can be without doors or windows. A door or window is a site through which a house and its outside are connected and move through both ways. Through the open doors and windows, an artist's senses leave the house towards the universe. Conversely, the cosmic wind blows into the house through them. The coming wind often shakes and destroys the house. It sometimes encroaches upon the house, crushing and crumpling people's faces. It resembles many of Francis Bacon's paintings. If we push further on the crushed and crumpled faces, we will reach the flesh once again. There is a mass of flesh that has no organs and expressions yet, and there are flows that run down on the flesh with zero intensity. Deleuze and Guattari called this a 'body without organs.'[15] Engraving a distribution with a certain intensity on the surface of the flesh once again, the artist creates a new face and a new house.

폴리아모리식 건축실험, 2016, C-프린트, 48.3×32.9cm
Polyamoriearchitect, 2016, C-print, 48.3×32.9cm

5

'우주'라는 말은 상반되는 의미를 담고 있다. 하나는 그리스인들이 '코스모스'(cosmos)라고 불렀던 것이다. 코스모스란 사물들이 있어야 할 자리에 있음이다. '질서'로서의 우주다. 제멋대로 변하는 줄 알았는데, 일 년 뒤면 정확하게 전에 있던 자리에 돌아오는 별자리들, 일 년을 주기로 반복되는 계절들, 봄이 되면 영락없이 꽃을 피우는 나무들…. 그것이 있기에 우리는 길을 찾고 농사를 짓고 내일 할 일을 계획하며 산다. 그렇기에 코스모스란 최대치로 확장된 세계이고 집이다. 케플러(Johannes Kepler)에게 그것은 기하학으로 정연하게 설계된 우주였다. 다른 하나는 이와 반대로 세계의 바깥, 카오스(chaos)를 뜻한다. 릴케가 우주의 바람을 말할 때, 그것은 '어제의 거리와 뒤틀린 습관의 맹종'을 보존하고 있는 세계 바깥, 우리가 알고 감각하는 방식으로 정렬된 세계의 바깥을 뜻한다. 사물들이 있는 걸 확인하고 그렸으나 결코 그 자리로 되돌아오는 법 없는 무한한 속도로 변화하는 우주가 거기 있다.

천대광이 자신의 작업에 '집우집주'라고 했을 때 우리는 거기서 어떤 우주를 보는가? 아마도 둘 다 가능할 것이다. '집 우', '집 주', 우주(宇宙)라는 한자의 음훈을 그대로 읽은 것이라고 본다면, 그것은 분명 확대된 집으로서의 우주다. 지붕을 뜻하는 '우'와 기둥을 뜻하는 '주'는, 그리스 건축에 대한 고전적 관념과 유사한 양상으로 건축물을, 건축된 세계를 뜻한다 할 것이다. 그러나 저 한자의 음과 훈을 하나씩 '알려주는' 제목이라 한다면, 한자를 처음 배우는 아이들의 직설적인 순진성을 가정하는 것이다. 심지어 『천자문』의 저자조차 '집 우', '집 주'를 '넓을 홍', '거칠 황'과 짝짓지 않았던가. 우주가 '넓다' 함은 단지 '아주 크다'고 할 가시적 외연량이 아니라 우리 인간의 시야를 벗어나 있음을 뜻한다. 우주가 '거칠다' 함은 우리 인간의 지식이나 예측을 벗어나 우리를 뜻밖의 방향에서도 덮쳐올 수 있음을 뜻한다. 그러니 『천자문』조차 '우주'를 그저 집의 연장이 아니라 집의 바깥, 세계의 외부로서 보고 있음이 분명하다. 작가가 '집우집주'를 하나로 붙여 쓴 것을 주목한다면, 오히려 그의 우주는 집과 집 사이에 끼어드는 어떤 것으로 읽힐 것이다. 우리가 살고 우리가 만드는 집들 사이로 끼어드는 우주, 그 어둠의 바람이 거기 있다 해야 하지 않을까?

그러나 우주를 표현하기 위해 끌어들인 『천부경』이나 '카발라' 같은 것은

5

The word 'universe' has opposite meanings. One meaning is what Greeks called 'Cosmos'. The word implies that things stand where they should be. It is a universe in the sense of the 'order.' Constellations, which return to their exact positions a year later, although one might think they would change at will; the seasons that repeat every year; and the trees that bloom without exception in spring... Thanks to that order, we live by finding our ways, farming our crops, and planning what we will do tomorrow. Thus, Cosmos is a world and a house that has been expanded to the farthest end. For Johannes Kepler, it meant a geometrically well-ordered universe. The other meaning, on the contrary, implies chaos, which is the outside of the world. When Rilke speaks of the cosmic wind, it means the outside of the world that had been preserving the 'yesterday's street, and the thinned-out loyalty of a habit,' which is outside the world arranged in the way we understand and sense. There lies a universe that changes at an infinite speed without ever returning to its place, although one depicts it after confirming that there exist objects.

When Chen Dai Goang refers to two traditional Chinese characters Wu (宇) and Ju (宙) as part of the title of his work in Korean, what kind of universe do we see in there? Perhaps both of them would be possible. If the traditional Chinese characters are read in their literal meanings, the meaning of the title obviously implies the universe as an expanded house. As 'Wu' symbolizes the roof and 'Ju' represents the pillar, the words imply architecture or the built world in a manner that is similar to the classical notion of Greek architecture. However, if the title of Chen's work is one that merely 'tells' the individual sound and meaning of each traditional Chinese character, it would be a title that assumes the plain innocence of children who are learning Chinese characters for the first time. Even the author of *Thousand Character Classics* (千字文) paired Wu and Ju with Hong (洪) and Hwang (荒) that respectively signify vast and wild. When the universe is described as being 'vast,' it means that it is beyond the scope of our human vision, not just the visible outlook to be depicted as being 'very large.' And when the universe is described as being 'rough,' it means that it can go beyond our human knowledge and prediction, rushing into us from unexpected directions. Thus, it is obvious that the 'universe' (宇宙) is not just considered as an extension

카오스를 견디기 위해 고대인들이 그린 그림이고 코스모스 아닌가? 그렇다면 작가가 집 사이에 우주를 끌어들였다 해도 그 우주는 사실 코스모스 아닌가? 더욱이 그는 과거의 역사, 기억을 집 속으로 끌어들이고 있지 않은가? 역사와 기억이란 지나간 세계를 뜻하는 것 아닌가?

6

건축가는 어디서나 이상주의자다. 이상 없는 예술가가 어디 있으랴 싶지만, 어떤 예술가보다도 건축가는 이상주의자다. 새로이 집을 짓는 것은 언제나 그것이 지어지기 이전보다 좀 더 나은 삶에 대한 꿈속에서 행해지기 때문이다. 좀 더 나은 삶의 꿈을 거의 다가온 미래로 보여주고자 하기에, 혹은 언젠가 다가올 미래를 집과 함께 도래할 세계 속에 새겨 넣으려 하기에 그럴 것이다. 그래서 건축가는 어디서나 이상적인 건축물을 만든다.

도시를 만들 때도 다르지 않다. 도시란 대개 사람들이 모여들며 자연발생적으로 만들어진다고 생각하지만, 사실은 그렇지 않다. 도시는 사람들을 불러들이기 위해 만들어진다. 왕의 도시든, 종교의 도시든, 자본의 도시든 다르지 않다. 신하나 '백성' 없는 왕이란 있을 수 없고, 인민 없는 권력이란 있을 수 없다. 신도 없는 종교가 있을 수 없듯이 노동대중 없는 자본이란 있을 수 없다. 백성이나 인민, 신도나 노동대중이 많아야 그것의 힘이나 권력도 커진다. 그래서 그들은 사람들을 불러 모으려 한다. 보거나 들어본 사람이라면 누구든 '가고 싶다', '거기 살고 싶다'고 하려 한다. 그러기 위해 그들이 가진 꿈을, 그들이 가진 감각을 유혹하려 한다. 그렇게 몰려들 자의 다수성을 과시하기 위해 화려한 장치를 만든다.

그렇기에 어디서나 건축가는 나름의 '이상 도시'를 기획한다. 사람들을 불러 모으기 좋은 멋진 형태, 사람들의 마음을 사로잡을 수 있는 이상적 형태를 도시에 부여하고자 한다. 그렇기에 이 이상은 사람들의 실제 삶과 멀리 떨어져 있는 경우가 많다. 거대한 똥과 오물더미로 자신을 둘러싸게 했던 르네상스의 멋진 이상 도시가 그러했다. 예술사의 시대구분을 넘어 19세기의 파리나 20세기의 수많은 도시의 '얼굴'을 만든 바로크 도시는 그런 이상적 형상에다 대중의 움직임을 통제할 수 있는 군사적 목적을 덧붙였다.[16] 모더니스트 도시의 가장 잘 알려진 모델 중 하나인 르 코르뷔지에의 '빛나는 도시'[17] 기획조차 사실 다르지 않았다. 모더니즘 건축가들의 도시를 떠받치는 '조닝'(zoning)이나 블록의 크기가 얼마나 사람들의 현실적 삶과 동떨어져 있는지, 그것이 가시적인 형상을 위해 삶을 망각하게 했는지는 이미 오래전에 제인 제이콥스(Jane Jacobs)가 지적한 바 있다.[18]

그 이상 도시의 형상은 '시대정신' 안에 있다. 많은 이들을 불러들이려면 그들이 이미 공유하고 있는 이상, 혹은 그들을 불러들이려는 권력자들의 이상에 충실해야 하기 때문이다. 그렇기에 이러한 이상은 미래의 꿈이란 자리를 차지하고 있지만, 본질적으로 과거에 속한다. 이미 공유된 감각과 생각의 시제는 미래가 아니라 과거이기 때문이다.

건축가만이 아니라 우리도 이상 없이 살 수 없다. 이상이 우주의 천장이 되어 삶을 덮치거나 감쌀 때, 그것은 삶에 달라붙어 삶을 조이는 멋진 구속복이 된다. 그때 이상은 삶을 조이는 사태를 해명하는 이유가 되거나, 조여드는 삶을 잊게 해주는 위안이 된다. 그러나 우리가 벗으로 삼아야 하는 것은, 훌륭한 이유와 멋진 위안으로 견디어야 하는 삶이 아니라, 이유도 위안도 없지만 자유로운 삶이 아닐까?

of a house but as the outside of the world even in *Thousand Character Classics*. Noticing that the artist put the two characters Wu and Ju in the title of his work, his notion of the universe can be read as something that intervenes between houses. Shouldn't it be said that there lies a universe that intervenes between the houses we live and build, which is the wind of darkness?

However, aren't *Cheon Bu Gyeong* or 'Kabbalah', which are brought in to express the universe, nothing but a picture and a Cosmos that had been depicted by the ancients? Then, even if the artist introduced the universe between the houses, isn't that universe actually a Cosmos? Moreover, isn't he bringing the past history and memories into the houses? Don't history and memories indicate the past that has been passed?

6

Architects are idealists in any place. One might think that every artist has his own ideal, but architects are idealists at their best than any other artist. This is because building a new house is always done in the dream of a better life than the life before it was built. It might be because it is done with a hope to show the dream of a better life as a near future to come or with an intention to engrave the future to come one day in the world to come along with the house. This is why architects create ideal structures in any place.

It is no different when it comes to building a city. It is often thought that cities are spontaneously created as people gather into them, but the truth is different. Cities are built to bring people together. It is no different whether a city is built for a king, religion, or capital. There can be no king without his vassals or 'subjects,' and there can be no power without the people. Just as there can be no religion without God, there can be no capital without the working masses. Their power increases when there are more subjects and people, believers, or working masses. That's why cities try to bring people together. Anyone who has seen or heard of them is likely to feel that he 'wants to go there' and 'wants to live there.' In order to do so, cities try to seduce their dreams and their senses. And to show off the multitude of people who would flock to cities, they create splendid devices.

As such, architects plan their 'ideal cities' in any place. They intend to give cities beautiful shapes that can attract people and fascinate their hearts and minds. Thus, this ideal is often distant from people's real life. Such was the case with the beautiful, idealistic cities of the Renaissance, which were surrounded by huge piles of feces and filth. The baroque city, which created the 'face' of Paris in the 19th century and numerous cities in the 20th century, beyond the division of art history, added a military purpose to control the movement of the masses to such an ideal shape of the city.[16] Even the *Radiant City* project, which is one of Le Corbusier's most well-known models, was no different.[17] Jane Jacobs has pointed out how the 'zoning' or the size of urban blocks, which support the cities by modernist architects, are distant from people's real life, and how it caused people to forget their lives for the sake of tangible shapes.[18]

The shape of the ideal city lies in 'the spirit of the time.' If it is to bring many people in, it must be faithful to the ideal they already share or the ideal of those in power that want to bring people in. Thus, while that ideal occupies its place as a dream of the future, it essentially belongs to the past. This is because the tense of senses and thoughts that have already been shared is the past tense, not the future tense.

그래도 현재의 삶이 충분히 만족스럽지 못하다면, 아니 현재의 삶 속에 견디기 힘든 갈등과 불만이 있기에, 우리는 어디서나 이상을 만든다. 별 없는 세상이 어디 있을 것인가. 그러나 우리가 만들어 올린 별 가운데 떨어지지 않은 별은 없으며, 떨어지지 않을 별 또한 없을 것이다. 떨어지는 별에 맞아 피 흘리는 이 또한 있을 것이다. 그래도 우리는 다시 별을 만든다. 별들을 연결하며 다시 우리의 우주를 만든다. 별도 이상도 우리의, 어찌할 수 없는 삶의 일부인 것이다!

기억 또한 그렇다. 좋은 기억이든 나쁜 기억이든 기억은 과거에 속한다. 현재를 떠받치고 현재를 가능하게 하는 과거다. 그렇기에 우리는 별 만큼이나 기억 없이 살 수 없다. 그러나 호르헤 루이스 보르헤스(Jorge Luis Borges)가 「기억의 천재 푸네스」[19]에서 멋지게 지적했듯이, 하루를 기억하는데 하루가 걸린다면, 우리는 도대체 무슨 새로운 것을 할 수 있을 것인가? 그저 과거를 기억하는 것 이상을 하지 못한다면, 우리는 과거 아닌 어떤 것을 가질 수 있을 것인가? 현재가 기억을 벗어날 수 없는 한, 우리는 '어제의 거리와 오래된 습관의 뒤틀린 맹종'에서 벗어날 수 없다. 그 거리에선 현재도 과거고, 미래도, 이상도 모두 과거다. 지워지지 않는 기억을 가진 이들이 그 기억의 주변을 떠나지 못하고 증상적 행위를 반복하는 '환자'가 됨을 우리는 안다.

진정한 미래는 기억을 지우며 온다. 이상을 지우며 온다. 이상이 입은 미래의 옷을 벗기고, 그것이 자라난 현재를 비우고, 그것이 발 딛고 선 과거를 지우며 온다. 그렇게 지우며 오는 시간으로 인해 현재는 현재에서 벗어날 수 있고, 과거 또한 과거에서 벗어날 수 있다. 지울 수 있을 때 과거는 현재의 자산이 되고, 미래의 재료가 된다. 삭제되거나 첨가되면서 다른 것과 결합될 수 있을 때, 기억은 새로운 삶의 자원이 된다. 기억을 과거로부터 구하는 것은 지우는 힘으로서의 망각이다. 이상을 멋진 구속복의 운명에서 구하는 것은 그것을 찢어서 우주의 바람을 불러들이는 사건이다. 이상을 과거로부터 구하여 현재를 만드는 힘으로, 도래할 다른 세계의 천장으로 만드는 것은 지우고 변형시키며 뜻밖의 것과 결합하는 사건이다.

7

천대광은 집 사이에 우주를 불러들인다. 집과 집을 연결하여 만들어진 현행의 세계를 지우며 우주를 끌어들인다. 그러기 위해 그는 과거의 기억을 애초의 장소와 시간에 떼어내 변형시켜 우주의 바람 속에 섞어 넣는다. 또한 건축가도 우리도 벗어날 수 없는 이상을, 혹은 우주의 형상을 고대의 하늘과 땅에서 떼어내 그 우주의 바람에 섞어 넣는다. 그 바람으로 다시 집을 짓고 다시 세계를 만든다. 그러나 그것은 결코 과거에 속한 어떤 이상의 재현이 아니며, 과거의 시간에 향수를 담아 불러내는 것도 아니다. 그렇게 불러내는 것은 부재하는 집이고 부재하는 세계다. 그렇게 그는 부재하는 집과 세계를 우리의 삶 속으로 밀어 넣으려는 것일 게다. 오래된 거리와 습관에서 벗어나 다른 세계를 살아보지 않겠느냐고 제안하려는 것일 게다.

Neither architects nor we can live without ideals. When an ideal becomes the ceiling of the universe, presses on or envelops life, it becomes a good-looking straitjacket that clings to life and oppresses it. The ideal then becomes a reason to explain the situation that oppresses life, or it becomes a comfort that puts the pressing life in oblivion. However, shouldn't it be that what we should be friends with is not a life that must be endured with good reasons and wonderful consolation but a liberated life without any reason nor comfort?

Nonetheless, if the present life is not satisfactory enough, or because there are unbearable conflicts and dissatisfaction in the present life, we create ideals in any place. Would there be a world that is without stars? Among the stars we have made, however, there was no star that did not fall, and there is no star that would not fall. There will also be those who will be hit by the falling stars and bleed. Yet we make stars again. We connect the stars and create our own universes once again. Both the stars and ideals are an unavoidable part of our lives!

So are our memories. Whether they are good or bad, memories belong to the past. They are the past that supports the present and makes the present possible. That is why we cannot live without memories as much as we cannot live without the stars. As Borges brilliantly pointed out in *Funes the Memorious*,[19] what new things can we do if it takes one whole day to remember a day? If we can't do more than just remember the past, how can we have anything other than the past? As long as the present cannot escape from our memories, we cannot escape from 'yesterday's street, and the thinned-out loyalty of a habit.' In that street, the present is the past, and the future and the ideal are all past. We know that those with indelible memories become 'patients' who cannot leave such memories and repeat symptomatic behaviors.

The true future comes with erasing memories. It comes with erasing the ideal. It comes with stripping off the clothes of the future that had been worn by the ideal, emptying the present in which it has built up, and erasing the past it has set its feet on. Thanks to the time that comes with erasure, the present can escape from itself and the past can also escape from itself. When the past can be erased, it becomes the asset of the present and the material for the future. When memories can be combined with other things by being deleted and added with, they become the resource for new life. What rescues memories from the past is forgetting as a power to erase them. What saves the ideal from the fate of being put into a good-looking straitjacket is the event of tearing it apart and calling in the cosmic wind. What saves the past from the past to create the present and what turns the ideal into the ceiling of another world to come are the event that erases, transforms, and combines the unexpected.

7

Chen Dai Goang invites the universe between the houses. He draws in the universe by erasing the world of now that has been created by connecting houses. In order to do so, he removes the memories of the past from their original place and time, transforms them, and blends them into the cosmic wind. And he separates the ideal or the shape of the universe, which neither the architect nor we can escape from, and mixes it with the cosmic wind. He builds houses again with that wind and creates the world once again. However, it is by no means a representation of an ideal that belongs to the past. Nor is it a nostalgic recall of time from the past. What is called forth is an absent house and an absent world. He is probably trying to push the absent house and world into our lives. He is probably attempting to suggest that we would escape from old streets and customs and live in a different world.

기억이 기억일 뿐일 때, 기억은 우리를 가두는 집이 된다. 이상이 이상일 뿐일 때, 이상 또한 우리를 가두는 세계가 된다. 지우는 시간의 힘으로 기억을 애초의 이음매에서 벗어나게 하고, 이상을 단단하게 채운 빗장을 풀어버릴 때, 기억도 이상도 비로소 새로운 삶을 구성하는 재료가 된다. 미래의 재료가 된다. 『천부경』과 '카발라', 캄보디아나 태국, 혹은 제주도나 동남아 건축물의 색들, 심지어 크노르의 상품들마저 새로운 집 속에서 새로이 동료가 된다. 그토록 다른 시간과 장소에 속해 있던 것이, 그렇게 이질적인 것들이 한 작가의 손을 빌려 하나의 공동체로 모여들고 있는 것이다. 전에 없던 공동체가 탄생하고 있는 것이다.

When memories are just memories, they become the house that confines us. When the ideal is only an ideal, it also becomes a world that confines us. When the erasing power of time liberates memories from their original seams and loosens the firm crossbar that had been keeping the ideals, both memories and ideals become the material that constitutes a new life. They then become the material for the future. *Cheon Bu Gyeong* and 'Kabbalah', colors of different architecture in Cambodia, Thailand, Jeju Island, or Southeast Asia, and even products made by Knorr become new companions in the artist's new houses. Things that had belonged to such different times and places are gathering into one community through the artist's hands. Here, a community that never existed before is in its birth.

1
마르틴 하이데거, 『형이상학의 근본개념들』 이기상·강태상 옮김 (서울: 까치, 2001), 354.

2
마르틴 하이데거, 「건축함, 거주함, 사유함」 『강연과 논문』 외 옮김(서울: 이학사, 2008), 189-191.

3
마르틴 하이데거, 「"…인간은 시적으로 거주한다…"」 『강연과 논문』, 245-246.

4
마르틴 하이데거, 「건축함, 거주함, 사유함」 186.

5
마르틴 하이데거, 『존재와 시간』 이기상 옮김 (서울: 까치, 1998), 131-141.

6
마르틴 하이데거, 『형이상학의 근본개념들』 310.

7
마르틴 하이데거, 『존재와 시간』 82.

8
프리드리히 니체, 『비극의 탄생』 서문: 자기비판에의 시도』 『비극의 탄생·반시대적 고찰』 이진우 옮김 (서울: 책세상, 2005), 12.

9
질 들뢰즈·펠릭스 가타리, 『철학이란 무엇인가』 이정임·윤정임 옮김 (서울: 현대미학사, 1995), 289.

10
D. H. Lawrence, "Chaos in Poetry," in Selected Literary Criticism, ed. A. Beal, (London: Heinemann, 1955), 234-236.

11
라이너 마리아 릴케, 『릴케 전집 2』 김재혁 옮김 (서울: 책세상, 2000), 10.

12
모리스 블랑쇼, 『문학의 공간』 박혜영 옮김(서울: 책세상, 1990), 166. '비인칭적 죽음'이라는 개념은 176 참고.

13
라이너 마리아 릴케, 『릴케 전집 2』 443.

14
질 들뢰즈·펠릭스 가타리, 『철학이란 무엇인가』 257-264.

15
Gilles Deleuze and Félix Guattari, L'Anti-Oedipe (Paris: Les Editions de Minuit, 1972), 15.

16
루이스 멈퍼드, 『역사 속의 도시 II』 김영기 옮김(서울: 지식을만드는지식, 2016), 836-837.

17
르 코르뷔지에, 『도시 계획』 정성현 옮김(파주: 동녘, 2007) 참고.

18
제인 제이콥스, 『미국 대도시의 죽음과 삶』 유강은 옮김(서울: 그린비, 2010) 참고.

19
호르헤 루이스 보르헤스, 「기억의 천재 푸네스」 『픽션들』 송병선 옮김 (서울: 민음사, 2011), 135-148.

1
Martin Heidegger, *The Fundamental Concepts of Metaphysics* (1983), Translated into Korean by Lee Kisang and Kang Taesang (Seoul: Kachi Publishing, 2001), 354.

2
Martin Heidegger, "Building, Dwelling, Thinking (1954)", in *Heidegger's Lectures and Papers*, Translated into Korean by Lee Kisang et al. (Seoul: Ehaksa, 2008), 189-191.

3
Martin Heidegger, "…Poetically Man Dwells… (1971)," *Ibid*, 245-246.

4
Martin Heidegger, "Building, Dwelling, Thinking," *Ibid*, 186.

5
Martin Heidegger, *Being and Time* (1927), Translated into Korean by Lee Kisang (Seoul: Kachi Publishing, 1998), 131-141.

6
Martin Heidegger, *The Fundamental Concepts of Metaphysics*, 310.

7
Martin Heidegger, *Being and Time*, 82.

8
Friedrich Nietzsche, "An Attempt at Self-Criticism, The Preface of *The Birth of Tragedy* (1872)," in *The Birth of Tragedy and Untimely Meditations*, Translated into Korean by Lee Jinwoo (Seoul: Chaegsesang, 2005), 12.

9
Félix Guattari and Gilles Deleuze, *What Is Philosophy?*(1991), Translated into Korean by Lee Jungim and Yoon Jungim (Seoul: Hyundae Mihaksa, 1995), 289.

10
D. H. Lawrence, "Chaos in Poetry," in *Selected Literary Criticism*, ed. A. Beal (London: Heinemann, 1955), 234-236.

11
Reiner Maria Rilke, *Complete Works of Rilke 2*, Translated into Korean by Kim Jaehyuk (Seoul: Chaegsesang, 2000), 10.

12
Maurice Blanchot, *The Space of Literature* (1955), Translated into Korean by Park Hyeyoung et al. (Seoul: Chaegsesang, 1990), 166. Regarding the concept of 'impersonal death,' please see 176.

13
Reiner Maria Rilke, *ibid*. 443.

14
Félix Guattari and Gilles Deleuze, *ibid*, 257-264.

15
Félix Guattari and Gilles Deleuze, *L'Anti-Oedipe* (Paris: Les Editions de Minuit, 1972), 15.

16
Lewis Mumford, *The City in History II* (1961), Translated into Korean by Kim Young-gi (Seoul: Zmanzclassic, 2016), 836-837.

17
Please see, Le Corbusier, *Urban Planning* (1925), Translated into Korean by Jung Sung-hyun (Paju: Dongnyok Publishers, 2007).

18
Please see, Jane Jacobs, *The Death and Life of Great American Cities* (1961), Translated into Korean by Yoo Kang-eun (Seoul: Greenbeebooks, 2010).

19
Jorge Luis Borges, "Funes the Memorious," in *Fictions* (1944), Translated into Korean by Song Byung-sun (Seoul: Minumsa Publishing, 2011), 135-148.

청주淸州 도심 거주환경과 문화

The Residential Environment and Culture of Central Cheongju

김태영
(청주대학교 건축학과 교수)

Kim Tai Young
(Professor, Department of Architecture, Cheongju University)

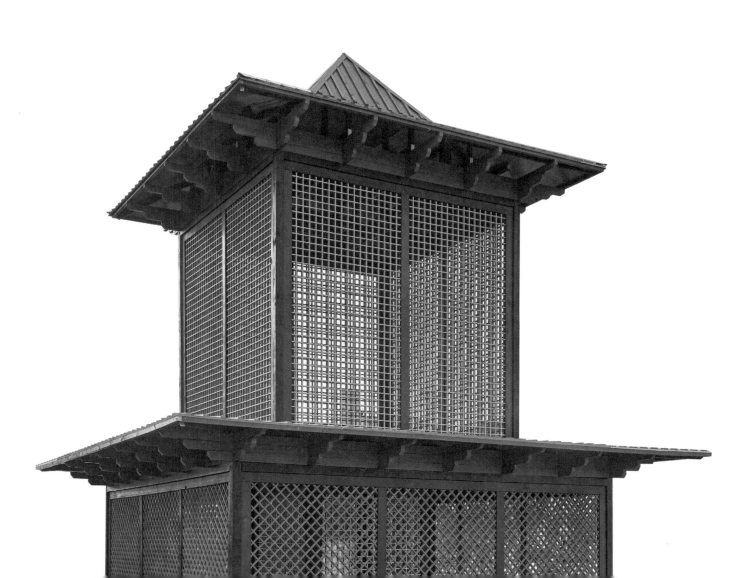

청주의 근대화, 도시화는 1908년 충주에서 관찰부가 청주 읍성 내 옛 병영으로 이관된 직후, 1911년부터 1915년까지 진행된 구 읍성의 파괴와 훼손으로부터 시작되었다. 파괴된 성곽 자리에서 시작된 청주의 근대 도시건축의 모습은 무심천과 우암산을 끼고서 남북방향의 기다란 선형으로 전개되었다.

최근 들어 초고층 아파트 건립과 더불어 잦은 도시개발사업으로 도심 경관에 있어서 많은 변화를 겪고 있으나, 청주는 다른 도시와 달리 도심 주변으로 옛 모습 및 흔적을 많이 간직하고 있다. 청주 읍성 곽의 흔적을 그대로 나타내고 있는 보행로, 옛 관아 터와 성안길, 4대문의 흔적, 매몰된 남석교, 남문 밖 주거지를 비롯하여 장소의 기점을 알 수 있는 철당간, 청주 병마절도사 영문, 압각수, 동헌 등의 전통문화재와 수많은 근대문화유산이 현존하고 있다.

건축물 하나하나뿐만 아니라 역사적인 도시공간구조와 거주환경 전체가 남아 있다는 것 자체로 매우 소중한 자산이다. 대구, 광주, 전주, 나주 등의 여느 내륙지방 도시 역시 예전 읍성곽의 흔적을 갖추고는 있으나, 청주처럼 읍성 곽을 근간으로 한 전통과 근대의 도시공간구조를 뚜렷한 모습으로 전해주지는 못한다.

청주시 권역의 시작이고, 원형이며, 기준점인 청주 읍성 주변의 구도심(성안동과 중앙동)을 대상으로 도시공간구조의 형성과정, 현존하는 전통 및 근대문화유산, 그리고 지역 주민의 생활을 담고 있는 거주환경에 대하여 살펴봄으로써, 청주만의 독자적인 특성과 정체성을 읽어내며, 가치 있다고 판단되는 거주환경의 보호와 함께 새로운 미래상에 대한 예측도 가능할 것이다.

청주 도심 공간의 형성과정

청주의 도심 공간은 청주 읍성을 중심으로 한 행정구역에서 근대도시로 성장하면서 주변 사주면(四州面)을 포함한 영역으로, 시기별로 청주 읍성, 구도심, 원도심 영역으로 나뉜다. 일제강점기, 가깝게는 1960년대까지의 주 생활무대이었던 읍성 주변의 성안동과 북문 밖 중앙동 일대를 구도심이라 하고, 이곳에서 내덕 칠거리에 이르는 1939년 청주시가지 계획구역이 원도심이다.

18세기 후반에 작성된 청주 읍성도는 정확한 축척을 가진 것으로, 현재의 가로망 및 지적선과 비교해 보아도 거의 유사함을 보이고 있다. 남북방향을 장축으로 한 400×600m 크기의 방형(方形)인 청주 읍성은 없어졌으되, 그 성곽의 흔적은 4대문을 잇는 보행 도로로 현존하고 있다. 성곽 이외에도 남문(淸南門)에서 북문(玄武門)으로 이어지는 성안길, 동문(關寅門)과 서문(淸秋門)으로 통하는 길, 그리고 동헌 영역과 병영군(兵營群)의 담장 길 등의 가로망들이 현재 재구성되어 있다.

The modernization and urbanization of Cheongju began with the damaging and destruction of Cheongjueupseong Fortress between 1911 and 1915, following the relocation of the provincial government seat from Chungju to a former military barracks site within the fortress in 1908. The modern urban construction of the city, which began on the site of the demolished the fortress, developed along a linear axis running from north to south between Musimcheon Stream and Mt. Uamsan.

Cheongju's urban landscape has undergone extensive change in recent times due to the construction of high-rise apartment blocks and frequent urban development projects. Unlike other cities, however, Cheongju retains much of its old form and traces of its past in the vicinity of the city center. These include traditional cultural heritage such as footpaths showing the original form of the fortress, former government building sites and the historic Seongan-gil street, traces of the four city gates, buried Namseokgyo Bridge, the iron flagpole that serves as a landmark for the residential area outside the south gate, the old the main gate of Chungcheong-do Military Headquarters, historic ginkgo trees, and the old magistrate's office, and numerous modern-era cultural heritage sites.

Aside from individual buildings, the historical layout and intact living environment that the city retains are also of extremely high value. Other inland provincial cities such as Daegu, Gwangju, Jeonju and Naju also retain traces of their old fortress, but, unlike Cheongju, no longer feature clear traditional and modern urban layouts based on these original fortresses.

The former city center in the area of Cheongjueupseong Fortress (today's Seongan-dong and Jungang-dong neighborhoods) constitutes the beginning, original form and key reference point of the city area. Examining this area in terms of its urban layout formation, its extant traditional and modern cultural heritage, and the living environment of its residents, will allow us to read Cheongju's unique features and identity, and to conserve this valuable residential environment and predict new future forms for it.

The Spatial Formation of Central Cheongju

In the process of growing from an administrative area centered on Cheongjueupseong Fortress into a modern city, Cheongju's downtown area came to incorporate adjacent Saju-myeon (四州面). According to era, it is classed either as Cheongjueupseong Fortress, the old city center, and the original city center. The old city center refers to Seongan-dong, in the area of the old fortress, and Jungang-dong, outside the city's northern gate. This area constituted the center of city life from the Japanese occupation period until as recently as the 1960s. The original city center denotes the area reaching from the old city center to Naedeok Intersection. This area was designated as the city of Cheongju by urban planners in 1939.

A city map of Cheongjueupseong Fortress produced in the late eighteenth century offers an accurate scaled representation, showing a near-perfect correspondence with today's street network and land boundary lines. Cheongjueupseong Fortress, which formed a 400 x 600m rectangle aligned along a north-south axis, are gone. But their traces survive as a walking path that links the city's four gates. In addition to the fortress, a network of old city roads survives today in reconstituted form. This includes Seongan-gil, linking the city's south gate (淸南門; Cheongnammun) to its north gate (玄武門; Hyeonmumun); a road connecting the east gate (關寅門; Byeoginmun) to the west gate (淸秋門;

근대기에 이르러 시구개정사업에 따라 청주 읍성이 허물어지면서 1920년대 북문 밖 철도역 개설과 동문 밖 주거지 조성, 1930~40년대 무심천 개수공사와 서문과 남문 밖 주거지 확대를 거치면서, 그리고 1960년대 후반에 들어서면서 청주역 이전과 청주 시청사 건립, 사직로와 상당로 개설, 무심천변 토지구획정리사업 등이 진행되면서 청주시가지가 확장되었다. 이곳이 현재의 성안동과 중앙동으로, 구도심 지역이다.

또한 내덕 칠거리에서 석교 육거리에 이르는 전장 3.3km에 이르는 원도심 지역은 일찍이 1939년 청주시가지계획 구역으로, 1967년 도시계획 재정비계획이 시행되기까지 청주시 행정구역이면서, 1970년대에 이르기까지 청주 시민의 생활 터전 중심지이었다. 상당로를 중심으로 서쪽 중앙로(성안길), 동쪽 대성로의 남북방향 도로에 120m의 간격으로 동서로가 형성되면서, 전체적으로 격자 형태의 명확한 가로망을 갖추고 있다.

이와 같이 근대기 100여 년이 지난 지금까지도 지속되고 있는 청주의 구(원)도심의 도시공간구조는 내륙지방 역사 도시로서의 청주 본연의 모습을 그대로 전해주면서, 도심 경관을 결정짓는 가장 중요한 요인으로 작용하여 왔다. 그야말로 청주의 정체성을 깊은 데에서 뿜어내고 있는 매우 귀중한 요소인 것이다.

전통문화재와 근대문화유산

현존하는 전통문화재

(객사 동헌 영역) 2021년 현재 청주시청 제2청사(구 청원군청, 상당구청)가 위치하고 있는 객사 동헌 영역에는 28칸 규모의 청주 동헌(충북 유형문화재 제109호, 1867년 현 위치로 이축)이 현존하고 있으며, 2006년에 발굴된 객사 터에는 마사토로 메워진 상태에서 CGV 청주 서문 부설주차장이 세워져 있다. 바로 옆 구 쥬네쓰 백화점(현, CGV 청주 성안길)이 있는 곳은 망선루가 있던 장소로, 청주 근대교육의 산실이다. 이 자리에 무(武)를 숭상하는 상무관(尙武館, 혹은 武德殿)이 세워져 1995년까지 존치하고 있었다. 망선루는 철거 당시 교육에 뜻을 둔 지역의 유지에 의해 제일교회로 이축 되었으며, 현재는 중앙공원에 이축 되었다.

청주 읍성의 어제와 오늘
1 청주읍성도
2 관아공해 배치복원도 /
 청주면 지적원도(1913)의 중첩도
3 청주 가로망도 / 읍성 곽의 흔적인 보행로
 정비계획(2020)
4 1939~1967년 청주시가지계획구역
 (청주 읍성, 구도심, 원도심 영역)

Past and Present of Cheongjueupseong Fortress
1 Cheongjueupseong Fortress Map
2 Restoration Map of Government
 Office Buildings' Locations in
 Cheongju / Cheongju-land
 Registration Map (1913)
3 Street Network Plan of Cheongju /
 Pedestrian Path Maintenance Plan
 of the Trace of Fortress Wall (2020)
4 Cheongju Local Area Plan from
 1939 to 1967 (Cheongjueupseong
 Fortress, old city center,
 original city center)

Cheongchumun); and a road running beside the fortress from the area of old the magistrate's office to the cluster of military barracks.

In the modern period, district rearrangement projects resulted in the demolition of Cheongjueupseong Fortress. In the 1920s, a railway station was built outside the north gate and a residential zone outside the east gate; in the 1930s and 40s, work took place to improve Musimcheon, and residential areas were expanded outside the city's west and south gates. In the late 1960s, Cheongju Station was relocated, the city hall was constructed, Sajik-ro and Sangdang-ro roads were built, and land along the banks of Musimcheon was re-zoned, expanding the city. This area corresponds to today's Seongan-dong and Jungang-dong, and is referred to as the old city center.

The original city center area extends for a total of 3.3km between Naedeok and Seokgyo intersections, and was demarcated in an urban plan of 1939. This constituted the administrative area of Cheongju as a city until an urban re-planning project in 1967, and was the center of life for the city's people until the early 1970s. Roads running from east to west were built at 120-meter intervals between the north-south-oriented Jungang-ro (Seongan-gil) in the west and Daeseong-ro in the east, with Sangdang-ro at their center, creating a clear overall grid formation.

Cheongju's old and original city center layouts have thus survived from the modern period, some 100 years ago, until today, establishing it as an original historical inland town and functioning as the most crucial factor in determining its urban landscape. This is an extremely valuable aspect of the city that provides it with a deep-rooted identity.

Traditional and Modern Cultural Heritage

Extant Traditional Heritage

(Inn and Magistrate's Office Area) As of 2021, this area is the location of Cheongju's second city hall building (formerly Cheongwon-gun Office, then Sangdang-gu Office). It is home to the city's historic magistrate's office (Dongheon; registered as Chungcheongbuk-do Tangible Cultural Heritage item No. 109; relocated to its current position in 1867), a building comprising 28 kan (inter-column spaces). Also located here is the site where the city's historic inn (gaeksa) once stood; this is now filled with granite-based soil and used as the parking lot for the Cheongju Seomun branch of the CGV cinema chain. Right beside this is the former site of Jeunesse Department Store (now CGV Cheongju Seongan-gil), which was previously the site of Mangseon-ru Pavilion and the birthplace of modern education in the city. It was here that the Sangmugwan, a shrine built in honor of the military, was built and remained until 1995. When Mangseonru was removed from here, it was relocated to the grounds of Jeil Church by community leaders with a strong sense of the value of education. It has now been relocated once again, to the city's Jungang Park.

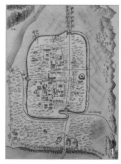
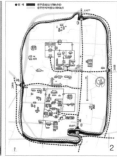

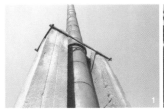
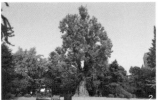
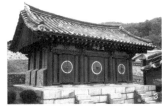
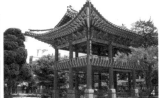
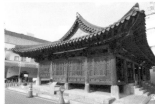
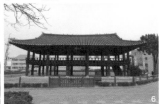

현존하는 청주읍성 내
주요 유구

1 철당간
2 압각수
3 표충사(삼충사)
4 충청병마절도사 영문
5 청주 동헌
6 망선루

Major Relics within the Existing
Cheongjueupseong Fortress

1 Iron Flagpole
2 Ginkgo Tree
3 Pyochungsa Temple (also known as Samchungsa)
4 Main Gate of Chungcheong-do Military Headquarters
5 Cheongju Government Office
6 Mangseonnu Pavilion

(Military Barracks Area) In Jungang Park, once the site of the city's military barracks cluster, are a historic ginkgo tree (designated Local Monument No. 5), the main gate of Chungcheong-do Military Headquarters (Chungcheongbuk-do Tangible Cultural Heritage No. 15), Unju-heon Pavilion (運籌軒), and Tonggun-ru Pavilion (統軍樓), thought to have been three stories high, and used as a government building until the early modern period. At the Cheongju branch of Woori Bank (formerly the Commercial Bank), in front of the main gate of Chungcheong-do Military Headquarters, was the Daebyeoncheong (待變廳), where medical treatment was provided for flagbearers, musicians, horse keepers and seriously sick patients. On the site of the current YMCA building, to the west of the main gate, was a storehouse for weapons and other items, and a medical treatment facility called the Guhyul-so. This later became the site of a charity clinic and, until the 1970s, Chungcheongbuk-do Provincial Hospital.

(Iron Flagpole and Other Historic Remnants) The city area within the fortress is also home to remnants of Samchungsa Temple (also known as Pyochungsa), a jail, a historic iron flagpole, a hongsalmun gate, a historic ginkgo tree, housed monuments, and eight wells. Parts of Samchungsa, the flagpole at the former site of Yongdusa Temple, the ginkgo tree, and some housed monuments survive today. Samchungsa was built near the city's northern gate in 1731 (7th year of the reign of King Yeongjo) in honor of those who died suppressing Yi In-jwa's rebellion. It has now been relocated and rebuilt at 87 Su-dong, an address outside the city's north gate. Memorial steles to righteous army general Jungbong Jo Heon and monk-general Grand Master Yeonggyu, who recaptured Cheongju during the Imjin War, have now been relocated from outside the west gate and the north gate to Jungang Park.

Extant Modern Cultural Heritage

Local modern architectural cultural heritage in downtown Cheongju can be divided into the municipally- and the city/province-registered and the state-registered. Chungcheongbuk-do cultural heritage includes buildings 1-6 of Tapdong Yanggwan, built in an eclectic style blending Korean and Western elements, and Cheongju Anglican Church, which borrows the construction style of a traditional Korean *hanok* roof. State-registered cultural heritage includes the main building of Cheongju Daeseong High School, listed in 2002 (formerly Cheongju Commercial High School; No. 6); a house built in eclectic style in Munhwa-dong (The Uri Music Academy No. 9), the main building of Chungcheongbuk-do Provincial Government (No. 55), the former auditorium of Cheongju Public School (Juseong Museum of Education; No. 350), the auditorium of Daeseong Girls' Middle School (formerly Cheongju University Auditorium; No. 351), the former Chungbuk Industrial Promotion Center (No. 352), the former official residence of the Governor of Chungcheongbuk-do Province (No. 353), and the water quality control facility at Cheongju's East Reservoir (No. 355).

(병영 영역) 병영군이 위치하였던 중앙공원 내에는 현존하는 압각수(지방기념물 제5호)와 충청병마절도사 영문(충북 유형문화재 제15호) 이외에 운주헌(運籌軒)과 3층 규모로 추정되는 통군루(統軍樓)라는 건축물이 근대 초기까지 관아(官衙)로 사용되었다. 영문 앞쪽에 위치한 구 상업은행(현 우리은행) 청주지점에는 기수(旗手)와 악수(樂手), 말을 부리는 사람, 위급한 환자를 치료하는 대변청(待變廳)이 있었고, 영문 서쪽 현 YMCA 쪽으로는 각종 무기와 물품 창고, 환자를 치료하는 구휼소가 있었다. 여기에 자혜의원이 들어섰으며, 1970년대까지 충북도립병원이 있었다.

(철당간 및 유구) 청주 읍성 내에는 삼충사(표충사), 감옥, 동장(철당간), 홍살문, 압각수, 비각, 그리고 8개소의 우물 등의 유구가 있었으며, 삼충사와 용두사지철당간, 압각수, 비각 일부가 현존하고 있다. 이인좌의 난 당시에 순절한 삼충신을 기리기 위해 영조 7년(1731) 북문 근처에 세워진 삼충사는 현재 북문 밖 수동 87번지에 이건 되었고, 임진왜란 때 청주 읍성을 탈환한 중봉(重峰) 조헌 의병장과 승병장 영규대사의 전장 기적 비는 서문 밖과 북문에서 중앙공원 내에 옮겨졌다.

현존하는 근대건축문화재

청주 도심 지역의 근대건축문화재는 시도유형문화재와 국가등록문화재로 나뉜다. 충청북도 유형문화재로는 한양 절충식의 청주 탑동 양관 1～6호, 전통 한옥 지붕의 가구 방식을 채용한 청주성공회성당이 있으며, 국가등록문화재로는 2002년에 등록된 청주 대성 고등학교 본관(구 청주상고 본관, 제6호)과 청주 문화동 일양 절충식 가옥(우리 예능원, 제9호)을 비롯하여 청주 충청북도청 본관(제55호), 구 청주 공립보통학교 강당(주성 교육박물관, 제350호), 청주 대성여자중학교 강당(구 청주대학교 강당, 제351호), 청주 구 충북 산업 장려관(제352호), 청주 충청북도지사 구 관사(제353호), 청주 동부 배수지 제수변실(제355호) 등이 있다.

청주의 근대문화유산

시도유형문화재
1 청주 탑동 양관 1호(6동)
2 청주 성공회성당

국가등록문화재
3 구 청주상고 본관
4 우리 예능원
5 충청북도청 본관
6 주성 교육 박물관
7 대성여중 강당
8 구 충북 산업 장려관
9 충북도지사 관사
10 동부 배수지 제수변실

Cheongju's Modern Cultural Heritage

City/Province-registered Tangible
Cultural Heritage

1 Tapdong Yanggwan no.1 (one out of 6)
2 Cheongju Anglican Church

State-registered Cultural Heritage
3 Main Building of Formerly Cheongju
Commercial High School
4 The Uri Music Academy
5 Main Building of Chungcheongbuk-do
Provincial Government
6 Juseong Museum of Education
7 Auditorium of Daeseong Girls' Middle School
8 Former Chungbuk Industrial Promotion Center
9 Former Official Residence of the Governor of
Chungcheongbuk-do Province
10 Water Quality Control Facility at
Cheongju's East Reservoir

Besides registered modern architectural cultural heritage, central Cheongju is scattered with other key modern historical sites and myriad houses and public buildings that stand on them. Among these, several key places of modern cultural heritage such as the Sangmugwan, the auditorium of Jungang Elementary School, the main building of Daeseong Girls' Middle School, and Jungang Theater, have been destroyed, while extant examples include public buildings such as the silk-reeling workshop of the Chungcheongbuk-do Provincial Sericulture Association, the former headquarters of Joseon Transportation, and Cheongju City Hall; educational buildings such as the brick buildings at Cheongju University, and elementary school auditoriums; and religious venues such as Cheongju Cathedral, Cheongju Jeil Church, the Cheongju temple of Won Buddhism, Seoun-dong Catholic Church, and Su-dong Catholic Church.

Efforts to Excavate, Restore and Regenerate Cultural Heritage
(Restoration and Conservation of Traditional Cultural Heritage) An international symposium held in March 2011 to mark the centenary of the destruction of Cheongjueupseong Fortress provided a chance for new reflection on the city's historical identity. An ongoing civic movement for the conservation of cultural heritage that had, until then, focussed on the iron flagpole at the site of Yongdusa Temple, continued as a project for the restoration of the fortress. The city government conducted a two-year excavation study within the old city from 2012 to 2013, followed by priority restoration work on part of Jungang Park that was thought to be the former site of the fortress by the west gate (near the current YMCA building). By September 2013, reconstruction of part of the fortress was complete.

문화재로 지정된 근대건축물 이외에도 청주 도심에는 근대사 현장과 그 위에 앉혀진 수많은 가옥과 공공 건축물이 곳곳에 산재하여 있다. 이 가운데 상무관, 중앙초등학교 강당, 대성여중 본관, 중앙극장 등의 몇몇 대표적인 근대문화유산들은 멸실되었으며, 현존하고 있는 것으로는 충청북도 잠업 진흥회의 잠사 건축물, 구 조선운송 주식회사, 청주 시청사 등의 공공 건축물 이외에 교육 시설로는 청주대학교 벽돌조 건축물들과 초등학교 강당, 종교시설로는 청주교구 주교좌성당, 청주 제일교회, 원불교 청주 교당, 서운동 성당, 수동성당 등이 있다.

문화유산의 발굴, 복원 및 재생 노력
(전통문화재의 복원과 보존) 2011년 3월 청주 읍성 파훼 100년 국제심포지엄 행사를 계기로 역사 도시 청주의 정체성을 다시금 돌아보게 되면서, 그

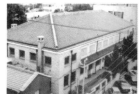
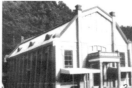
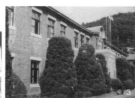

동안 용두사지철당간을 중심으로 꾸준히 전개되어 온 문화유산 보존 시민운동은 청주 읍성 복원 사업으로 이어졌다. 청주시는 2012~2013년 2개년에 걸쳐서 읍성 내 문화재 발굴조사 이후, 우선적으로 서문 성벽으로 추정되는 중앙공원 일부 구간(YMCA 인근)의 복원공사를 진행하여, 2013년 9월 청주 읍성곽 일부 완공을 보았다.

또한 청주시에서는 객사 동헌 영역과 병영 영역을 잇는 관아공원의 조성, 철당간 광장 주변 환경 정비, 남석교의 재현 등의 사업을 비롯하여 VR과 AR 기법을 활용한 다양한 행사를 계획하고 있다. 또한 보행로로 남아 있는 성곽 둘레의 흔적 디자인이라든가, 성곽과 4대문에 면한 건축물 외관 디자인에 있어서, 청주 읍성곽 및 문루의 이미지를 현대적으로 재해석한 창조적 계승 방안에 대한 노력도 진행되고 있다.

(청주 연초제조창의 컨버전) 2011년 구 청주 연초제조창에서의 공예비엔날레 행사를 계기로, 이곳이 문화예술 및 복합공간으로 용도 변경(Conversion)되어야 한다는 데 공감대가 형성되었다. 전통적인 목공예를 비롯한 현존하는 최고의 금속활자로 간행된 직지의 금속공예, 철기문화를 대표하는 철당간의 철 공예, 수많은 충북의 산성에서 보이는 석공술, 그리고 이들 공예와 연관되는 건축과 공공디자인 등 문화, 전시, 상업, 교육의 다양한 기능을 담는 공간이었다.

이후 2012년 2월 남쪽 동 일부가 국립현대미술관 청주 수장보존센터로 확정되고, 2014년 5월 도시재생 선도지역(경제 기반형)으로 지정되면서, 2019년 8월 문화제조창으로 준공되었다. 청주시에 유휴공간으로 남아 있던 이곳이 청주시의 독특한 지역성을 나타내는 장소로서, 도시환경 및 문화 창달을 전하는 문화유산으로서 탈바꿈되었다.

(근대문화유산의 보존과 활용) 선교사 사택으로 지어진 청주 탑동 양관 1호는 선교 본부, 병원, 방송국 등 다양한 용도로 사용되어 왔으며, 현재는 전시 용도로 변경되었다. 1923년에 건립된 구 청주 공립보통학교 강당은 보존 상태가 양호하여 2001년 1월 주성 교육박물관으로 새롭게 변신하여 활용되고 있으며, 1937년 충청북도청 본관의 신축에 따라 1939년에 지어진 충청북도지사 구 관사는 2012년 충북문화관으로 전용(轉用)되어 활발하게 이용되고 있다.

Cheongju's city government is also planning to create a government building park linking the historic inn and magistrate's office area and the vicinity of the military barracks; to improve the area surrounding the square by the iron flagpole; to re-create Namseokgyo stone bridge; and to hold a variety of events using virtual and augmented reality techniques. Efforts are also being made to preserve the form of the fortress and gates through creative contemporary reinterpretations incorporated into the remnants-based design elements of the extant footpath around the fortress, and the external design of buildings looking onto the four city gates.

(Conversion of Cheongju Tobacco Plant) The use of Cheongju's former Tobacco Plant as a venue for the city's craft biennale in 2011 produced a consensus on the need to convert the plant into an art and culture complex. The space would play diverse cultural, exhibition-based, commercial and educational roles related to traditional woodwork; the metalwork behind *Jikji*, the world's oldest extant work printed with metal type; the ironwork behind Cheongju's iron flagpole, a key example of iron-based culture; the stonemasonry found in Chungcheongbuk-do's many mountain fortresses; and to architecture and public design related to these.

Later, in February 2012, some of the complex's southern buildings were expanded to become MMCA Cheongju Art Storage Center, and designated an economy-based priority area for urban regeneration in May 2014. In August 2019, the complex's conversion into a Culture Factory was complete. What had once been an idle leftover space was now transformed into a cultural asset continuing Cheongju's urban and cultural development by manifesting its unique local character.

(Conservation and Use of Modern Cultural Heritage) Building 1 at Tapdong Yanggwan, constructed as a residence for missionaries, has served various purposes over the years, from missionary headquarters to hospital and broadcasting station. Today, it is used as an exhibition space. The former auditorium of Cheongju Public School, built in 1923, remains in a good state of preservation and has been used to house Juseong Museum of Education since its transformation in January 2001. The former official residence of the Governor of Chungcheongbuk-do Province, built in 1939 after the construction of the new main provincial government building in 1937, was later converted into Chungbuk Cultural Center and is in active use as such today.

왼쪽 페이지 아래
청주의
멸실 근대문화유산

Bottom of Left Page
The Lost Modern Cultural
Heritage of Cheongju

1 상무관(무덕전)
2 청주 중앙초등학교 강당
3 대성여중 본관
 (1990년대 후반 멸실)
4 중앙극장(2006)
5 남선당 약국(2019)

1 Sangmugwan (Mudeokjeon)
2 Auditorium of Jungang Elementary School
3 Main Building of Daeseong Girls' Middle
 School (Destroyed in the late 1990s)
4 Jungang Theater (2006)
5 Namseon Pharmacy (2019)

오른쪽 페이지
문화유산의 발굴,
복원 및 재생

Right Page
Excavation, Restoration and
Regeneration of Cultural Heritage

1 청주읍성 일부 구간 복원 준공
 (2013.12.)
2 옛 청주 역사 전시관 개관
 (2019.1.)
3 청주 문화제조창 준공(2019.8.)
4 철당간 광장 주변 환경 정비 계획
5 관아공원 복원계획

1 Completed Restoration of Parts of
 Cheongjueupseong Fortress (December, 2013)
2 Opening of the Old Cheongju History Exhibition Hall
 (Jan,2019)
3 Cheongju Culture Factory Completion (August 2019)
4 Environment Maintenance Plan around
 Iron Flagpole Square
5 Gwana Park Restoration Plan

 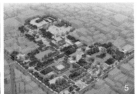

2016년부터 개최된 청주 문화재 야행 행사를 계기로 근대문화유산이 시민들에게 개방되고, 홍보되면서 많은 관심을 받기 시작하였다. 또한 2012년 도시활력증진지역 개발사업으로 선정되어 진행된 구 청주 역사 재현 및 환경 정비 사업의 결과로, 2019년 1월 옛 청주역이 이전 복원되어 청주 역사 전시관으로 개관되었다. 이외에도 청주 시청사 앞 구 통계사무소 건물이 빵집과 학원으로 용도 변경되었으며, 북문로 2가동의 상록회관(137-4, 구 동일여관), GO'S BAR(65-8), 한겨레 두레 협동조합(136-4), 문화동의 한계 가든(69-9) 등의 한옥이 음식점, 여인숙 및 사무실로 전용되었다.

(근대문화유산의 조사기록 활동) 전통 및 근대건축문화재는 문화재청 주관의 실측 조사보고서와 목록화 보고서 발간을 통하여 기록되었다. 또한 구도심인 성안동과 중앙동 일대를 중심으로, 근대기 삶의 모습에 대한 터줏대감들의 구술 아카이브를 비롯하여, 도시공간구조 및 거주환경에 대한 사진 자료 및 도면 기록물들이 청주시와 관계 전문가들의 노력으로 꾸준히 축적되고 있다. 최근 기록물로는, 성안길 구술자료집 『청주약국 앞 홍문당 옆 청주빼까리』(2013), 남주동과 남문로를 이야기한 『근대 청주의 자화상』(2016), 그리고 현재의 구도심이 조성되기 시작한 1960년대 후반의 성안동과 중앙동의 도심 경관 복원 모델을 수록한 『CHEONGJU PROJECT 1960.1990.2020-』(2021) 등이 있다.

청주 도심 거주환경

청주 주거지의 변천 과정

(다양한 주택 유형의 혼재) 청주의 주택은 타 도시와는 달리 과거 전통적인 한옥 군이 뚜렷이 형성되어 있는 곳이 없이 과거의 초가집, 토막집, 전래 가옥, 일본식과 양식 가옥, 영단 주택, 6.25 전쟁 직후의 시멘트 블록집, 간이 주택, 재건 및 후생주택, 1960·70년대의 공영 및 공단 주택, 작가 주택, 1980년 이후 다세대주택, 다가구주택, 공동주택 등 다양한 주택 유형들이 혼재해 있다.

(낮고 두터운 도심경관자원) 청주 읍성을 중심으로 한 도심 주거지는 1970년대 경부고속도로의 개통으로 서부지역, 1980년대 중부고속도로의 개통으로 북서부 지역으로 확장되었으며, 1990년대 도심 공동화 현상 이후에는 대규모 아파트 단지의 대부분이 도심 남부와 북부 외곽의 신흥 주택지에 세워졌다. 구도심 주변은 예전의 스카이라인인 3~5층 이하의 건축물이 가로경관의 90% 이상을 차지하면서, 여타 도심의 혼란스러운 개발에서 벗어나 낮고 두터운 군집 형태를 유지하였다. 다른 어떠한 역사적 도심 지구에서도 볼 수 없는 소중한 도심 경관자원이다.

Cheongju cultural heritage nighttime tours that have run since 2016 have opened the city's modern cultural heritage destinations to citizens, and have begun receiving high levels of interest thanks to the resulting publicity. In 2012, the area was chosen as the target of an urban regeneration development project, leading to the recreation of elements of Cheongju's history and work to improve the surrounding environment. As a result, the city's old station was relocated and restored in January 2019, and reopened as a historical exhibition center. In addition, the former Office of Statistics building in front of the city hall is now used as a bakery and private study academy, while *hanok* buildings in Bungmun-ro 2-ga-dong such as the Sangnok Club (located at 137-4; formerly Dongil Inn), Go's Bar (located at 65-8), Hangyeore Dure Cooperative (136-4), and Hangye Garden in Munhwadong (69-9) are now used as restaurants, inns and offices.

(Study and Recording of Modern Cultural Heritage) Traditional and modern cultural heritage is recorded in survey reports and listing reports published by the Cultural Heritage Administration. In addition, Cheongju city government and other experts are steadily accumulating materials such as an oral archive of accounts from long-term residents of life in the Seongan-dong and Jungang-dong areas in the modern period, as well as photographs and drawings of urban layouts and living environments. Recent records include *Cheongju Bakery, Next to Hongmundang by Cheongju Pharmacy* (청주약국 앞 홍문당 옆 청주빼까리; 2013); *A Self-portrait of Modern Cheongju* (근대 청주의 자화상; 2016), an account of Namju-dong and Nammun-ro; and *Cheongju Project 1960.1990.2020-*(2021), which records urban scenery restoration models of Seongan-dong and Jungang-dong from the late 1960s, when creation of the current old city center began.

The Living Environment in Downtown Cheongju

Transformation of the Residential Environment

(A Mixture of Residential Forms) Unlike other cities with clearly demarcated clusters of traditional *hanok* houses, Cheongju's housing stock is a diverse mixture of forms ranging from historic rice straw-thatched houses to shacks, traditional *hanok*, Japanese and Western-style houses, corporation housing, post-Korean War breeze block houses, single-frame houses (*gani jutaek*), government housing, corporation 1960-70s public and corporation housing, 1980s apartment buildings, and shared housing.

(Low, Close-set Urban Landscape as a Resource) Cheongju's residential area, with Cheongjueupseong Fortress at its center, expanded westward with the opening of Gyeongbu Expressway in the 1970s and north-westward with the opening of Jungbu Expressway in the 1980s. Since work to move housing away from the city center began

(초고층 아파트의 등장) 청주 도심을 대상으로 2006년 건물의 노후화 정도와 호수밀도 등을 조사하여 '2010년 청주시 도시 및 주거환경정비기본계획'이 마련되면서, 38개 정비 예정 구역에서 재개발, 재건축이 시행되었다. 경기 침체와 시민단체의 반대로 대부분 해제되었으나, 도심과 인접한 탑동, 금천동 및 모충동 구역에서 초고층 아파트가 들어서게 되었다. 더욱이 2010년대 이후 인구 유인책이라든가 법적, 경제적 타당성이라는 수도권 아파트 개발 논리를 앞세우면서, 읍성 동문 밖(33층 센트럴칸타빌)과 북문 밖(25층 한신휴플러스, 49층 코아루휴티스)의 예전 대형 필지에 25~49층 규모의 초고층 아파트가 세워지면서, 역사적 도심 경관에 커다란 변화를 가져왔다.

근대기 청주의 주거지와 주택

(가지형과 바둑판형 주거지) 근대기 청주의 주거지는 나무의 가지 모양을 한 가지형(수지형, 樹枝形)과 바둑판형(격자형, 格子形)으로 구분할 수 있다. 가지형은 물이 흐르는 방향에 맞춰 자연스럽게 형성된 길을 따라 건물이 입지하여 골목길이 꺾일 때마다 생생한 현장을 연상할 수 있는 다양한 체험이 가능하지만, 대지를 효율적으로 이용할 수 없다. 바둑판형은 생활에 편리하고 하부시설 설치가 용이하고, 규격화와 유형화가 가능하여 매우 경제적이지만, 단조롭고 무미건조하다. 가지형은 남문 밖 옛 주거지에서, 바둑판형은 동문과 북문 밖 근대기 주거지에서 볼 수 있다.

이들의 대표적인 사례로는 예전의 가지형 주거지 구조를 그대로 간직한 남문 밖 남문로 1가동과 남주동, 새로운 근대식 가로망 구조를 지닌 동문 밖 문화동을 들 수 있다. 남문로 1가동과 남주동의 주거지는 옛 조선시대의 가로망을 그대로 유지한 채, 가구(街區, block)가 정리되었다. 가구 안쪽으로는 기존의 구거(溝渠)를 따라 형성된 뚫린, 혹은 막힌 골목길 형태로 되어 있어, 각각의 대지가 불규칙한 형상으로 나누어져 있다. 반면에 충청북도 도청 앞 관사 자리이면서, 1930년대 격자형 가로망으로 개발된 문화동의 거주지에는 도시 한옥, 일본식 주택, 장옥(長屋) 등 여러 유형의 주택들이 질서 정연하게 배치되어 있다.

(한옥 밀집 주거지) 청주 읍성 밖 성안동 주변에는 오래된 한옥이 산재하여 있다. 특히 남문 밖 남문로 1가동과 남주동, 동문 밖 문화동과 서운동, 그리고 석교동 쪽에 밀집하여 주거지를 형성하고 있으며, 대부분 터줏대감인 노인 부부나 독거노인들이 살고 있다. 이들 도시 한옥은 중부지방의 대표적 유형인 ㄱ자형으로, 안방을 중심으로 부엌과 대청이 결합되어 개개의 실을 형성하고 있다. 한 칸의 기본 모듈은 8자(2.4m)에서 9자(2.7m)이며, 규모는 20평(66㎡) 전후이다. 안채에는 안방, 대청, 건넌방, 부엌, 곳간이 있고, 부속실에는 대문과 측간이 있다.

in the 1990s, most large apartment complexes have been built in new residential zones on the city's northern and southern outskirts. In the area of the old city center, buildings three to five stories high, which constituted the old city skyline, account for some 90% of the street-side scenery, maintaining a low, closely-packed cluster form that differs from the chaotic development patterns of other cities. This is a rare type of urban landscape not found in any other historic city area.

(The Appearance of High-rise Apartment Blocks) In 2006, a basic plan was formulated for the restructuring of Cheongju's urban and residential environments by 2010. This led to redevelopment and rebuilding in 38 areas. Most of the plan was discarded due to economic stagnation and opposition from civic groups, but high-rise apartment blocks were built in the neighborhoods of Tap-dong, Geumcheon-dong and Mochung-dong near the city center. In the 2010s, amid calls for apartment complex development in the greater Seoul region on legal and economic pretexts such as population increase policies, apartment blocks ranging from 25 to 49 stories high (including the 33-story Central Cantavil complex outside the east gate of the old city, and the 25-story Hanshin Hue Plus and 49-story Koaroo Hutis complex outside the north gate) brought huge change to Cheongju's historic urban landscape.

Cheongju Residential Areas and Housing in the Modern Period

(Branch-form and Grid-form Residential Areas) Cheongju's modern-era residential areas can be divided into branch-form, resembling the branches of a tree, and grid-form. Branch-form areas follow streets that formed naturally along waterways, producing a variety of experiences and vivid scenes with every turn of road and alleyway, but failing to allow efficient use of land. Grid-form areas are convenient to live in, easy to install infrastructure in, and highly economical for the standardization and categorization that they allow, but are also dry and dull. Examples of the branch and grid forms can be found in the old residential area outside the southern gate and the modern-era residential areas outside the east and north gates, respectively.

Prime examples of each form include Nammun-ro 1-dong and Namju-dong neighborhoods outside the south gate, which retain their original branch-form layouts, and Munhwa-dong neighborhood outside the east gate, with its modern-style street network. Nammun-ro 1-dong and Namju-dong's residential areas retain their street networks from the Joseon period and are arranged into blocks. Alleyways leading into each block, both open- and dead-ended, formed along the paths of sewer ditches, leading to irregular shapes for each individual plot. By contrast, Munhwa-dong's residential area, the site of official residences by the old provincial government building, was developed in grid form in the 1930s and features

(근린생활시설) 근대기 주택에는 순수한 주택 용도 이외에 점포, 음식점, 사무실, 의원 등이 거주공간과 함께 있는 근린생활시설(도시복합주택, 점포주택)이 있다. 일제강점기와 6.25 전쟁 전후까지는 대부분 목조 2층 이하이었으며, 1960년대 들어서면서 3개 층 규모의 조적조와 철근콘크리트조로 변경되기 시작하였다. 이들 근린생활시설은 1980년대 후반 급격한 경제 성장으로 말미암아 청주의 가로경관을 변경하였던 주요 인자들이었으며, 도시한옥과 더불어 청주의 전통적 생활문화를 현대적으로 표현한 가장 일반적인 건축물이다.

거주환경의 재생 노력

주거지와 주택 계획에서 지역의 정체성과 전통성이 가장 잘 표현될 수 있음에도 불구하고, 청주 도심 지역에서는 이와 관련하여 구체적으로 실천된 사례가 전무하다. 연구진을 중심으로 진행된 도심 거주지의 모델 개발 시도와 노력을 예시하여 본다.

(서운동 옛 주거지의 개발) 1950년대에 조성된 서운동 주거지에는 도로에 면한 접도 조건이 여의치 않아 개발하기 힘든 필지(대지)들이 산재하여 있다. 이들 필지들을 대상으로, 공동 개발이 가능한 개발 단위 중 한 곳을 선정하여 필지 간 공동 개발, 블록형 개발을 적용하여 집합주택 모델 시안을 작성한 뒤, 주민들과의 대화를 통하여 개발 가능성을 검토하였다. 2001년부터 시작한 프로젝트는 2006년 '도시 및 주거환경정비기본계획' 수립에 대한 발표와 동시에 지가 상승에 따른 아파트 건립이 선호되면서 중지되었다가, 이후 필지 간 공동개발에 의한 주택 모델 시안 연구(2007.4), 도심 주거지의 재생을 위한 건축협정의 도입과 적용 방안(2007.6), 1~3차 주민워크숍(2007-2008), 가구 단위 개발계획 등 주민과 함께하는 거주환경의 보존과 재생 활동으로 전개되었다.

청주 거주환경의 모델 개발 예시

1 서운동 집합주택 모델시안
 (블록형 개발)
2 도심 한옥밀집주거지의 재생
 (서운동 성당 주변 블록)
3 도시형 생활한옥모델 시안
 (서운동 진달래길 2개 필지)

several housing styles, from urban *hanok* to Japanese and commercial street-side buildings (*jangok*; 長屋) laid out in an orderly fashion.

(**Hanok-rich Residential Areas**) The area of Seongan-dong, outside the fortress, contains a scattering of *hanok*. These are particularly concentrated in Nammun-ro 1-ga-dong and Namju-dong outside the city's south gate, Munhwa-dong and Seoun-dong outside the east gate, and in Seokgyo-dong, forming residential areas of their own. The *hanok* here are inhabited mostly by elderly couples or single elderly individuals who are long-term residents of Cheongju. These urban *hanok* feature the ㄱ-shaped floor plan commonly found in Korea's central region, with a central anbang (main room), and combined kitchen and daecheong (main wooden-floored room). Each modular element of the *hanok* (*kan*) measures between 2.4 and 2.7 meters, while total floor spaces are approximately 66m^2. The main building of each house contains the *anbang*, *daecheong*, *geonneonbang* (opposite *anbang*), kitchen and storeroom, while the other structures include the front gate and outhouse.

(**Neighborhood Facilities**) Modern-era houses include both ordinary houses and neighborhood facilities such as shops, restaurants, offices and clinics that are combined with residential buildings (also known as urban mixed-use dwellings or commercial-residential buildings). During the Japanese occupation and until around the time of the Korean War, most buildings were two-story wooden structures. From the 1960s, a shift towards three-story brickwork and reinforced concrete buildings began. Such facilities were major factors in altering Cheongju's street-side scenery due to rapid economic growth from the late 1980s and are, together with urban *hanok*, the most common contemporary expression of the city's traditional living culture.

Revival Efforts in Residential Areas

Despite the fact that local identity and tradition can best be expressed through residential area and building design, there are no cases of concrete action in this regard having been taken in central Cheongju. The following is a selection of examples of efforts to develop urban residential area models, led by teams of researchers.

(**Development of Former Seoun-dong Residential Area**) The Seoun-dong residential area was created in the 1950s and is scattered with plots that are hard to develop due to poor road access. One research team chose several of these plots with the potential for joint development, created a plan for multiple dwellings based on joint, block-form development of the plots, and examined the possibility of proceeding with such a development through dialogue with local residents. This project, which began in 2001, was halted in 2006 due to the simultaneous publication of a basic urban and residential environment restructuring plan and emerging preference for building apartments due to an increase in land prices. Later, the project developed into other activities for conserving and regenerating the living environment, including a study of plans for housing models based on joint plot

Examples of Model Development of the Cheongju Living Environment

1 A Model of a Collective House in
 Seoun-dong (block-type development)
2 Regeneration of a Downtown Hanok-dense
 Residential Area (a block around
 Seoun-dong Cathedral)
3 A Model of an Urban Living Hanok
 (2 lots on Jindalae-gil in Seoun-dong)

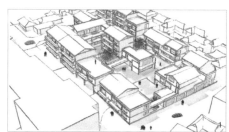

(도시 한옥의 적응형 재생모델 개발) 청주 도심 지역에 산재하고 있는 기존의 도시 한옥을 변화하는 시대에 적응하도록 하는 방안으로, 노인 중심의 주거로 개선하거나, 빈집에 대해서는 적절한 변경과 증축을 통하여 새로운 용도로 변경하고, 도로변에 면하여 개발 가능성이 높은 한옥을 주변 경관과 어우러지는 중층 규모로 창안하는 모델 시안을 제안하였다. 특히 지상 4개 층의 도시형 생활 한옥은 철근콘크리트조의 중층형 주택 구조에 목구조의 한옥이 지닌 중정, 열림과 트임의 공간, 목가구 형식 및 의장 요소 등의 성격을 융합시키는 새로운 재생 모델이다.

(옛 마을의 주거지 계획) 구도심 지역 동서남북 사방은 사주(四洲) 내 외면에 속하는 곳으로, 당대의 옛 마을들이 곳곳에 여전히 산재하여 있다. 현존하는 50여 개 마을 중 옛 마을 구조를 그대로 간직한 22개 마을이 우암산 자락과 서쪽 구릉지인 모충동에 위치하고 있으나, 탑 대성동의 '호두나무 거리'와 '탑골'에서와 같이 주택재개발(탑동 2구역)으로 흔적도 없이 사라져버리고 있는 실정이다. 2014년 청주시 권역이 확대되면서 옛 마을에 해당되는 농촌 자연마을이 총 1,180여 개소에 이르고 있으며, 이들 역시 적극적인 도시화 과정을 겪을 것으로 예상된다. 기존의 획일적인 도시 개발 방식의 도입을 지양하고, 유서 깊은 옛 마을의 보호와 동시에 마을 공간구조의 원형과 형성 과정에 초점을 둔 주거지 계획이 입안되어야 할 것이다.

이제는 어느 도시나 할 것 없이 환경상의 가치를 중시한다. 개발로 인한 환경의 변화가 반드시 삶을 윤택하게 하지는 않는다는 것을 알게 되었다. 파괴하기는 쉬우나 좋은 생활과 작업 환경을 만들어내는 것은 어려운 것이다. 이러한 환경은 흔히 좋은 건축물, 잘 가꿔진 환경, 그리고 안정된 삶을 영위하기 위한 장소에 달려 있다.

이런 점에서 볼 때 청주의 구도심은 여느 도시와는 다른 훌륭한 환경상의 가치를 지니고 있다. 예전부터 이어져 내려온 도시의 공간구조라든가, 낮고 두터운 도시건축 경관, 그리고 무엇보다도 100여 년이 지나도 변함없는 예스러움이다. 남북방향으로 길게 뻗은 우암산 자락, 남에서 북으로 흐르는 무심천, 우암산의 서사면과 굴곡진 무심천 사이에 형성된 배 모양의 구도심, 청주읍성의 형태를 그대로 드러낸 보행로, 성안 길과 옛길, 물길, 터줏대감의 삶과 일, 나무와 조경, 수많은 전통문화재와 근대문화유산은 역사 문화적 메시지를 전달할 수 있는 잠재력 있는 자원이다.

환경의 관점에서도, 예스러운 기존 건축물을 지속적으로 재생하여 사용한다는 것은 그것이 건축적으로 중요한 위치를 차지하거나 역사적 관심사를 지니고 있음을 넘어서, 건축물의 에너지 효율 개선은 물론, 기존 환경의 보호에서도 매우 중요한 것이다. 기후 변화의 위기를 겪고 있는 지금, 청주 도심 지역에서 보여준 작은 건축에 대한 소중한 가치를 다시 한번 돌아보았으면 한다.

development (April 2007), a plan for the introduction and application of building agreements for the regeneration of urban residential areas (June 2007), three workshops for local residents (2007-2008), and a household-based development plan.

(Development of an Adaptive Regeneration Plan for Urban *Hanok*) This plan to adapt existing urban *hanok* scattered throughout central Cheongju for a changing era proposed models for improving *hanok* as dwellings for senior citizens, conversion of empty *hanok* for new uses through appropriate amendments and extensions, and reinventing street-side *hanok* with high development potential into medium-rise buildings that existed in harmony with the surrounding urban landscape. This regeneration model featured four-story urban lifestyle *hanok* combining a reinforced concrete medium-rise residential structure with characteristics of a wooden *hanok* such as a central courtyard, open spaces, timber framing and other design elements.

(Residential Area Planning for Old Villages) The areas around Cheongjueupseong Fortress to the north, south, east and west still contain a scattering of old villages. Of the approximately 50 extant villages, 22 retain their original old layouts; these are located at the foot of Mt. Uamsan and in Mochung-dong to the west, but have now disappeared without a trace, like Tapdaeseong-dong's 'Walnut Tree Street' and 'Tapgol,' due to the Tapdong Zone 2 residential redevelopment project. Since the expansion of Cheongju's administrative limits in 2014, the city has come to include some 1,180 naturally-formed farming villages that can be classed as 'old villages.' These, too, are expected to undergo processes of active urbanization. Conventional monolithic urban development methods must be rejected in favor of drafting residential area plans that conserve the old villages and their long histories while focusing on their original layouts and formation processes.

Today, all cities place importance in environmental value. We have come to realize that the environmental changes brought by development do not always make our lives better. Destruction is easy, but creating good quality of life and working environments is not. Such environments frequently depend on good buildings, well-cultivated surroundings and places for administering stable lifestyles.

In this regard, Cheongju's old city center is of outstanding environmental value unlike that of any other city. This includes its unaltered historical layout, its low, close-set built landscape, and, above all, its old-fashioned qualities that remain intact after 100 years or more. The long area at the foot of Mt. Uamsan, extending along its north-south axis; northward-flowing Musimcheon; the pear-shaped old city center formed between the western slopes of Mt. Uamsan and undulating Musimcheon; the footpath delineating the fortress in its original form; Seongan-gil and old roads within the fortress; waterways; the lives and work of long-time residents; trees and landscaping; and numerous traditional and modern-era cultural heritage destinations are resources with the potential to convey historic and cultural messages.

From an environmental perspective, too, continuously reviving and using existing old-fashioned buildings is vital not just because they occupy architecturally-important positions or are of historical interest, but because this practice improves their energy efficiency and preserves existing environments. In the face of today's climate crisis, we would do well to reconsider the value of small-scale architecture as found in central Cheongju.

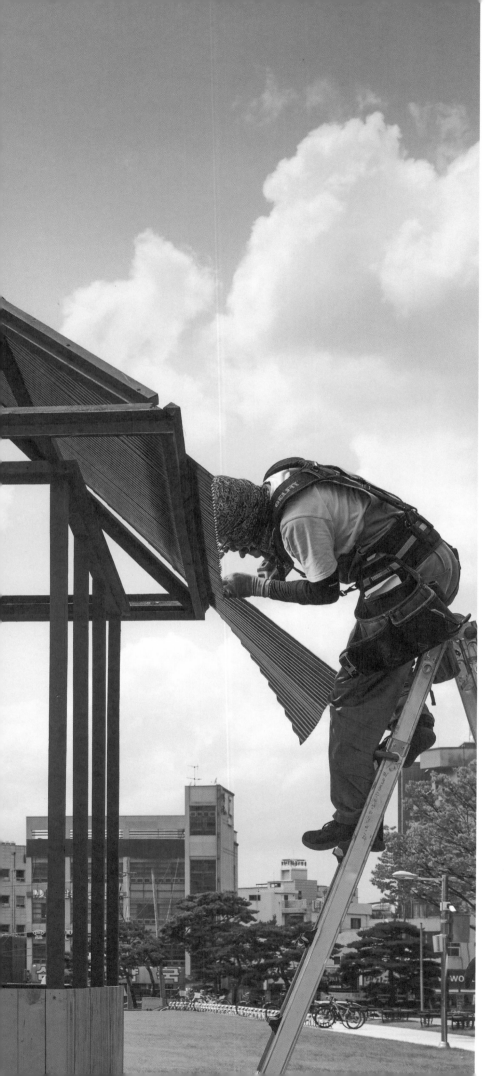

작가 인터뷰

천대광
(작가)

현오아
(국립현대미술관 학예연구사)

Artist Interview

Chen Dai Goang
(Artist)

Hyun OhAh
(Curator, MMCA)

이번 신작 <집우집주>에 대해 설명 부탁드린다.

동서양의 우주에 관한 사상이나 철학을 작품의 근원이 되는 소재로 두고 싶었다. 나는 한국 대종교 경전인 『천부경(天符經)』과 중세 유대교 신비주의 사상인 '카발라'(Kabbalah)가 그 근원이 비슷하다고 생각했다. 그래서 이 두 사상에 영감을 받아 <집우집주>를 제작하게 되었다. '카발라'에 나오는 '세피로트의 나무'(생명의 나무)의 도상을 기반으로, 완벽하지는 않지만 집, 벤치 등 총 10개의 작품을 배치하고자 했다.

거창하기도 하고 내가 감당 못하는 내용일 수도 있는데, 주역에 보면 시대를 후천과 선천으로 구분한다. 우주의 거대한 움직임을 뜻한다고 하는데, 이제는 선천이 지나가고 후천이 온 것 같다는 생각을 했다. 후천에 대한 제시를 이번 작업을 통해서 하려 했는데, 워낙 넓은 주제이고 대규모의 작업이라 시도 자체에 의의를 두고 진행하였다.

이번 작품에 모티브가 된 건축물들은 어떻게 발견하고 어떤 기준으로 선택하게 되었는가?

2000년대 후반 여행을 많이 다녔는데, 평소 관심이 있었던 건축적인 부분(도시의 형태, 건축 양식 등) 사진을 많이 찍고 모아 두었다. 그때 찍었던 사진과 기록들이 이번 작업의 모태가 되었는데, 여러 가지 조형적인 실험을 사진 속에서 끄집어내는 것이다. 내가 보고, 경험하고, 기록한 수집품을 통해 내가 지금 존재하는 동시대를 제시하고 싶었다.

독일 유학 중에 거의 모든 유럽 국가를 여행했다. 다양한 문화를 접하면서 서양 사람들이 어떻게 살고 있는가를 경험할 수 있었다. 유학을 마치고 돌아와서 한국 주변 나라들을 여행하기 시작했다. 의도한 것은 아니지만 식민주의 시대를 지나오면서 형성된 식민 국가와 피식민 국가를 방문하게 된 거다. 여행 중 건축 양식에서 굉장히 흥미로운 지점들을 많이 발견했고 이를 사진 자료로 남겼다. 건축물, 미술품 같은 시각적인 체험, 즉 몸으로 직접 체험한 경험을 통해 내가 축적해 온 자료 안에서 모든 작업들이 진행되었다.

Please tell us about your new work *Dreams of the Perfect City* .

My hope was to have a school of thought or philosophy about the universe, throughout the east and the west, as a basis of the work. I imagined something that becomes the source of the universe. I supposed that the thoughts of Korean Daejongism scripture *Cheon Bu Gyeong* and Medieval Jewish Mysticism 'Kabbalah' were similar to this source. So I created *Dreams of the Perfect City* inspired by *Cheon Bu Gyeong* and 'Kabbalah.' I tried to install ten pieces in the form of houses and benches based on the image of 'the tree of Sefirot (the tree of life).'

And this may be a subject bigger than my understanding, but *The Book of Changes* distinguishes the era with concepts as Seoncheon (先天, The First Heaven) and Hucheon (後天, The Later Heaven). It is told that it signifies the grand movement of the universe, and I think now the time of Hucheon has arrived after the inherent has passed. Through the work, I tried to present something about the acquired. But because it is such a wide ranging topic and a large scale work, I tried to appreciate the importance of the endeavor itself.

How did you discover the buildings that became the motif of the artwork? And what was the reason behind your choices?

I took a lot of pictures of architectural elements (a form of a city, an architectural style, etc), which I have long been interested in, as I was actively traveling in the late 2000s. The documents and the pictures I collected became the ground substance of the work I present in this exhibition. It is about extracting various formal experiments from the pictures. I wanted to present the contemporary that I now exist in through the collection of what I saw, experienced, and documented.

I traveled to almost all European countries while I was studying in Germany. I was able to have a feel of life and culture in these countries. I started to travel the countries around Korea as I came back after finishing my study. In other words, it was a trip to the countries of the colonizer and the colonized, which were formed after the era of colonialism. I am not an expert on architecture, but I find a great deal of interesting points from the architectural style and make many photographic records of them. All the works were created within the visual experience with architecture and culture, and the records were accumulated through a first hand bodily experience.

이번 전시를 위해 청주 소재의 근대기 건물을 모티브로 한 '탑'을 설치했는데 작품 구상 및 제작 과정에 대해 설명 부탁드린다.

일제식민지 시절 적산가옥이 많이 지어졌는데 한옥과 일본 건축 양식이 결합되어 미묘한 형태의 건물들이 많았다. 그중 청주에 있는 적산가옥과 서양식 주택인 탑동 양관의 자료를 수집해 내 방식대로 표현하고자 했다. 한국 전통 건축물은 자연스러운 곡선이 많고, 화려한 단청이 특징이라면, 일본 전통 건축물은 직선적이고 세련된 인공적인 형태가 두드러진다. '후천개벽 탑'의 지붕은 일본 사찰에서 많이 쓰는 주황색 도료를 사용했고, 탑 중앙 부분은 우리나라 사찰 단청 색을 다양하게 배치하여 신비로운 느낌을 주려 했다. 작업의 제목처럼 한 시대가 지나가고 새로운 시대가 도래하는 과도기적인 분위기를 건축 양식의 혼합을 통해 표현하고자 했다.

재료와 색을 아주 다양하게 사용하는데 선정 기준이 있는가?

동남아 여행과 외국에서 체류하며 모은 자료들에서 건축물의 색이나 디자인 요소를 가져와 부분 부분 조합하는 편이다. 그래서 작업의 기본 바탕은 나의 창작물이 아닐 수도 있다. 때때로 부분적으로 색을 바꾸기도 하는데, 사실 정해져 있는 규칙이 있는 것은 아니다. 마치 어린아이가 레고를 가지고 놀듯이 놀이의 결과라고 할 수 있다. 하지만 조합하고 변형하며 어떤 형태를 만들어가는 과정 속에 나의 느낌과 의지가 들어가 있다.

내부에 있는 오브제들은 작품마다 어떤 관계가 있는가??

작품마다 다르지만, 내부에 거울, 사진 액자, 사람들이 앉을 수 있는 벤치 같은 것들도 만들어 놓고, 조명도 설치했다. '캄퐁 플럭의 수상가옥'이라고 이름을 붙인 집 안에는 실제 거주민이 사용할 법한 집기와 가구를 설치해 두었다. 캄퐁 플럭의 수상가옥은 역사적으로 어떤 국가에도 속하지 못한, 오갈 데 없는 난민과 이주민이 많이 살고 있는 가난한 마을이다. 온전한 땅도 그렇다고 온전한 물 위도 아닌 그곳은 그들에겐 마지막 희망 같은 공간이다. 건축 구조물, 집기와 가구를 통해 관객이 좀 더 그들의 삶을 다양한 감각으로 경험할 수 있기를 바란다.

이번 신작이 지속해오던 <견인 도시 프로젝트>의 연장선에 있다고 하는데, <견인도시 프로젝트> 소개를 부탁드린다.

<견인 도시 프로젝트>는 필립 리브(Philip Reeve)의 SF 소설 『견인도시 연대기』의 제목을 차용한 것이다. 미래 핵전쟁으로 지구 전체가 궤멸하게 되고 캐터필러를 장착한 커다란 도시가 세계를 이동하면서 소도시를 잡아먹으며 도시의 생존을 유지하는 내용의 소설인데, 인류가 맞닥뜨렸던 그리고 인류가 행했던 일과 굉장히 비슷하다고 생각했다. 현대 사회는 어떤 식으로든 도시가 형성되고 그 안에서 사람들이 살아가는데, 이러한 도시의 시각적인 부분을 연구한 작품이다. 예술적 시도를 통해 다양한 형식의 작품을 계속 만들어 나가고 있다.

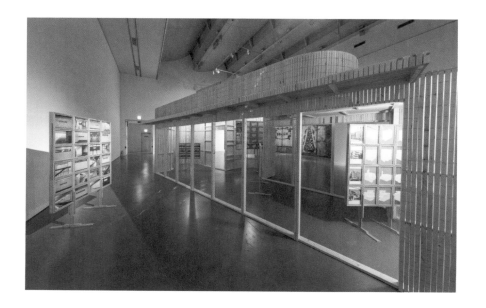

<견인도시프로젝트 2 - 물까치프로젝트, 양평 파빌리온>, 2016, 혼합재료, 500×1000×360cm, 《산책자의 시선》, 경기도미술관, 안산

Traction City Project II-Water Magpie Project, Yangpyeong Pavilion, 2016, Mixed media, 500×1000×360cm, *In the Flâneur's Eyes*, Gyeonggi Museum of Modern Art, Ansan, Korea

Installed for the exhibition, there is a 'pagoda' made with the motif of a building in Cheongju during the Japanese occupation. Please tell us about the process of planning and producing the work.

During the Japanese occupation, a lot of Jeoksan Gaok (enemy's property or houses) whose style combines *hanok* and Japanese architecture were built across the state. I collected information about Jeoksan Gaok and the Western-style Buildings in Tapdong Yanggwan both located in Cheongju, and I tried to express them in my own way. If Korean architecture has many curves and features like Dancheong, Japanese architecture stands out with its tendency of straight, highly refined, artificial forms. Here I tried to combine a Buddhist style. I used the colors of Dancheong from Buddhist temples, the orange paint widely used in Japanese temples, and chose to use Japanese style aesthetic of a straight line in replacement of the curvy roof. Creating confusion that is neither this nor that was the intent of combining all the elements. Like its name, *Hucheongaebyeok (後天開闢) Pagoda*. I wanted the pagoda to express the passing of an era.

You seem to use various materials and colors. How do you choose them?

I tend to combine bits and pieces of architectural design and their color from the records I collected while I traveled Southeast Asia or some Western countries. It could be seen that the basic background to this architectural installation is not my creation. Still there are variations of color in some parts of the work, so there are no fixed rules. I could say that it is the result from a playful process like a child playing with LEGO. My feeling or will is imbued in the process of combining, transforming, and creating a certain form.

There are objects inside each work. What relation do they have with the works?

It varies by each work, but mostly there are mirrors, photo frames, benches for people, and lighting installed inside. Inside the house titled *Kampong Phluk Floating House* there are household supplies and furniture that a resident could actually use. Kampong Phluk Floating House is a deprived village with many desperate refugees and immigrants and historically it does not belong to any country. A place that is neither grounded in complete land nor on complete water is still a space of last hope to the residents. I hope the audience could experience their lives in more diverse ways through the architectural structures, household items, and furniture.

Your new work is an extension to the existing work *Traction City Project* that you worked on for some time. Please tell us more about *Traction City Project*.

The name *Traction City Project* comes from the title of a science fiction novel called the *Traction City Chronicles* written by Philip Reeve. The novel is set in the future where the entire earth is in destruction due to the nuclear war. In the story, a huge city equipped with a caterpillar is moving around and eating up the small cities. It is a tale of a city persevering for survival. I thought the plot is very similar to the things that mankind has encountered and executed. My work is about doing research on the visual parts of a city of the contemporary world, where a city is formulated in one way or another with people living in. I am continuously creating various forms of art through artistic approaches.

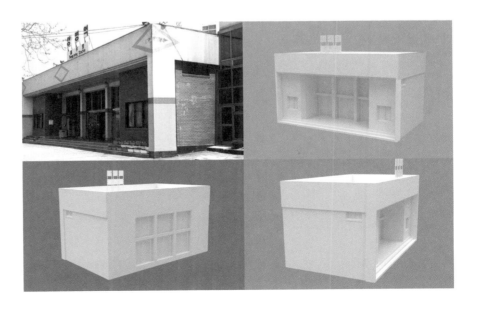

<건인도시프로젝트 2 - 물까치프로젝트,
건축채집(양평군 양평읍 역전길 30 양평역,
철거됨)>, 2016, C-프린트, 32.9×48.3cm

*Traction City Project II-Water
Magpie Project, Building collection
(30 Yeokjeon-gil, Yangpyeong-eup,
Yangpyeong-gun, Yangpyeong
Station, demolished),
2016, C-print, 32.9×48.3cm*

<세상의 모든 종교/라엘리언식 도시 건축을
위한 실험>, 2016, C-프린트, 48.3×32.9cm

*All Religions in the World/ Experiments
for Raëlian-Style City Architecture,*
2016, C-print, 48.3×32.9cm

<견인 도시 프로젝트> 중 양평에서 진행한 작업은 양평군에 실제로 존재하는 건물을 사진 촬영하고 3D 모델링하여 조형적인 3차원 형태의 이미지로 남겨 놓은 것이다. 그 안에서 다양한 종교에서 추구하는 이상 도시의 형태를 발견해 보고자 했다. 예를 들면 '라엘리안 무브먼트'라는 유사 종교 단체에서 말하는 이상적 건축물 형태는 모든 인간이 살 수 있는 엄청나게 크고 높은 건물이다. 이러한 주거 형태는 인간이 점유, 지배하는 수평적 공간을 줄여 더 넓은 녹색공간을 만들 수 있다는 것이 그 종교의 주장이다. 과학적으로 증명이 되고 안 되고를 떠나 그 사고 자체는 재미있게 받아들일 수 있다고 생각한다.

여기서 아이디어를 얻어 실제 양평에 있는 단독 주택들을 조합해서 유사한 고층 빌딩을 디자인하는 작업도 진행했다. 그리고 다양한 건축물을 혼합해서 새로운 건축물 형태를 만들기도 하고, 또는 지극히 개인적인 상상으로 양평의 5층 이상 되는 건물들을 다 없애버린 도시 모델을 공중에서 바라본 3차원 부양법 이미지 형태로 남겨 놓은 작업도 있다. 또 다른 도시의 건축물과 양평의 건축물의 공통점과 차이점을 찾아내고 다른 요소들을 뒤섞어 보기도 하고, 그런 놀이의 부산물들이 모여서 작업의 결과물이 되는 작업들을 계속 진행하고 있다.

**'건축적 조각'은 언제부터
어떤 계기로 하게 되었는가?**

지금 하고 있는 이런 종류의 건축적 설치 조각을 처음 시작한 것은 2000년쯤부터다. 1999년 독일에서 공부를 시작했다. 한국에서는 서양화를 전공했지만, 2차원에서 표현이 나한테는 충분하지 않게 느껴져 졸업전에는 조각, 설치 작품을 출품했다. 그 연장선에서 작업을 계속해 나가면서 독일에서 키네틱, 악기의 구조를 반영한 조각, 설치 등 다양한 분야에 흥미가 생겨 연관된 작업을 했다.

<보청기>, 2001, 목재, 1100×240cm,
뮌스터 쿤스트아카데미, 뮌스터, 독일

Hearing Aid, 2001, Timber,
1100×240cm, University of Fine Arts
Münster (Kunstakademie Münster),
Münster, Germany

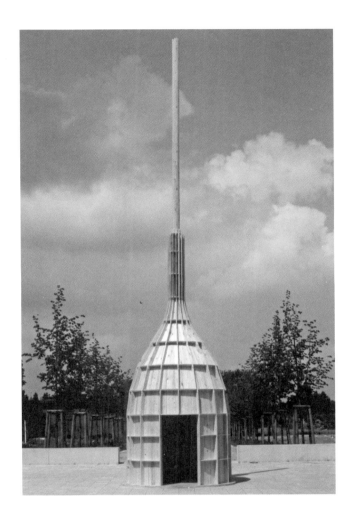

One of the works from *Traction City Project*, there was a work creating 3D models and photographs of the actual buildings from the entire space in Yangpyeong. It is a three-dimensional image imprinted in a figurative form. My aim was to discover the ideal form of a city that is pursued by various religions inside this form. For example, the ideal architectural form suggested by a pseudo religious organization called 'Raëlism' is a tremendously big, high-rise building where all humans could live in. This religion claims that this type of housing could reduce horizontal dimension of space where humans occupy and control, and it could create a wider green space. Regardless of whether it is scientifically feasible or not, I think the concept itself could be interesting.

Developed from this idea, I undertook this work combining some independent houses and designing them into a high-rise building. These houses are some actual buildings that exist in Yangpyeong. There are other works where I created a new architectural form by converging many different buildings. Sometimes, based on a very personal imagination, I removed all the buildings in Yangpyeong that is more than five-stories high and then created a model of a city in a bird's-eye view. Some works mingle a certain architectural aspect from the photographs of places outside of Yangpyeong. I would look for the similarities and disparities with the architecture of Yangpyeong. The by-products of such playful activities come together and become the result. This is the kind of work that I am continuing to do.

When and how have you started working on your 'architectural sculpture'?

It was around the year 2000 when I started this sort of architectural installation sculpture. I started school in Germany in 1999. In Korea, I majored in western style painting, but I made works of sculpture and installation for the graduation show because the two-dimensional expression felt inadequate to me. As I continued my work down this line, I started to make kinetic works, sculptures that reflect the structure of a musical instrument, installations, etc. This interest in various fields sprouted during the time when I was in Germany.

그중 커다란 악기와 같은 작업이 있는데, 작업 안에 사람이 들어갈 수도 있다. 말하자면 악기 안에 사람이 들어가는 형태다. 그 당시 독일 생활을 하면서 느낀 개인적인 소외, 이방인으로서 소통의 문제 등을 생각하는 과정에서 <보청기>(2001)라는 작품을 제작했다. 나팔을 거꾸로 엎어놓은 것과 같은 종 비슷한 모양인데, 서양에서 사용했던 초창기 나팔 모양의 보청기에서 영감을 받아 만든 작품이다. 작업 윗부분에 커다란 파이프를 달아서 바람이 불면 공명이 되고, 내부에서 사람이 그 소리를 들을 수 있다. 또 공간이 둥그렇게 종 모양으로 생겼기 때문에, 벽에 반사된 자신의 목소리도 들을 수가 있다. 소리에 대한 다른 경험을 할 수 있는 그런 작업을 시도했었는데, 규모가 크고 사람이 들어갈 수 있으니 거기에서 자연스럽게 건축적인 요소가 드러나게 된 것이다. 그 작업이 첫 작업이었고, 그 이후 사람이 작품 안으로 들어가 직접 체험하며, 작품의 일부분이 되는 부분에 매력을 느껴 건축적 조각 작업을 계속하게 된 것 같다.

**개별 구조물 제목에
모두 '건축적 조각'이라는 용어가 붙어 있다.
천대광 작가의 '건축적 조각'은
어떤 것인지 설명 부탁드린다.**

서양미술사 용어로 해석을 했을 때 '건축적인 조각'이라는 용어는 1970년도 정도에 정립이 됐다고 하는데, 그 이전에도 건축물 앞에 서 있는 조각이나 설치물도 건축적 조각이라고 칭했다. 건축적 조각이라는 것을 염두에 두고 작업을 시작하지는 않았다. 독일에서 공부하며 활동할 당시에 평론가가 작업을 하는 과정에 건축적 요소가 들어있다고 해서 그렇게 명명해 준 거다. 말하자면 건축적 조각이라는 개념은 이미 있었던 것이고 그 범주로 내 작업이 분류된 것이다. 하지만 그렇게 중요하게 생각하지는 않는다.

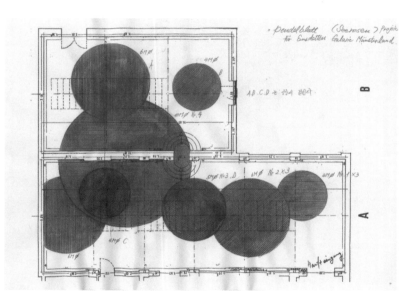

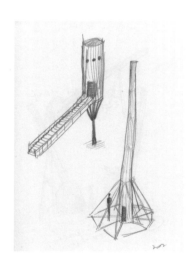

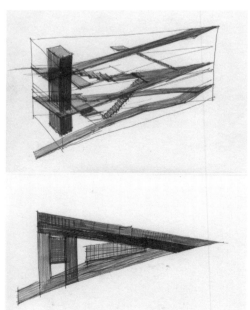

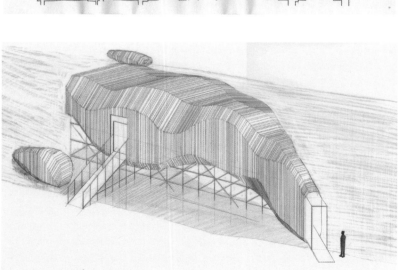

One of the works looked like a large instrument and people were able to go inside the work. It was a form where people could physically go inside an instrument. At the time, I had thoughts about the feeling of alienation, problems with communication as a foreigner as I was living in Germany. And it led to creating this work called *Hearing Aid* (2001). It had a shape of a bell placed upside down that was inspired by a hearing aid, a horn-like shaped, previously used in the West. The huge pipe on the upper part of the work made a sound resonate when the wind blew, and the person inside the work could hear this sound. Also, because the space was bell-shaped and round, the visitors could listen to one's own voice that is reflected from the wall. It was an experiment on a sound experience, but the architectural element was naturally part of it due to its scale that could house several people. This was the first work that the visitors could experience the work by going inside. The incorporating aspect of that experience was appealing so I continued to make architectural sculptures.

Each and every structure has this term 'architectural sculpture' in its title. Please elaborate on what this word means to the artist.

According to western art history, it is known that the term 'architectural sculpture' was coined around the 1970s. Prior to this, there were sculptures or installations in front of buildings and they were called the architectural sculpture. At first, I did not begin the work with this concept of architectural sculpture in mind. A critic once told me this term saying that my work process contained an architectural element when I was studying and working in Germany. That is to say, the concept of architectural sculpture already existed and my work was categorized into that group. But I don't really put much weight to this thought.

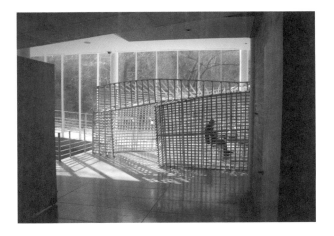

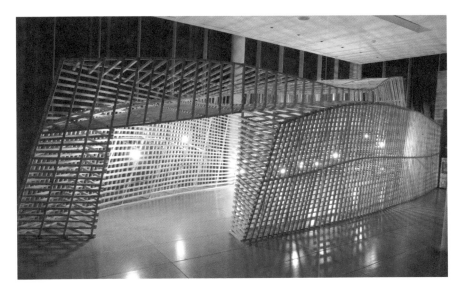

왼쪽 페이지
천대광 작가 아이디어스케치

Left Page
Parts of Artist's Idea Sketches

오른쪽 페이지
<반딧불이 집>, 2006, 목재, 조명,
450×1000×450cm, 의재미술관, 광주

Right Page
Firefly House, 2006, Timber, lighting,
450×1000×450cm, Uijae Museum
of Korean Art, Gwangju, Korea

별도의 건축 설계 도면이 없이 작품을 제작하는데, 구상에서부터 설치 완료까지 작업 과정에 대해 설명 부탁드린다.

한국에 귀국했을 때, 내가 건축과 출신이라고 생각하는 사람이 많았다. 미술계보다 건축 계통에서 더 많이 소개되었기 때문이다. 그러나 실상 나는 건축에 대해서 잘 모르고, 내 작업을 스스로 건축적이라고 생각하지 않는다. 건축적 조각과 건축은 엄연히 다른 것이다. 건축은 사람이 들어가서 오랫동안 머물고 거주해야 하기 때문에 다양한 것들이 고려되어야만 한다. 건축주가 의도하는 철학, 생활 방식 등도 반영되어야 하고, 또 사람이 생활하는 과정에서 필수적인 요소들 예를 들어 화장실도 가야 하고, 목욕도 해야 하고, 밥도 먹어야 하는 것 등도 고려되어야 한다. 그리고 계단의 높이, 간격 이런 것들도 건축법적으로 정해져 있기 때문에 건축은 매우 제한적이라고 생각한다. 여러 부분을 맞춰야 한다는 게 부자유스럽게 느껴진다.

내가 관심이 있고 연구하는 분야는 다르다고나 할까. 내 작업 중 설계를 하는 작품도 있긴 하지만 항상 설계대로 만들지는 않는다. 설계도를 섬세하고 자세히 그려서 그대로 하는 것이 내 기질과 성미에 맞지 않는 것 같다. 작업을 하는 과정에서 의식이 흘러가는 대로 맡겨버리는 부분이 있다. 즉흥적인 요소가 굉장히 많이 가미되어 있다. 전시 제의가 들어와서 전시 장소로 사전답사를 갔을 때 새로운 아이디어가 많이 생기는 편이다. 공간에 가면 받는 기운 또는 느낌이라고 할까? 그 공간이 주는 감응을 온전하게 받아들이려고 노력한다. 예전에 광주에 있는 의제 미술관에서 한 <반딧불이 집>(2006)이라는 작업은 그냥 목재를 주문하고 앉아서 30분 생각한 다음에 그 공간 안에서 즉흥적으로 드로잉을 하듯이 작업했다. 내가 좋아하는 작업 중 하나다. 다시 설계를 해서 만든다고 해도 그 정도의 완성도가 나올 것 같지는 않다.

1970~80년대 유년 시절 서울 내에서 전학을 꽤 많이 다녔다. 유년 시절 이사를 자주 다녔던 경험이 집이나 도시에 대한 관심에 영향을 끼쳤는가?

초등학교만 6~7번 전학을 한 것 같다. 부모님이 혈혈단신 아무것도 없는 상태에서 서울에 올라와 셋방살이를 하셨다. 요즘 사람들은 어떤 직업을 가져야겠다는 목적이 있는데, 그 당시에는 어디서든 돈을 많이 벌기만 하면 되던 때였다. 그 시절 아버지가 직장을 여러번 옮기셨고, 이사도 여러 차례 하게 되었다. 어린 시절 나의 눈에 비친 서울은, 내가 살던 곳에 한정되어 있을 수 있는데, 전체가 공사판 같았다. 어디나 집을 짓고, 목수들이 뚝딱뚝딱 거리고, 아침에 일찍 나와 그 모습을 매일 보고 다녔는데 재미있고 좋았다. 톱을 쓰고 못질을 해서 형태를 만들고 하는 것이 그 영향의 발현인 것 같다.

영화를 제작한 경력이 있다. 어떤 영화인지 설명 부탁드린다. 그리고 영화가 현재 작업에 영향을 끼쳤는가?

중학교 때 '나는 누구인가'라는 생각하기 시작했는데, 학교에서는 절대 배울 수 없었다. 나를 알아야지 어떻게 살지가 결정이 되는데, 그걸 모른채 살아가는게 너무 갑갑했다. 공부는 잘 못하기도 했고, 흥미도 없었다. 그래서 동시상영관에 자주 갔다. 그때 상영한 영화들이 <뻐꾸기 둥지로 날아간 새> 그런 류였는데... 당시 군사 독재 정권 하에서 외설 금지, 반공, 한국 영화 부흥책 등과 맞물려서 예술영화도 아니고 에로영화도 아닌 묘한 분위기의 영화가 많았다. 나는 이런 메타포적인 성격이 강하고 상징적 요소가 많은 영화들을 좋아했다.

시대적인 상황도 내가 영화에 관심을 가지게 된 요인으로 작용했다. 한 번은 길거리에서 내가 머리가 길다는 이유로 바로 잡혀 닭장차(경찰버스)에 실려 유치장으로 끌려간 적이 있다. 다른 이유는 없었다. 내게 세상은 모순 덩어리에 부조리한 것이었다. 힘과 정치권력이 한 개인의 삶을 아무렇지도 않게 난도질하는데 어떻게 똑바로 살겠는가. 그 당시의 독일 영화를 보면 난장판이 따로 없다. 거기는 다 환자들만 나온다. 나 같은 놈들이 영화에서 무더기로 나오니까 너무 좋았다. 그래서 독일 영화를 좋아했다.

군대 제대하고 복학을 했는데, 그 당시에도 방황을 많이 했다. 학교에서는 고흐하고 똑같이 그려봐라, 사실주의, 인상주의 기법으로 그려보라고 하는데, 이게 무슨 의미인지도 모르겠고 짜증이 나는 거다. 그래서 숙제도 안 하고, 반항적이었다. 그때 혼자 상상을 많이 했다. 뮤지컬 같은 작업도 상상하고, 총체적, 종합적인 작업에 대해 관심이 생겨 영화를 배워야겠다는 생각이 들었다.

여기저기 찾아보다가 '한겨레 영화아카데미'에 등록했다. 거기서 보통 다큐멘터리를 찍는데, 나는 실험 영화를 찍었다. 영화라 하기에도 부끄럽고 시나리오 감독, 배우, 음향 등등 하여튼 전부 혼자서 하는 1인 영화를 멋대로 만들었다. 독일 유학도 애초에는 영화를 배우려고 간 거였다. 그런데 독일에는 영화 아카데미가 없었다. 영화학교가 있는지 없는지도 모르고 무작정 독일로 갔으니 내가 참 대책 없는 사람이다. 당시엔 인터넷도 잘 안 되어 있고, 내가 잘 찾지 못한 것일 수도 있는데, 그래서 그냥 미술을 하게 됐다.

Unlike the usual practice in architecture, you produce your work without the stage of plan drawing. Could you please tell us about your work process from ideation to installation?

When I returned to Korea, many people thought I studied architecture. This is because I was more exposed to the architecture group within the art world. But in reality, I do not have much knowledge about the study of architecture, and I do not wish to designate my work as architecture on my end. Architectural sculpture and architecture are strictly two different things. There must be a list of things that should be considered when it comes to architecture, because people have to stay and live in it for a long time. The commissioner's philosophy and the way of life must be reflected on the structure. And there are integral and practical issues such as using the bathroom, bathing, eating, and also technical issues such as the height of the stairs and alignment that the architect must abide to by the architectural law. In that aspect, having to fulfill many things, I feel that architecture is very restricted.

I must say my research interest is quite different. There are works that I prepare a plan but I don't always make them according to the plan. I think delicately drawing and strictly following a blueprint does not fit my temperament. In the process of working, there are times I leave my consciousness flow and take its own action. There are many improvised elements. I tend to have new ideas when I visit an exhibition space after receiving the commission. Should I say that it's the energy or feeling you get when you actually visit the space? I try to fully accept the sensations that the space gives me. Once, when I was working on *Firefly House* (2006) for Uijae Museum of Korean Art in Gwangju, I just ordered the woods I needed, sat down to think for thirty minutes, and then spontaneously started drawing by hand in that space. It's one of my favorite works. I think it is unlikely to have a better result even if I plan and redesign it.

You were moving quite a bit when you were a child in the 1970s and 80s. Has the experience of frequent moving shaped your interest in houses and cities?

I think I transferred to six to seven different elementary schools. My parents moved to Seoul and lived in a rented room without any grounds. Nowadays people seem to find their purpose through a certain job, but making a lot money anywhere was the only thing mattered at the time. My father changed his job several times, hence my family had to move a number of times. In my eyes when I was a child, Seoul seemed to be a one big construction site. It may be just the places I lived. Building houses everywhere, the carpenters were working. I enjoyed seeing such landscape everyday early in the morning. I think using saws and nails in my work seems to be the manifestation influenced by such experience.

You have experience in producing films. Could you explain what the film was about? And is there any association between film and your current work?

I began to question 'who am I' since I was in middle school, but those stuff you could not learn anything from school. Knowing yourself determines how you would live, and not knowing it was stifling. I was neither talented nor interested in studying. So I often went to the theater. The theater screened films such as *One Flew Over the Cuckoo's Nest*. Made during the military dictatorship, these films were strange. Involved with policies of prohibiting obscenity, anti-communism, and a revival policy for Korean film, they were neither art films nor erotic films. The film contained a very strong metaphoric and symbolic quality. I liked them that they had strong symbolic elements, for example, a scene would create a provocative mood without an undressed human figure.

The social background was also a factor that arrested my interest in films. One time, I was forcefully taken into a detention center by a police bus. There was no other reason but my long hair. To me, the world was something negative, contradictory, and irrational. Some power, some political power would rip off an individual's life without a flinch. How could a man live properly after such damage? German films at the time were also charged with chaotic confusion. The films were full of patients. It was nice to see a bunch of men that are like me in those works. That are why I was fond of German films.

I was lost again when I went back to school after being discharged from the mandatory military service in Korea. In art school, people would tell me to draw just like Vincent van Gogh, Realism, or Impressionism. It was confusing and annoying. So I was uncooperative and rebellious at school. Instead, I imagined a lot. During that time, I came up with a lot of my musical works and I found out that I wanted to study film as I was thinking about a total and all-encompassing form of work.

I enrolled in 'Hankyoreh Film Academy' after searching what was at hand. People in the program usually made documentaries, but I made an experimental film. It is embarrassing to say it is a film since it was a one-man production in which I took up all the roles as director, writer, actor, and sound engineer, etc. My original intent on moving to Germany was to study film. I made my decision not knowing there were no film schools in Germany. I was reckless. There was a vocational school that was similar to what I was looking for, but I wasn't able to find it. The internet was not well connected then as it is now, or it was simply my shortcoming. So I just end up doing art again.

작품에 조명이 항상 함께 설치된다. 빛이 작품에서 어떤 역할을 하는지 설명 부탁드린다.

초기 작업 중에 독일의 베베어카 파빌리온(Wewerka Pavillion)이라는 곳에서 전시했던 <안의 밖, 밖의 안> (2003)이라는 작업이 있다. 인도 전통 의학 아유르베다(Ayurveda)에서 착안한 작업인데, 아유르베다에서는 내장 기관을 피부로 본다. 입을 벌리면 다 뚫려 있으니 내장 기관을 몸 안에 있는 것이 아닌 피부의 연장으로 보는 것이다. 전시장 밖 잔디밭에 설치된 유리 구조물은 원래 관객이 입장할 수 없는 공간인데, 유리 구조물 입구부터 출구까지 통로를 만들어 공간에 들어가는 것도 아니고 들어가지 않는 것도 아닌 모호한 상황을 연출해 보고 싶었다. 이 작업에서 처음 내부에 조명을 사용했는데, 낮에는 구조물 안으로 햇빛이 들어와 빛과 그림자가 드로잉을 그리듯 움직임을 만들고, 밤에는 작품 안에서 빛이 나와 밖에서도 작품의 형태를 알수 있다. 낮에는 밖에서 안으로 빛이 들어오고, 밤에는 안에서 밖으로 빛이 나가는 양면적인 표현이 재미있어서 계속 조명을 쓰게 되는 것 같다.

관객이 작품 안에 들어가서 그 공간을 느끼는 것이 작품의 중요한 부분인데, 관람자가 작품의 공간에서 어떤 경험을 했으면 좋겠다고 염두에 두고 있는 부분이 있는가?

'작업을 이렇게 봐줬으면 좋겠다'라는 방식을 그다지 좋아하진 않는다. 관객이 아무 전제 조건이나 배후 설명 없이 공간 안에서 스스로 생각해서 뭔가 찾아내는 방식이 좋다고 생각한다. "내 의도가 이러니 이렇게 보세요"라고 얘기하고 싶지 않다. 그리고 나 또한 작업에 구체적으로 어떤 의미를 부여하지 않는다. 모든 게 약간씩 모호하고, 통일된 것도 없고, 뭉뚱그려 작업의 배경이 된 것들이 있기는 하지만 그게 확연하게 제시되거나 드러나거나 하는 방식은 아니기 때문이다. 그냥 설명을 보고서 '아 그런 거구나' 거기서 끝내는 게 아니라 관객이 원하는 게 있다면 자신 안에서 주체적으로 무엇인가를 찾아보았으면 한다. 그래서 관객 한 명 한 명마다 내 작업에서 받는 느낌이 전부 달랐으면 좋겠다.

본인이 생각하는 이상 도시는 무엇인가?

일단 지구가 평화롭기 위해서는 각 나라가 평화로워야 하고, 각 나라가 평화로우려면 각 마을이 평화로워야 하고, 각 마을이 평화롭기 위해서 그 구성원들이 평화롭고 행복감을 느껴야 한다. 그런 도시가 이상 도시라 생각한다. 예전에 읽었던 노자의 『도덕경』을 보면 이상 도시에 대한 이야기가 나온다. 너무 평화로워서 나라의 왕이 누군지 모르고, 먹을 것, 입을 것, 마실 것, 사는 것에 대한 걱정 없이 자기가 원하는 일을 하면서 즐거운 마음으로 고민 없이 살 수 있는 평화로운 상태. 그러한 상태의 도시가 이상 도시가 아닐까. 그 중에서도 각 개인의 행복이 이상 도시를 이루는 가장 중요한 부분이라고 생각한다. 개개인이 행복한 도시.

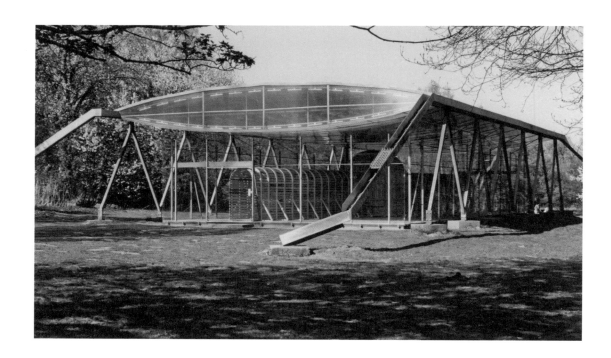

Your works are always installed with lighting. What does the light do in your work?

Among my initial works, there is a work titled *The Exterior of the Inside, The Interior of the Outside* (2003) that was exhibited at Wewerka Pavilion in Germany. The work was conceived by a concept from Ayurveda, a traditional medical science in India. In Ayurveda, internal organs are viewed as skin. With a passage through an open mouth, the internal organs are seen as an extension of the skin rather than the inside of the body. The glass structure in the lawn was outside the exhibition hall and was originally a space where the audience could not enter. However, I wanted to create an ambiguous situation that is neither a place that has an inside nor a place without an inside by creating a passage between the entrance and the exit of the glass structure. During the day, the sunlight would shine into the structure and make a movement as if the light and shadow is in action of drawing. At night, there was a light source inside and gave a silhouette of the work's form. I remember this was the first time using light in my work. The two-fold expression of light, where it shines in during the day and it bleeds into during the night, interests me.

The viewers physically entering and sensing the work are important parts of your work. Do you have a certain experience in mind that you wish the viewers to have?

I am not a fan of directing 'I hope you see the work like this.' I prefer the viewers to come up with something of one's own when they are inside the space, without any preconditions or explanations. I wouldn't want to say, "This is my intention, so look at it this way." I also do not imbue specific meanings to the work. Everything is a bit ambiguous and nothing is unified. There are some things that became the background of the work but they are not shown in a clear manner. I hope the viewers would actively discover the message one wants, rather than ending one's questions after reading the explanation. So I hope each and everyone of the viewers would have different impressions from my work.

How would you envision an ideal city?

First, each country must be peaceful for the earth to be peaceful, each village must be peaceful for the country to be peaceful, and each member of the society must feel peace and happiness for the village to be peaceful. That is the ideal city in my opinion. I once read a story about an ideal city from *Tao Te Ching* of Laozi. It described a peaceful state where one is not aware who the king is because it is so peaceful. In this state of mind, anyone could do the deed they want without the concern about food, cloth, drink, and life. I think the city in such state is the ideal city. Among all, the most crucial part composing the ideal city seems to be each individual's happiness. A city where each individual is happy.

<안의 밖, 밖의 안>, 2003, 목재, 조명,
300×2000×300cm, 베베어카 파빌리온,
뮌스터, 독일

The Exterior of the Inside, The Interior of the Outside, 2003, Timbet, lighting, 300×2000×300cm, Wewerka Pavilion, Münster, Germany

천대광 (1970 –)

서울과 양평에서 활동 중

학력

2007 마이스터슐러, 뮌스터 쿤스트아카데미,
마이크와 디억 뢰버트 교수에게 사사

2006 독일 뮌스터 쿤스트아카데미 석사 졸업

1996 동국대학교 예술대학 미술학과 졸업

주요 개인전

2020 《2020 야외설치미술 1: 공간실험展》, 양평군립미술관, 양평

2019 《수미산에서 바라본 풍경》, 갤러리 담담,
주독일 한국 문화원, 베를린, 독일

2016 《공허한 빛의 파장》, 현대 모터스튜디오, 서울

2014 《아이소핑크 Nr.1》, 스페이스 K, 과천

2011 《캔 크로스 컬처 프로젝트 2011: 공간읽기》, 스페이스 캔, 서울
《어두운 기억》, 경기창작센터, 안산

2010 《풍경》, 프로젝트 스페이스 사루비아, 서울

2009 《격자무늬 터널》, 브레인 팩토리, 서울

2008 《뒤틀린 공간》, 커뮤니티 스페이스 리트머스, 안산

2007 《공간 속의 공간》, 갤러리 야누아, 보쿰, 독일

2006 《왕은 그 노화가의 손에 이끌려 그의 그림 속으로 사라졌다》,
뮌스터 쿤스트아카데미, 뮌스터, 독일

2005 《물, 바람, 불》, 듈멘 자연공원, 듈멘, 독일

2003 《안의 밖, 밖의 안》, 베베어카 파빌리온, 뮌스터, 독일

주요 단체전과 프로젝트

2021 《공공미술프로젝트: 월암별곡 》, 왕송호수변, 의왕
2019 《안양공공예술프로젝트6(APAP6)》, 안양예술공원, 안양
2018 《경기아카이브_지금》, 경기상상캠퍼스(구 임학임산학관), 수원
 《환상벨트 프로젝트》, 돈의문 박물관 마을, 서울
2017 《공사 구간 프로젝트》, 서울디자인재단, 서울
2016 《산책자의 시선》, 경기도미술관, 안산
 《어느 곳도 아닌 이곳》, 소마미술관, 서울
2015 《물도 꿈을 꾼다》, 제주도립미술관, 제주도
 《건축가로서의 예술가: (불)가능!》, 마르타 헤르포르트 미술관,
 헤르포르트, 독일
2014 《2014 창원조각비엔날레: 달그림자(月影)》, 돝섬, 창원
2013 《엠셔쿤스트 트리엔날레 2013》, 엠셔강변, 오버하우젠, 독일
 《감각의 구축》, 아르코 미술관, 서울
 《탐하다》, 경남도립미술관, 창원
2012 《2012 태화강국제설치미술제: 행복, 지금 여기》, 태화강변, 울산
2011 《경기창작센터 지역협력프로젝트: 유주의 삶》, 경기창작센터, 안산
 《THINKING OF SARUBIA 2010》, 가나 컨템포러리, 서울
2010 《유원지에서 생긴 일》, 경기도미술관, 안산
 《지구를 지켜라》, 금호미술관, 서울
2009 《오픈 스튜디오 part1, 2》, 고양창작스튜디오, 고양
2008 《서울시 도시갤러리 프로젝트 2008》, 잠실종합운동장, 서울
 《호퍼+비트리너+쿤스트+프로젝트》, 호퍼 호텔, 쾰른, 독일
2007 《조명 시장》, 베어카멘, 독일
 《의재 공공미술 프로젝트 2007》, 의재미술관, 광주
2006 《수변 설치전 2006》, 코스펠트, 독일
 《모두를 위한 과일》, 빌라 로마나, 피렌체, 이탈리아
2005 《교차로》, KX, 함부르크, 독일
 《뵈더 프라이즈 2005》, 뮌스트 쿤스트할레, 뮌스터, 독일
2004 《조각프로젝트 2004: 물 사이로》, 쿠어공원, 바트 아이블링, 독일
 《친선교류전》, 미마르 시난 예술대학교, 이스탄불, 터키
2003 《준비!》, 빌라 로마나, 피렌체, 이탈리아
 《쿤스트 아카데미 MS x 4》, 갤러리 뮌스터란트, 엠스데튼, 독일
2002 《2002 베스트팔렌 성의 수제자들》, 베어카멘/하일, 독일

주요 수상 및 레지던시 프로그램

2019 문화예술진흥기금 예술가 해외레지던시 지원 선정
 (독일 에니거 하우스 데어 쿤스트), 한국문화예술위원회, 서울
2017 공유도시 공공미술 프로젝트 공모 당선, 서울디자인재단, 서울
 시각예술 중견작가 작품집 발간지원 공모 당선, 서울문화재단, 서울
2016 전문 예술 창작지원 선정, 경기문화재단, 수원
2013 아르코 공공예술 아이디어 공모 당선, 한국문화예술위원회, 서울
2012 스페이스캔 레지던시 입주작가 선정, 베를린, 독일
2011 경기창작센터 지역협력 프로젝트 기획안 당선, 경기문화재단, 수원
2010 경기창작센터 입주작가 선정, 경기문화재단, 수원
2008 2010 프로젝트 스페이스 사루비아 전시 공모 당선,
 프로젝트 스페이스 사루비아, 서울
 고양창작스튜디오 입주작가 선정, 국립현대미술관, 고양
2006 의재 창작스튜디오 입주작가 선정, 광주
 2006 목조각 심포지움 참여작가, 엡스타인, 독일
2005 독일 학술교류처 장학금 선정, 뮌스터, 독일
 뵈더 프라이즈 2005 대상 수상, 뮌스터, 독일
2004 2003 독일 전국 미술대학 연간 전시 도록 수록/
 올해 최고 학생 예술가 선정
 파리국제예술공동체 레지던시 입주작가 선정, 파리, 프랑스
2003 뮌스터 쿤스트아카데미 유럽 교류 장학금 선정, 피렌체, 이탈리아

CHEN DAI GOANG(1970-)

Lives and works in Seoul and Yangpyeong, Korea

EDUCATION

2007 Meisterschüler, Maik and Dirk Loebbert,
 University of Fine Arts Münster (Kunstakademie Münster),
 Münster, Germany
2006 University of Fine Arts Münster, MFA, Münster, Germany
1996 Dongguk University, Department of Fine Arts, BFA,
 Seoul, South Korea

SELECTED SOLO EXHIBITIONS

2020 *Outdoor Installation Art Project 1: Space Experiment*,
 Yangpyeong Art Museum, Yangpyeong, Korea
2019 *The View from Mount Sumeru*, Gallery Damdam,
 Korean Cultural Center, Berlin, Germany
2016 *Void Color Space/ RGB CMYK*, Hyundai Motorstudio, Seoul, Korea
2014 *Iso Pink Nr.1*, Space K, Gwacheon, Korea
2011 *Can Cross Culture Project 2011: Reading the Space*, Space Can,
 Seoul, Korea
 Dark Memories, Gyeonggi Creation Center, Ansan, Korea
2010 *Scenery*, Project Space SARUBIA, Seoul, Korea
2009 *Lattice Tunnels*, Brain Factory, Seoul, Korea
2008 *The Distorted Space*, Community Space Litmus, Ansan, Korea
2007 *Space in space (Raum im Raum)*, Gallery Januar, Bochum, Germany
2006 *So the King Disappeared with the Old Painter into the Picture of
 the Forest*, University of Fine Arts Münster, Münster, Germany
2005 *Water, Wind, Fire (Wasser, Baum, Feuer)*, Wildpark, Dülmen, Germany
2003 *The Exterior of the Inside, The Interior of the Outside
 (Das Äussere des Inneren)*, Wewerka Pavilion, Münster, Germany

SELECTED GROUP EXHIBITIONS AND PROJECTS

2021 *Public Art Project: Woram Rhapsody,* Wangsong Riverside,
Uiwang, Korea

2019 *Anyang Public Art Project 6*, Anyang Art Park, Anyang, Korea

2018 *Gyeonggi Archive_Now*, Gyeonggi SangSang Campus,
Suwon, Korea
RingRing Belt Project, Donuimun Open Creative Village,
Seoul, Korea

2017 *Gongsagugan Project 2017*, Seoul Design Foundation,
Seoul, Korea

2016 In the *Flâneur's Eyes*, Gyeonggi Museum of Modern Art,
Ansan, Korea
Some Where No Where, Seoul Olympic Museum of Art,
Seoul, Korea

2015 *Water Also Dreams,* Jeju Museum of Art, Jeju Island, Korea
*Artist as Architect: (Im) possible! ((un)möglich!-Künstler
als Architekten)*, MARTa Herford, Herford, Germany

2014 *Changwon Sculpture Biennale 2014: The Shade of the Moon*,
Dotseom, Changwon, Korea

2013 *Emscherkunst 2013*, Emscher Riverside, Oberhausen, Germany
Memorable Space, Arco Art Center, Seoul, Korea
Seek & Desire, Gyeongnam Art Museum, Changwon, Korea

2012 *Taehwa River Eco Art Festival 2012: Happiness, Now & Here*,
Taehwa Riversied, Ulsan, Korea

2011 *Local Collaboration Project, The Life of the Liberal*,
Gyeonggi Creation Center , Ansan, Korea
THINKING OF SARUBIA 2010, Gana contemporary, Seoul, Korea

2010 *Works in the Open Air*, Gyeonggi Museum of Modern Art,
Ansan, Korea
Save the Earth, Kumho Museum of Art, Seoul, Korea

2009 *Open Studio part 1, 2*, Goyang International Art Studio,
Goyang, Korea

2008 *Seoul City Gallery Project 2008*, Jamsil Sports Complex,
Seoul, Korea
Hopper + Vitrine + Art + Project, Hopper Hotel, Cologne, Germany

2007 *Light Market 2007*, Bergkamen, Germany
Uijae Public Art Project 2007, Uijae Museum of Korean Art,
Gwangju, Korea

2006 *Water Installations*, Coesfeld, Germany
Fruits for All (Frutti per Tutti), Villa Romana, Florence, Italy

2005 *Crossroad*, KX, Hamburg, Germany
Förder Prize 2005, Kunsthalle Münster, Münster, Germany

2004 *Sculpture Project 2004: Between Water (Zwischenwasser)*,
Kurpark, Bad Aibling, Germany
Friendship Exchange Exhibition (Freundschafts Spiel),
Mimar Sinan Fine Arts University, Istanbul, Turkey

2003 *Ready!(Pronto!)*, Villa Romana, Florence, Italy
University of Fine Arts Münster x 4, Gallery Münsterland e.V.,
Emsdetten, Germany

2002 *Best Pupils in Westphalian Castles 2002*, Bergkamen / Heil, Germany

SELECTED AWARD & RESIDENCY

2019 Sponsorship for Intersnational Art Residency
(House of Art Enniger, Germany), Korea Cultural Foundation, Korea

2017 Shared City Public Art Plan Project, Seoul Design Foundation,
Seoul, Korea
Support for Publishing Catalog, Seoul Foundation for
Art and Culture, Korea

2016 Scholarship for Professional Artists, Gyeonggi Cultural Foundation,
Suwon, Korea

2013 ARCO Conspiracy Ideas Public Art, Seoul, Korea

2012 Project Space in Berlin Artist Residency, Can foundation,
Berlin, Germany

2011 Winner of Proposal for Local Collaboration Project of
Gyeonggi Creation Center, Gyeonggi Cultural Foundation,
Suwon, Korea

2010 Gyeonggi Creation Center Residency,
Gyeonggi Cultural Foundation, Hwaseong (Jebu Island), Korea

2008 Winner of Exhibition Proposal Contest, Project Space Sarubia,
Seoul, Korea
MMCA Residency Goyang, Goyang, Korea

2006 Uijae International Artist Residency, Gwangju, Korea
Wood Sculptors (Holz Bildhauer) Symposium 2006,
Eppstein , Germany

2005 DAAD Scholarship of German Academic Exchange Service,
Münster, Germany
1st Prize, Förder Prize 2005, University of Fine Arts Münster,
Münster, Germany

2004 Listed in *Yearly Nationwide Exhibition Catalogue of
Art Collage Students in Germany (Jahrbuch der Kunstakademien)*,
Publishing House D.M. Basic Man, Düsseldorf, Germany
Cité Internationale des Arts Residency, Paris, France

2003 European Journey Scholarship of the Academy of Arts Münster,
Florence, Italy

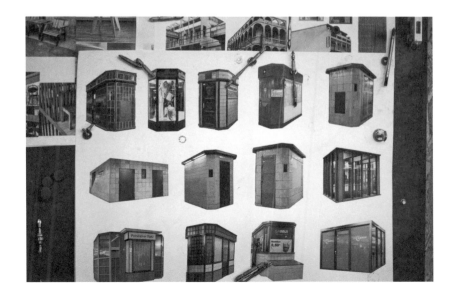

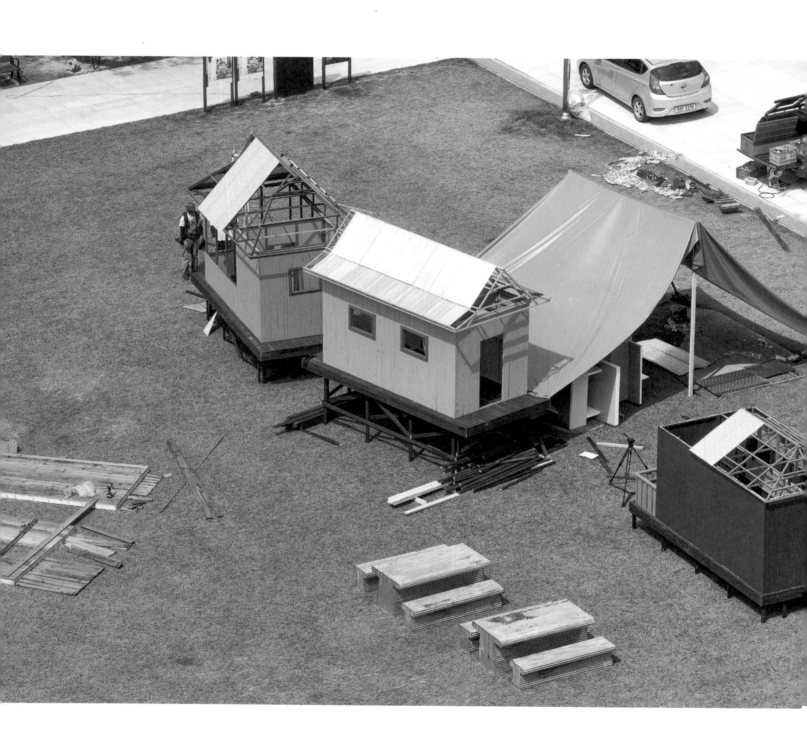

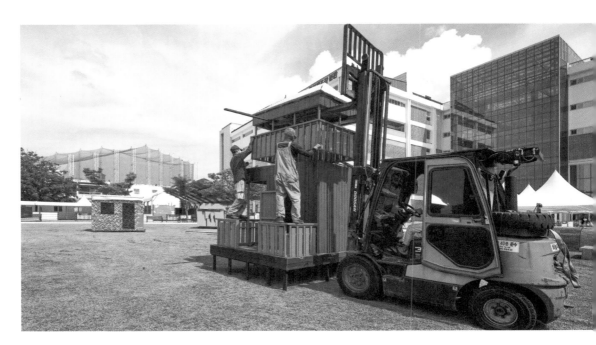

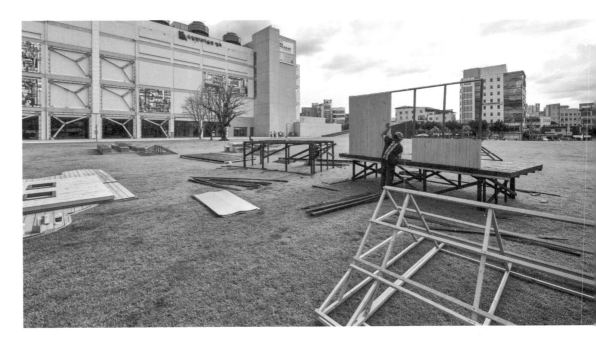

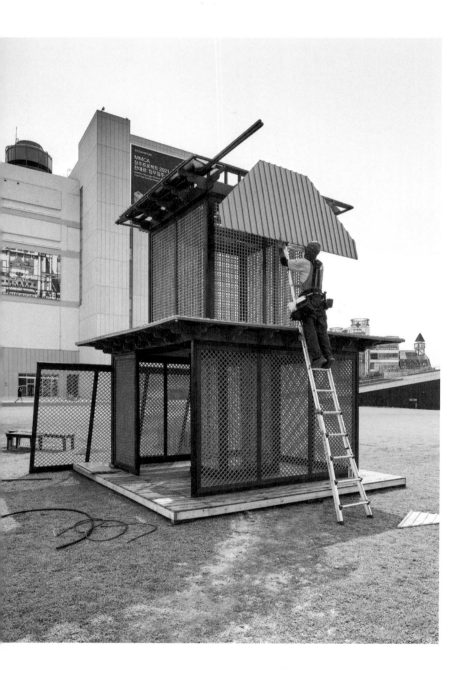
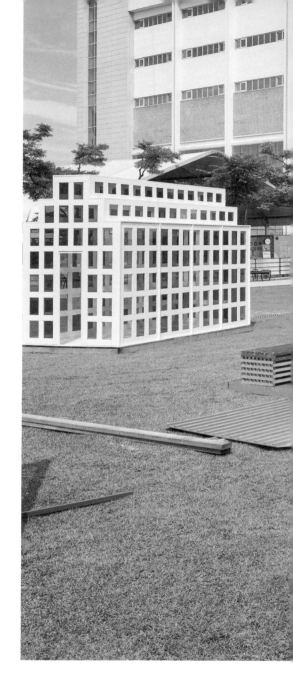

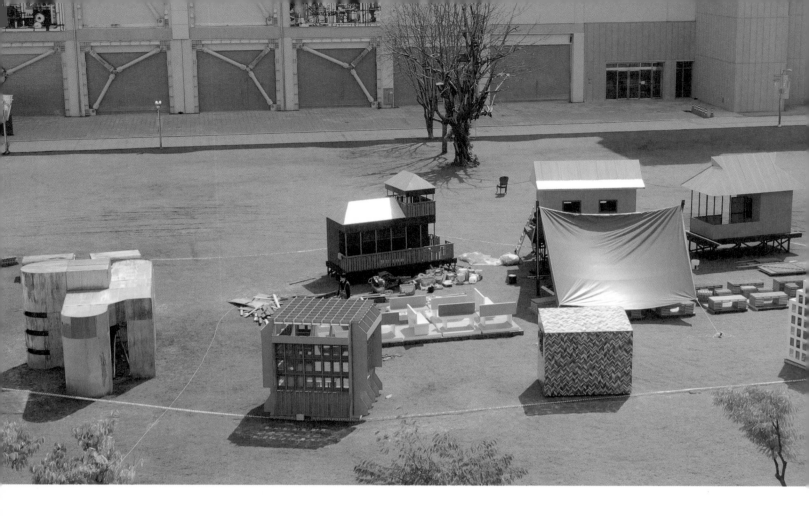

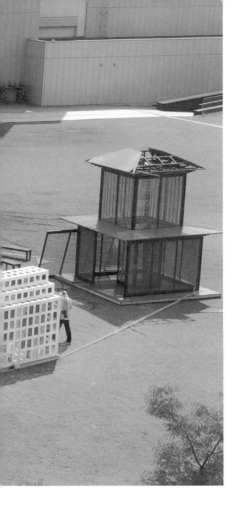

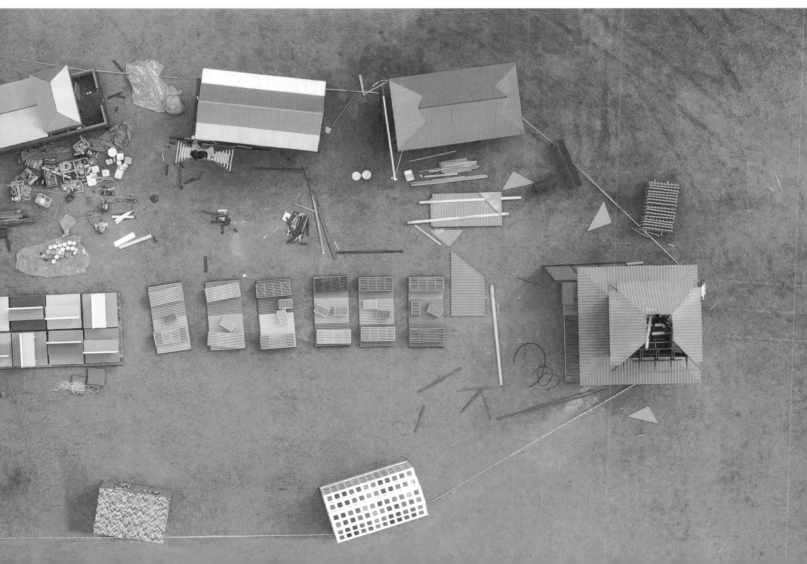

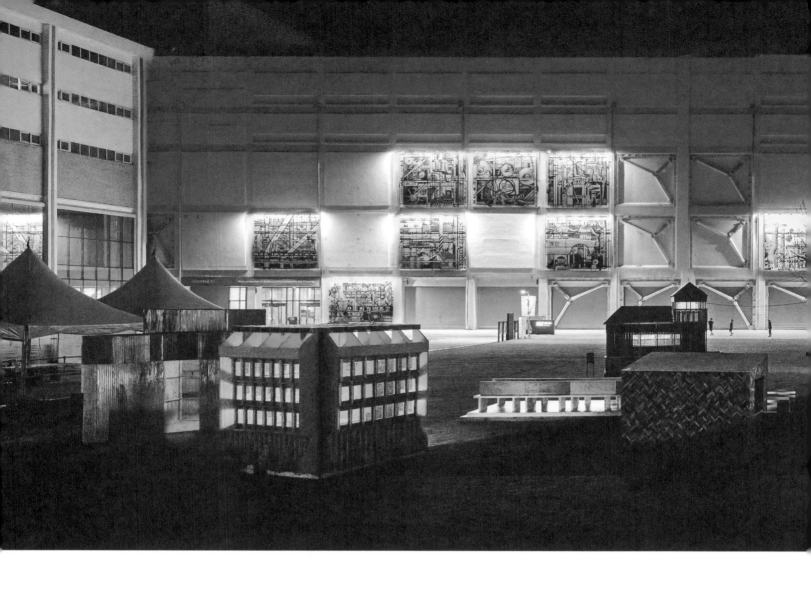

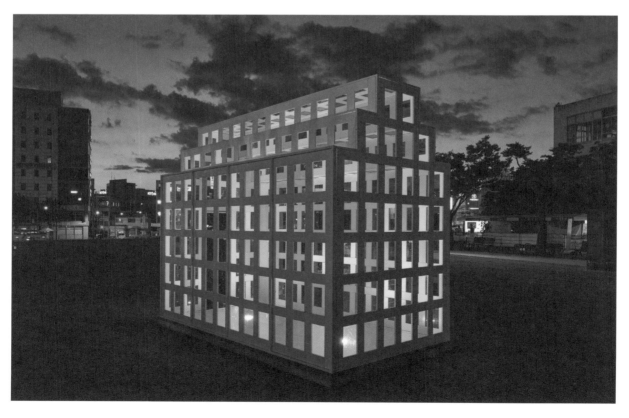

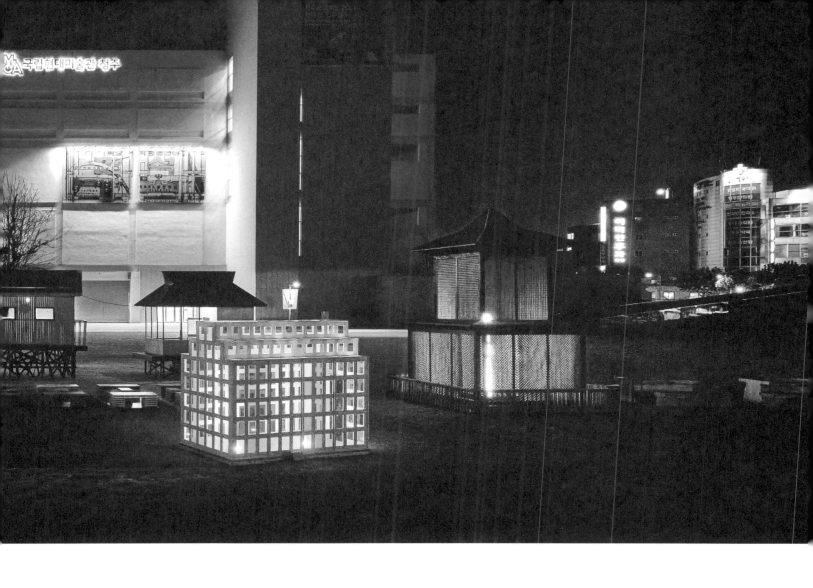

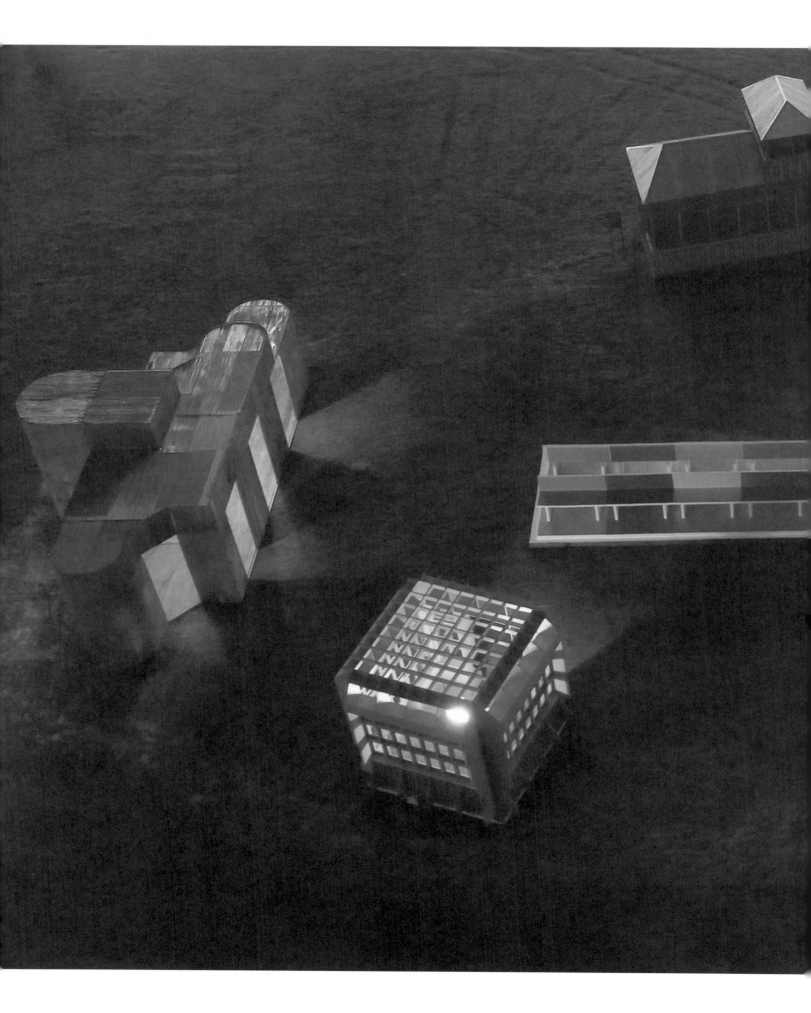

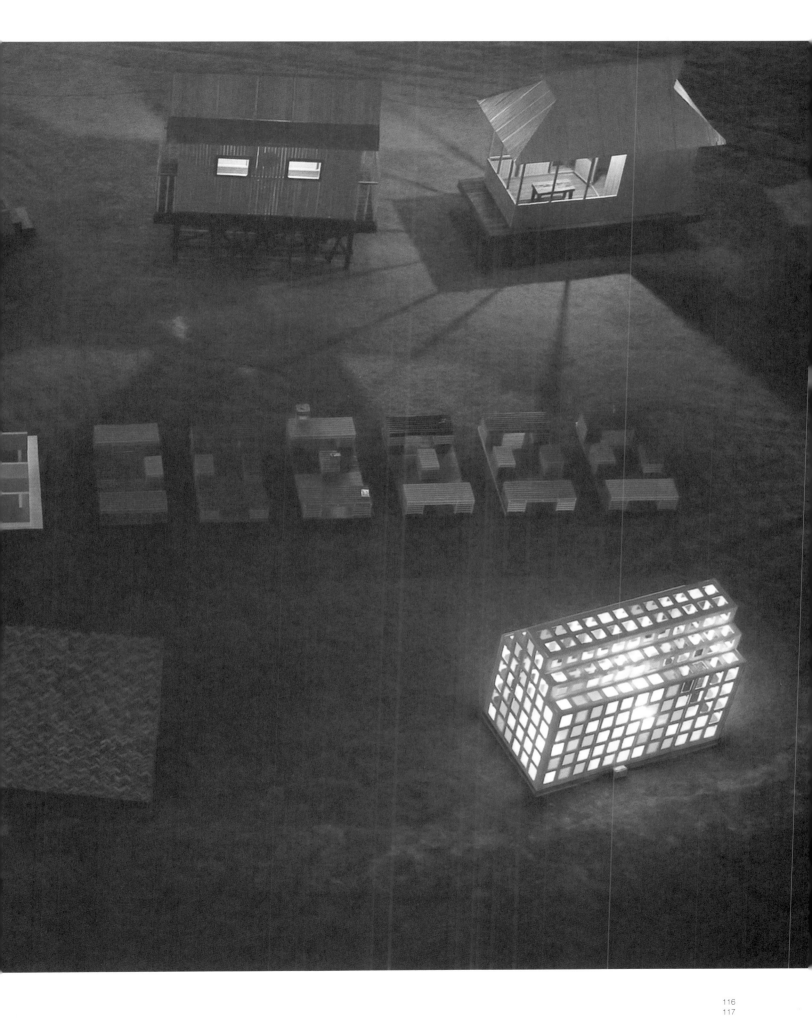

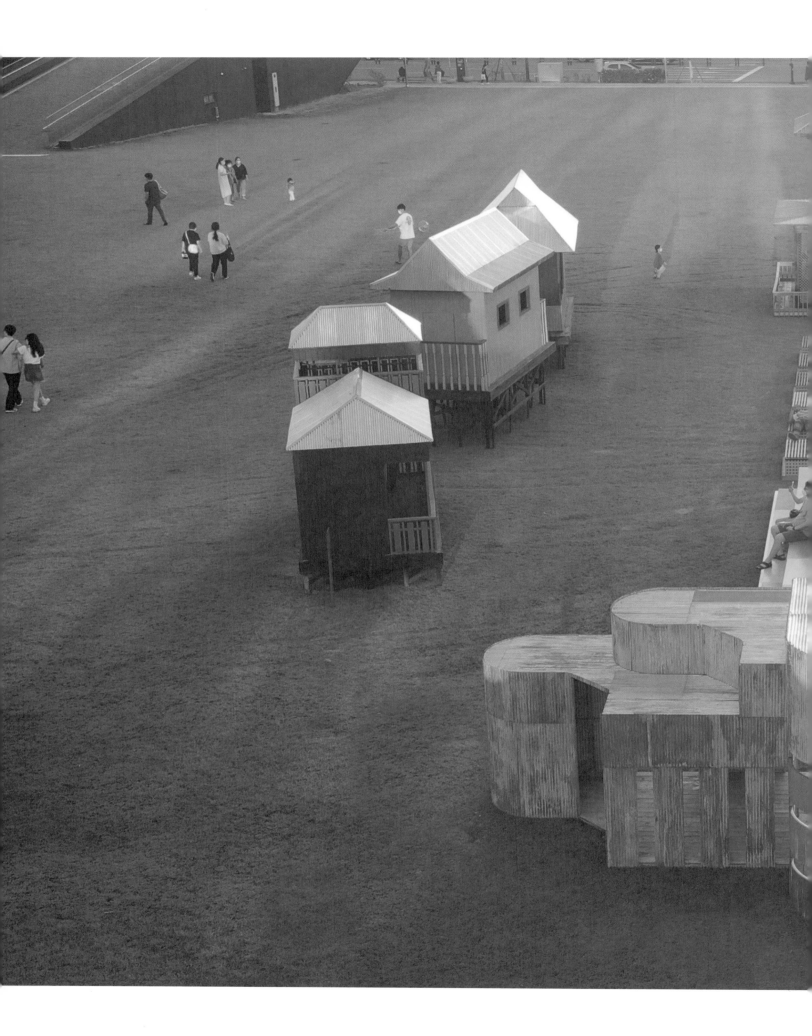

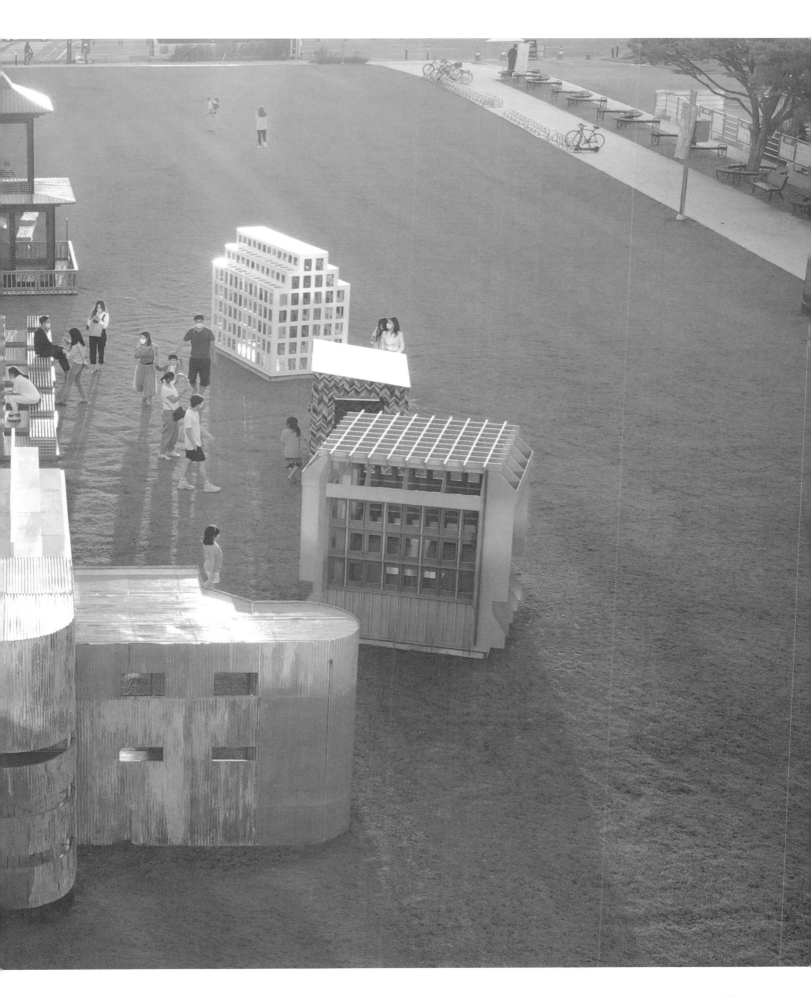

MMCA 청주프로젝트 2021 《천대광: 집우집주》

발행인	윤범모
편집인	김준기
제작총괄	임대근, 김경운
기획·편집	현오아
공동 편집	장래주
편집 보조	허동희
글	김남수, 김태영, 이진경, 현오아
번역	벤 잭슨, 박재용, 임서진
사진	정환영, Studio-AA(드론 촬영)
디자인	별디자인
인쇄	에이치와이프린팅
제작진행	국립현대미술관 문화재단
발행일	2021. 10. 18.
발행처	국립현대미술관
	(28501) 충청북도 청주시 청원구 상당로 314
	tel. 043-261-1400
	www.mmca.go.kr

MMCA Cheongju Project 2021, Chen Dai Goang: Dreams of the Perfect City

Publisher	Youn Bummo
Production Director	Gim Jungi
Managed by	Lim Dae-geun, Kim Kyoungwoon
Editor	Hyun OhAh
Co-editor	Jang Raejoo
Editorial Assistant	Huh Donghee
Text by	Kim Nam Soo, Kim Tai Young, Yi-Jinkyung, Hyun OhAh
Translation	Ben Jackson, Park Jaeyong, Yim Seojin
Photography	Andy H. Jung, Studio-AA(drone)
Design	Byul Design
Printing	HYprinting&co
Published in association with	National Museum of Modern and Contemporary Art Foundation, Korea
Date	October 18, 2021
Published by	National Museum of Modern and Contemporary Art, Korea
	(28501) 314 Sangdang-ro, Cheongwon-gu, Cheongju-si, Chungcheongbuk-do, Korea
	tel. +82-43-261-1400
	www.mmca.go.kr

국립현대미술관
National Museum of
Modern and Contemporary Art, Korea

ISBN
978-89-6303-283-2

가격
32,000원

Price
32,000 KRW